MW01069634

In the Footsteps of Grant and Lee

TEXT BY GORDON C. RHEA

PHOTOGRAPHS BY CHRIS E. HEISEY

# In the Footsteps of Grant and Lee

## THE WILDERNESS THROUGH COLD HARBOR

LOUISIANA STATE UNIVERSITY PRESS ❧ BATON ROUGE

Published by Louisiana State University Press

Copyright © 2007 by Louisiana State University Press

All rights reserved

Manufactured in China

First printing

Designer: Melanie O'Quinn Samaha

Typeface: Centaur MT

Printer and binder: Kings Time Printing Press, Ltd.

Library of Congress Cataloging-in-Publication Data

Rhea, Gordon C.

   In the footsteps of Grant and Lee : the Wilderness through Cold Harbor / text by Gordon C. Rhea ;

photographs by Chris E. Heisey.

      p. cm.

   ISBN-13: 978-0-8071-3269-2 (cloth : alk. paper)

1.  Virginia—History—Civil War, 1861–1865—Campaigns.

2.  Virginia—History—Civil War, 1861–1865—Battlefields.

3.  Virginia—History—Civil War, 1861–1865—Battlefields—Pictorial works.

4.  United States—History—Civil War, 1861–1865—Campaigns.

5.  United States—History—Civil War, 1861–1865—Battlefields.

6.  United States—History—Civil War, 1861–1865—Battlefields—Pictorial works.

7.  Grant, Ulysses S. (Ulysses Simpson), 1822–1885. 8.  Lee, Robert E. (Robert Edward), 1807–1870.  I. Title.

   E476.52.R476 2007

   973.7'309755—dc22

                                                                            2006102883

# Contents

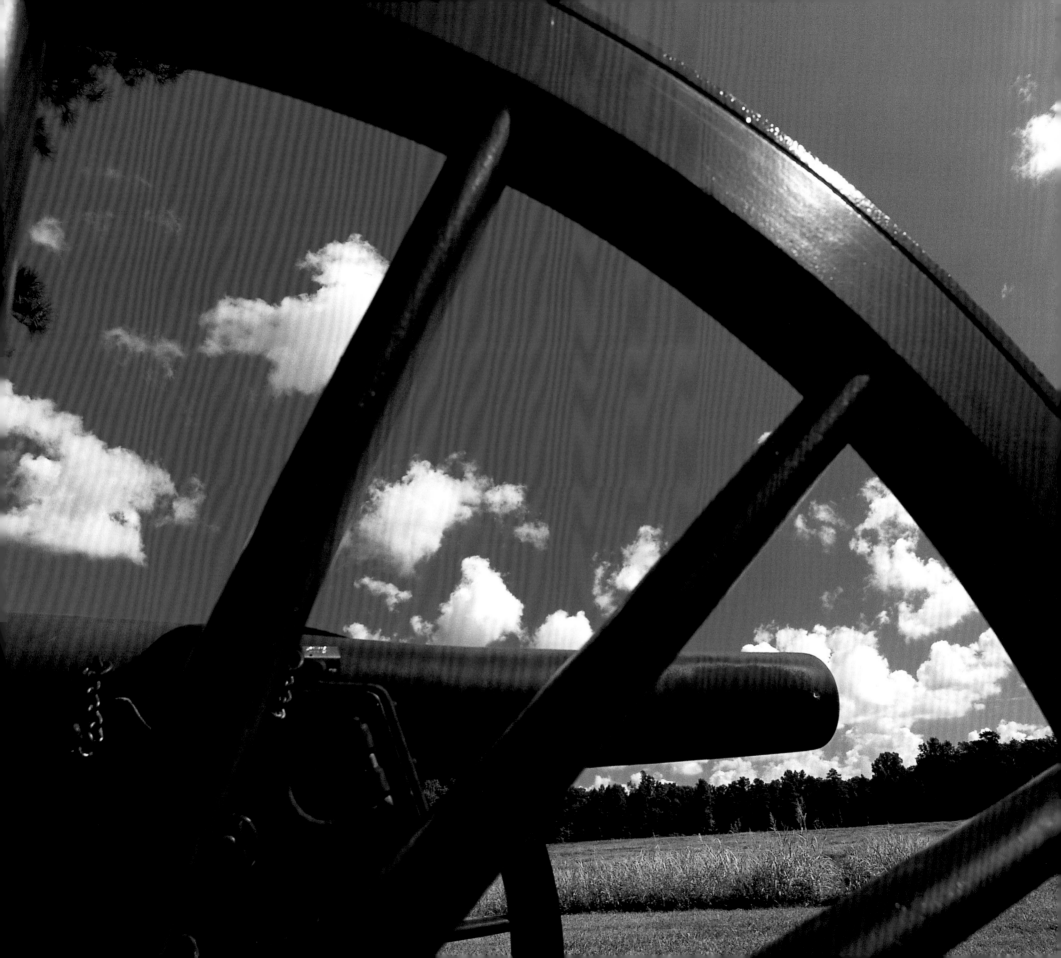

# Preface

My fascination with Civil War battlefields originated with my father. He was born in a flyspeck of a town near Pulaski, Tennessee, thirty-six years after the end of the war. The old men sitting around the grocery store were Confederate veterans itching to talk about their wartime experiences, and my father made a rapt audience. He became a voracious reader, and history—especially Civil War history—was his favorite topic. I remember as a child sitting with him in our living room while he gave vigorous recountings from Douglas Southall Freeman's award-winning biography of Robert E. Lee.

I also remember family summer vacations. Gettysburg was a favorite destination; I have childhood photos of me sprawled across the boulders of Devil's Den looking, at least in my imagination, like one of those dead Confederates so famously photographed by Mathew Brady. We visited Chattanooga, and I recall standing on top of Lookout Mountain trying to conjure scenes from the dramatic battle above the clouds.

I earned a bachelor's degree and a master's degree in history, focusing on topics other than the Civil War. But my interest in America's bloodiest conflict rekindled in the mid-1970s, while I was working in Washington as an assistant United States attorney. Virginia's battlefields were close by and afforded welcome diversion from the courtroom. Visiting the national military parks around Fredericksburg and Richmond, I became fascinated with the grueling match of wits and will between Ulysses S. Grant and Robert E. Lee called the Overland Campaign.

To my disappointment, few of the thousands of books written about the war dealt with the big battles in the spring of 1864. Judging from popular literature, the conflict seemed to have involved fights at places like Manassas, Antietam, Fredericksburg, and Chancellorsville, culminating in a massive bloodletting at Gettysburg in 1863 and followed almost two years later by Lee's surrender at Appomattox. The rolling campaign in the spring of 1864 between the war's two best generals played some part in bringing about that outcome, but details were vague and hard to find.

Curious to learn more, I started a quest that continues to this day. For the next thirty years I visited scores of archives and pored over thousands of yellowing books, manuscripts, letters, diaries, and newspapers. The more I read, the more it became clear that the fields themselves were key to understanding the

battles. You can learn a great deal by reading about the Union charge across Saunders' Field in the Wilderness on May 5, 1864. The full extent of that attack's futility does not hit home, however, until you stand in the swale that bisects Saunders' Field and walk in the footsteps of the New York and Pennsylvania soldiers who tried to capture the high ground held by Virginians and North Carolinians in front of them. By now, I have strolled these battlefields and conducted tours on them until they have become old friends.

Chris E. Heisey, a talented photographer and a leading interpreter of Civil War battlefields on film, shares my passion for the places where our nation's bloodiest war was waged. He has a unique talent for capturing the mood of these sites. How many Civil War buffs have waited on a misty morning in the Bloody Angle at Spotsylvania Court House to photograph the ground fog the way it looked to soldiers who fought and died there during the brutal offensive of May 12, 1864? How many of us have waded into the North Anna River at Ox Ford to capture that strategic river crossing on film? Have any of us lain on the ground at Cold Harbor for hours at night to record the last images seen by wounded soldiers abandoned between the battle lines? Chris has done all of those things, and his dedication, diligence, and imagination make this book special.

Chris shot the photographs presented here during numerous visits to central Virginia from the summer of 2005 through the summer of 2006. While some of the sites he photographed are preserved as part of national battlefield parks, many are on private land, held in trust for posterity through the benevolence of their owners. Virginia's hallowed ground has come under increasing pressure from urban development; the Wilderness and Spotsylvania battlefields lie near the burgeoning metropolis of Fredericksburg, and the Cold Harbor sites are a mere handful of miles from downtown Richmond. Those who love these battlefields as Chris and I do are grateful not only for the care bestowed by the National Park Service and private landowners, but also for the dedication of the myriad of organizations committed to raising funds to purchase and preserve these historic sites. Leading the preservation effort in central Virginia are the Civil War Preservation Trust, the Central Virginia Battlefield Trust, Friends of the Wilderness Battlefield, the Blue and Gray Education Society, and the Richmond Battlefields Association. They deserve our support.

Battlefields conjure images of violence, death, and sorrow. Chris's photographs remind us that battlefields can also be places of beauty and contemplation. Working with Chris on this project has taught me new ways to look at familiar ground. Central Virginia, after all, not only saw the Civil War's most protracted fighting; it also boasts some of our nation's most stunning landscapes. Hopefully this book will help those who share our love of history to see afresh the places where history was made.

We have also included a smattering of wartime photographs and drawings of the Overland Campaign, as historians have christened the forty bloody days of combat that took the opposing armies from the Rapidan River to the James River. Some of Mathew Brady's associates accompanied the Union army and left us priceless images, as did battlefield artists for leading northern newspapers, most notably Edwin Forbes and Alfred R. Waud. A few of their works appear here, along with photographs less well-known to students of the Civil War, such as a picture of Widow Tapp's daughter Phenie standing in Widow Tapp's Field in the Wilderness with Dr. A. M. Giddings, who purchased the land and donated it to the National Park Service.

The focus, though, is on Chris's wonderful renderings. We hope you enjoy this book as much as we enjoyed making it.

GORDON C. RHEA
MOUNT PLEASANT, SOUTH CAROLINA

In the Footsteps of Grant and Lee

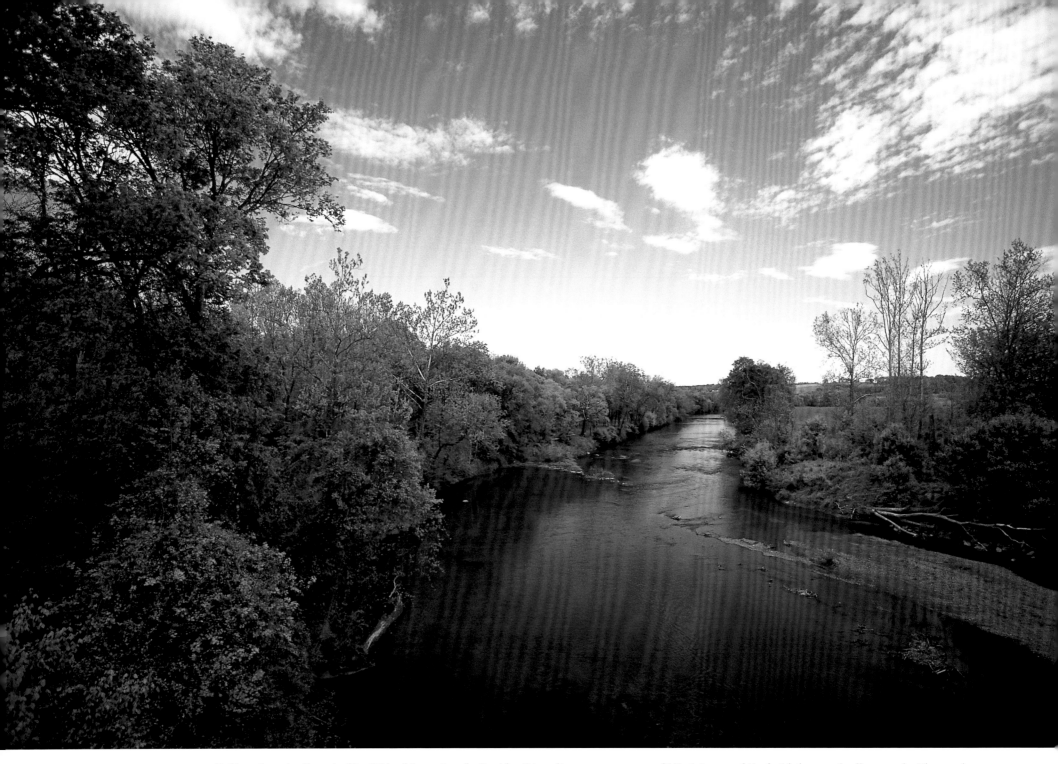

Fed by tributaries from the Blue Ridge Mountains, the Rapidan River slices east across central Virginia toward Fredericksburg and rolls on to the Chesapeake Bay. In the spring of 1864, the Federal Army of the Potomac lay encamped around Culpeper Court House, ten miles north of the Rapidan. The Confederate Army of Northern Virginia waited south of the river near Orange Court House, protected by the formidable river barrier.

# I

# Grant and Lee Prepare for the Spring Campaign

When the American Civil War opened in the spring of 1861, statesmen North and South predicted a quick conclusion to hostilities. Victory, however, proved elusive. In the Western Theater—the nation's broad heartland extending from the Appalachian Mountains to the Mississippi River and from the Gulf Coast to the Ohio River—Union armies achieved signal successes. But in the Eastern Theater, the relatively narrow band of country between the Appalachian Mountains and the Atlantic Ocean, the armies of rebellion held sway.

A little over a hundred miles separated Washington, D.C., from Richmond, Virginia. This chessboard of hills, fields, and forests between the rival capitals remained the domain of General Robert E. Lee and his Army of Northern Virginia. Since assuming command of the rebel host in June 1862, Lee had administered resounding defeats to a string of northern generals. Major General George G. Meade had broken that dismal pattern by repelling Lee's foray into northern territory with his victory at Gettysburg in July 1863; summer, fall, and winter had passed; however, and Meade had done little to exploit his success. By the spring of 1864, Lee had nourished his army back

to strength, and the Union high command had frittered away whatever promise Gettysburg had offered. The frustrated President Abraham Lincoln and his constituency could only wonder whether the years of bloodshed had been in vain.

Eighteen sixty-four was an election year, and President Lincoln was not at all confident that voters would award him a second term. Profound war-weariness, expressed in draft riots and antiwar pronouncements, had gripped the nation's populace.

A tulip on Main Street in downtown Culpeper Court House reaches for the spring sky. In March 1864, Lieutenant General Ulysses S. Grant set up headquarters across the street and matured his plans for a coordinated offensive designed to bring the war to a close.

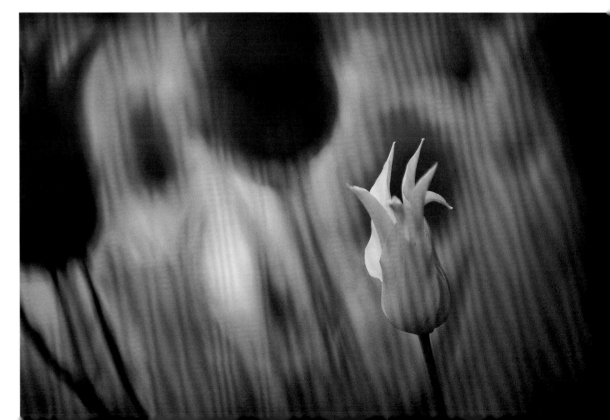

Major General James Ewell Brown "Jeb" Stuart, commanding the Army of Northern Virginia's cavalry corps, left his signature on this wall at Brandy Station. Located a few miles north of Culpeper Court House on the Orange and Alexandria Railroad, the station served as an encampment for Stuart's horsemen in the spring of 1863. A year later, the settlement buzzed with activity as the Army of the Potomac's nerve center.

paper reminded its readers. "The battlefields of 1864 will hold the polls of this momentous decision."

Acutely aware of the need for military successes, Lincoln summoned his best general to Washington. A midwesterner, Ulysses S. Grant had graduated from the Military Academy at West Point and had gone on to win laurels in the war against Mexico. But boredom, loneliness, and—according to rumors that shadowed him all his life—drink had gotten the best of him. Resigning from the army, Grant had settled on a job clerking in his father's leather-goods store.

The Civil War revived Grant's fortunes. Political connections landed him a colonelcy, followed by a brigadier generalship. In January 1862, he won the North's first major victory by taking Forts Henry and Donelson, driving the Confederates from Kentucky and much of Tennessee. He celebrated that success with another triumph at Shiloh, topped by a dazzling campaign of maneuver and siege that captured Vicksburg and ensured Union domination of the Mississippi River. After accepting the surrender of a rebel army at Vicksburg, Grant drove another Confederate force from its mountain fastness above Chattanooga. By 1864, the Yankees were winning the war in the West, and Grant was largely the reason for their ascendance.

Hoping that Grant might work his magic in the East, Lincoln arranged for his promotion to lieutenant general and placed him in charge of the nation's military might. Lincoln promised Grant a free hand running the war and all the troops and supplies he needed to win; in return, Grant assured Lincoln victories, sealing perhaps the most compatible working relationship between president and commander in chief the nation has seen. The president's political fortunes, a New York newspaper noted, "not less than the great cause of the country, are in the hands of General Grant, and the failure of the General will be the overthrow of the President."

On March 10, Grant jostled by train sixty miles down

Unless Lincoln's armies could produce victories, the presidential race seemed destined to go to an opposition candidate willing to negotiate with the South. The spring of 1864 would determine the outcome of the war.

Pondering his fledgling nation's precarious fortunes, the Confederacy's President Jefferson Davis reached much the same conclusion as had his adversary. The North's overwhelming edge in manpower and industry prevented the South from winning independence by military prowess, but by staving off Union victories, Confederate armies might nourish the budding northern peace movement and encourage Lincoln's defeat at the polls. The president's successor, southern politicians reasoned, would then negotiate a settlement to bring the bloodshed to an end. Under this scenario, an exhausted North would let its defiant sister go. "Every bullet we can send is the best ballot that can be deposited against [Lincoln's] election," a Georgia news-

the Orange and Alexandria Railroad to Brandy Station. The hamlet north of Culpeper Court House was the nerve center for the Army of the Potomac, which had spent the winter en-camped there. Grant's purpose was to have a chat with Meade, the army's commander, to gauge whether he should appoint a new general to head the Union's premier fighting force in the East. Ten years Grant's senior, the fifty-two-year-old Meade was notorious for his explosive temper. He could be impossibly close-minded and overbearing, and his prominent hooked nose and eyes accentuated by drooping bags reminded many who met him of an owl. "He has none of the dash and brilliancy which is necessary to popularity," a soldier commented.

Once he had reached Brandy Station, Grant splashed through rain and mud to his first meeting with Meade. Blasts of "Hail to the Chief" accompanied him. To his surprise, the hero of Gettysburg offered to step aside so that Grant could appoint someone of his own choosing. Impressed by Meade's magna-nimity, Grant decided to keep the general on. Loosely defining

Spring frocks cascade across Cole's Hill, where Major General Winfield Scott Hancock's Union 2nd Corps camped dur-ing the winter of 1863–64. Grant conducted a grand review of the Army of the Potomac here, inspecting the force assigned to bear the brunt of the campaign against Lee.

their respective spheres of responsibility, he decreed that he himself would concentrate on coordinating the war effort on all fronts, setting broad strategic policy and ensuring that the far-flung armies acted in concert. Meade was to command the Army of the Potomac. "My instructions for that army were all through him," Grant later wrote, "and were all general in their nature, leaving all the details and the execution to him." Although neither man realized it at the time, the arrangement was a recipe for disaster. Willing to take risks, Lincoln's new commander in chief would find himself hobbled by a subordinate whose caution threatened to undermine Grant's bold plans. The tension between Grant's aggressive nature and Meade's more timid style of warring became a major theme of the impending campaign.

On returning to Washington, Grant set about fundamentally changing the way the nation was fighting the war. His objective was a coordinated offensive for the spring in which forces East and West would move in tandem, bringing the Confederacy's main armies to battle at one fell swoop. The days of short encounters were over. Henceforth, Union armies would engage rebel armies and hold on like bulldogs, fighting every step of the way. And no longer would the chief Union objective be to occupy territory. Some places, of course, were worth seizing; Richmond had psychological value and worth as a rail and manufacturing center, as did Atlanta in Georgia. But Grant's chief aim was the destruction of the Confederate armies, and he determined to press them, as he put it, "until the military power of the rebellion was entirely broken." In short, Grant meant to "hammer continuously against the armed force of the enemy and his resources until by mere attrition, if in no other way, there should be nothing left to him but an equal submission with the loyal section of our common country to the constitution and laws of the land."

The new commander in chief gave his friend and trusted subordinate Major General William T. Sherman the assignment of coordinating Union forces in the West. He took it on himself to see that the eastern armies acted in concert. "Lee's army will be your objective point," Grant directed Meade, in words that left no room for misinterpretation. "Wherever he goes, there will you go also." To prod Meade into a more aggressive mind-set and coincidentally avoid Washington and its intrigues, Grant decided to travel with the Potomac army in the field.

The logic underpinning Grant's remorseless style of warfare was compelling. Assuming the general kept his resolve, the Union must surely win. "Grant is like a bulldog," President Lincoln was heard to remark. "Let him get his teeth in, and nothing can shake him loose."

Throughout April and into the first days of May, Grant bent his energies to preparing the Army of the Potomac for its campaign against Lee. He ordered soldiers on furlough back to their commands, arranged for the recruitment of new men, and ripped garrison troops from their comfortable quarters in the North's urban centers and sent them to the front. An additional body of troops—the 9th Corps, commanded by Major General Ambrose E. Burnside—joined the burgeoning Federal monolith. Meade's quartermaster gathered vast stores of food, forage, and military accoutrements in Alexandria and dispatched those stockpiles by train to depots at Brandy Station. Stevedores in Alexandria readied more supplies for transport by boat down the Potomac River, to be unloaded and brought cross-country by wagons slated to keep pace with the army as it marched south. The enterprise was phenomenal. Workers packed over a million rations, a hundred rounds of ammunition for each of the army's 118,000 soldiers, and medical supplies for 12,000 wounded troops. Purveyors gathered fodder for the 60,000 horses hauling the army's 4,300 wagons, 835 ambulances, and 275 field guns, along with their caissons, battery wagons,

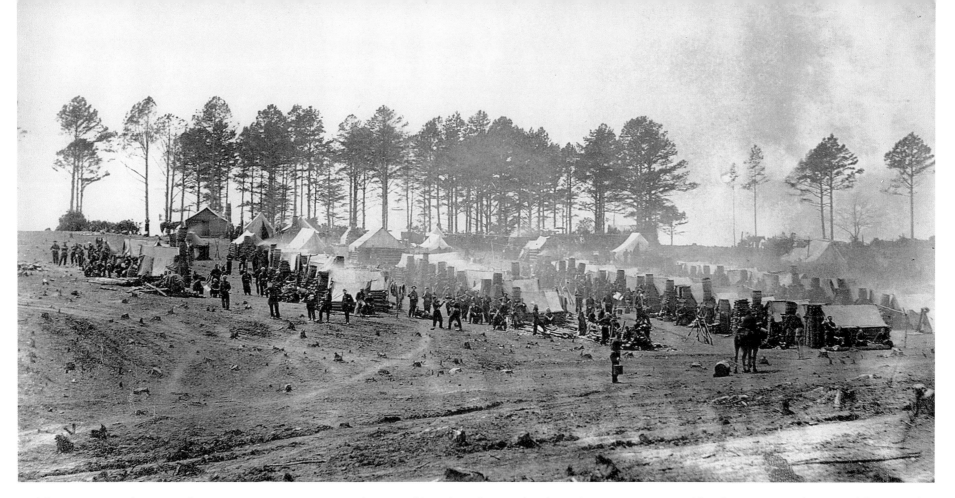

and forges—more than enough wagons, a reporter estimated, to form a train extending from the Union army's encampments to Richmond. Grant also arranged for a herd of cattle to accompany his force as a commissary on the hoof. "Probably no army on earth ever before was in better condition in every respect than was the Army of the Potomac," the quartermaster effused.

But the Army of the Potomac's massive support network and impressive numbers concealed serious flaws. Raw recruits, sprinkled liberally with "substitutes, bounty jumpers, thieves, and rogues," bloated Meade's ranks, and the practice of placing new men into new regiments served to magnify their inexperience. Grant estimated that for every five men enlisted, "we don't get one effective soldier." In addition, the army's veterans had volunteered for three years. Their terms of service were due to expire, which understandably dulled their appetite for combat.

Add to these factors the elusive but important variable of morale—the Potomac army had a tradition of defeat at the hands of Lee—and Grant's success was by no means assured.

The Potomac army's command structure also left much to be desired. Meade and Grant had very different military temperaments, and whether Grant would tolerate Meade's deliberate manner once the shooting started remained open to question. The addition of Burnside's 9th Corps brought further complications. The portly New Englander, boldly festooned with side-whiskers, had led the Army of the Potomac during its failed offensives around Fredericksburg in the bitter winter of 1862–63, and his commission as major general preceded Meade's. Grant's solution was an unwieldy arrangement in which Burnside managed his corps as an independent command, with Grant serving as middleman.

Headquarters of the Army of the Potomac at Brandy Station. From the Library of Congress.

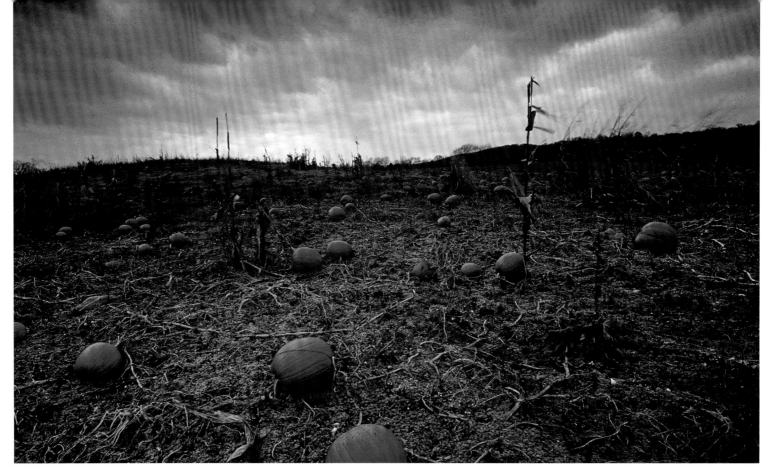

Pumpkins stand sentry duty on Clark's Mountain, south of the Rapidan River. The mountain and associated hills and ridges formed an impenetrable screen that hid the Army of Northern Virginia from Grant's view. Camped immediately behind the mountain, along tiny Mountain Run, were the soldiers of Lieutenant General Richard S. Ewell's Confederate 2nd Corps.

Complicating matters was the fact that Meade's subordinate generals had never worked as a team. Major General Winfield Scott Hancock, commanding the Union 2nd Corps, was a strikingly martial figure of considerable talent, but a debilitating wound at Gettysburg had impaired his ability to exercise field command. And while Major General John Sedgwick, heading the 6th Corps, was sufficiently dependable—"steady and sure," a friend aptly summarized his strength—his steadiness might well prove a handicap in the fast-moving campaign envisioned by Grant. Leading the Union 5th Corps was Major General Gouverneur K. Warren, at thirty-four the youngest of the Union infantry corps commanders. Although Warren made a good first impression on Grant, who pegged him as Meade's likely successor, those who knew Warren questioned how long Grant would tolerate the gangly New Yorker's penchant for second-guessing his superiors. Also uncertain was the fate of

Major General Philip H. Sheridan, one of Grant's subordinates from the West now commanding the Potomac army's cavalry. Accustomed to speaking his mind, the hot-tempered son of Irish immigrants was soon enmeshed in a nasty feud with Meade over the proper role of cavalry.

Undaunted, Grant pitched in with resolve and industry that impressed even his critics. Meade wrote home that Grant's "great characteristic is indomitable energy and great tenacity of purpose." Meade's staffer Theodore Lyman agreed, adding that Grant "habitually wears an expression as if he had determined to drive his head through a brick wall, and was about to do it." Even the rebels expressed grudging admiration. Although southern wags suggested that U. S. Grant stood for "Up the Spout Grant," those who knew him counseled caution. "That man," predicted Lee's vaunted lieutenant James Longstreet, a close friend of Grant, "will fight us every day and every hour until the end of the war."

Clark's Mountain affords an unobstructed vista north to Culpeper Court House and, on a clear day, all the way to Washington, D.C. A Confederate signal station on top of the mountain kept close watch on the Union army, seeking clues that might reveal the timing and direction of the inevitable onslaught.

The Rapidan River coursed eastward across the center of the Old Dominion, drawing a physical and psychological line between Virginia's northern region, occupied by Union forces, and the state's southern portion, still governed by the Confederacy. The Army of the Potomac and the Army of Northern Virginia had faced each other from camps on opposite sides of the stream all winter, their pickets within shouting distance. North of the Rapidan, around the village of Culpeper Court House, Union troops stirred restlessly in their log and earthen encampments, preparing to cross the river and begin the campaign. On the Rapidan's south bank, in camps around Orange Court House, Lee's rebels girded to counter the Union offensive.

In his headquarters by the railroad tracks in Culpeper Court House, Grant settled on a plan that made impressive use of his massive edge in numbers and materiel. The Army of the Potomac was to attack the Army of Northern Virginia

and engage it in battle. At the same time a second Union army under Major General Franz Sigel was to start south through the Shenandoah Valley west of Lee, depriving the Confederates of food and forage from the rich Valley farms and threatening the rebel army's western flank. Simultaneously the Army of the James, commanded by Major General Benjamin F. Butler, was to move against Richmond from the south and sever Lee's supply lines. Battered in front by the massive Potomac army, denied supplies by the Valley incursion, and harassed in the rear by Butler, Lee would be cornered and brought to bay. Grant's plan was a thoughtful exercise, carefully drawn to bring the war in the East to a swift conclusion.

Keeping with their arrangement, Grant left Meade to devise the details of the Potomac army's movement against Lee. In most respects, Meade's plan—drawn in large part by his chief of staff, Major General Andrew A. Humphreys—was well con-

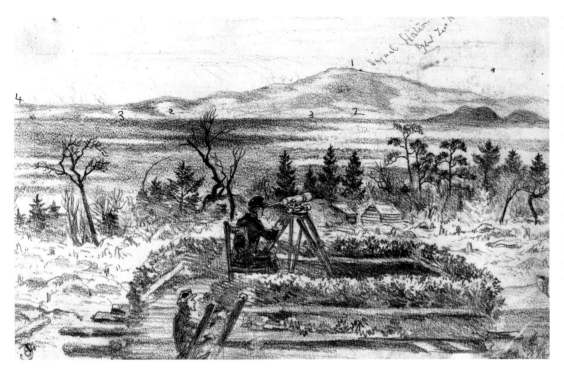

A Union lookout at an observation post on top of Pony Mountain, near Culpeper Court House, peering across the Rapidan River toward a Confederate observation post on top of Clark's Mountain. Drawing by Edwin Forbes, from the Library of Congress.

had been mined by the early 1800s, but then gold was discovered in the region, and the smelting continued, devouring the rest of the region's trees. Planks also had to be cut to pave the two main roads through the wasteland—one crossing at Germanna Ford, and the other linking Fredericksburg and Orange Court House—as a hedge against the Virginia mud.

By 1864, a dense mat of brush and chinquapin had grown up where forest once stood. Streams meandered in unexpected directions, and serpentine foliage made it difficult for travelers to find their way. The region was virtually uninhabited except for a few hardscrabble farms that dotted the suffocating landscape. Roads were scarce, and trails knifed through the green expanse to destinations known only to locals.

Meade and his staff knew from hard experience that this dreary forest of second growth was the worst place imaginable for fighting Lee. As soon as troops advanced, the skein of branches and saplings would swallow them up. Grand maneuvers were impossible, and combat would degenerate into localized brawls. Grant held an impressive edge in artillery, but his cannon would be useless against an unseen enemy, and his cavalry would be confined to a few roads and blind trails. The Confederates, on the other hand, would benefit tremendously from their intimate knowledge of the Wilderness's obscure byways.

Yet the Federal brass decided to bring the Army of the Potomac into the Wilderness and to stay there for a night, exposing themselves to the risk of battle in the very forest they had hoped to avoid. Meade, it seems, was concerned that his ponderous supply wagons might fall behind. Sensing endless possibilities for mischief, he directed his infantry to end its first day's march in the Wilderness to give the wagons time to catch up. His assumption that Lee could not move quickly enough to ambush the Union army in the dark forest—the "first misfortune of the campaign," a Union officer called it—ranks among

ceived. Rather than attacking the rebels head-on, Meade elected to slip several miles downstream and cross to Lee's side of the Rapidan, negating Lee's strong defenses and turning him out of his earthworks. Two fords—Germanna and Ely's—provided convenient crossings and were familiar to the Union generals from earlier campaigns. Meade decided to use the fords to bring his army across the river in two columns, speeding the maneuver.

The movement was well designed to flush Lee into open country and secure Grant the fight that he was seeking. But the strategy contained a fatal flaw. After crossing the Rapidan, the northerners would find themselves in an eerie, inhospitable region of tangled second growth. In colonial times, iron ore had been discovered in the area, and the lieutenant governor of the Virginia Colony, Alexander Spotswood, had embarked enthusiastically on a smelting business. By the 1750s, six blast furnaces consumed more than two acres of woods a day. Most of the ore

the most egregious command errors of the Civil War. And thus it happened that Grant unknowingly planned to open his campaign by giving Lee a windfall, halting his army at the best location the rebel commander could have imagined for his smaller force to give battle.

For three years, hostile armies had scoured Virginia, and even homes that had escaped the tread of troops felt the conflict's heavy hand. Inflation had emptied everyone's pocket, goods were scarce, and widows kept lonely vigils, striving to preserve what remained of their families and property. News from the front grew bleaker by the day. Vicksburg and Gettysburg had dashed the Confederacy's hope for foreign intervention, and now Grant was assembling a juggernaut on the Rapidan River, sixty miles north of the southern capital. Reports suggested a second Union army gathering at Fortress Monroe, southeast of Richmond on the James River, and a third enemy force in the Shenandoah Valley, poised to attack from the west. Grant held Richmond and its defenders in a three-jawed vise, and his intentions were apparent. When the skies cleared, he would slam the vise's jaws shut, crushing the rebellion's capital and the Confederacy's premier army.

Richmond's fate and the fortunes of the Confederacy were in the talented hands of General Lee, whose victories during the past two years had made him a symbol of the rebellion's determined spirit. The Virginia aristocrat's threadbare veterans trusted him completely. "General Robert E. Lee is regarded by his army as nearest approaching the character of the great and

Green and blue from trees and the sky reflect from currents rippling over shallows in the Rapidan River at Raccoon Ford. Little more than ankle deep, the ford was a favored crossing on the Rapidan, and the opposing armies stationed patrols here to guard against surprise attacks. Bored Yankee and Confederate pickets entered into informal truces to exchange newspapers, coffee, and tobacco.

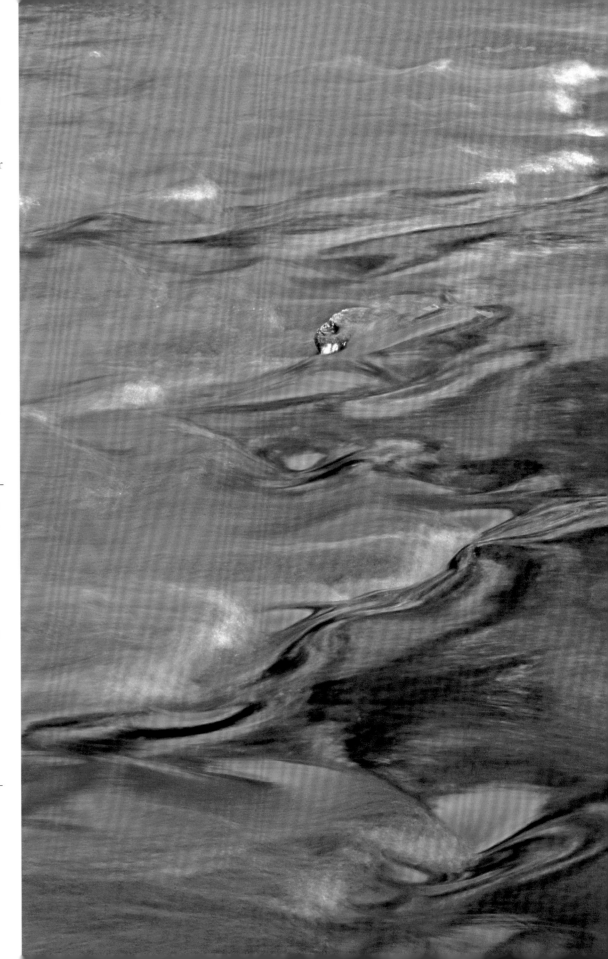

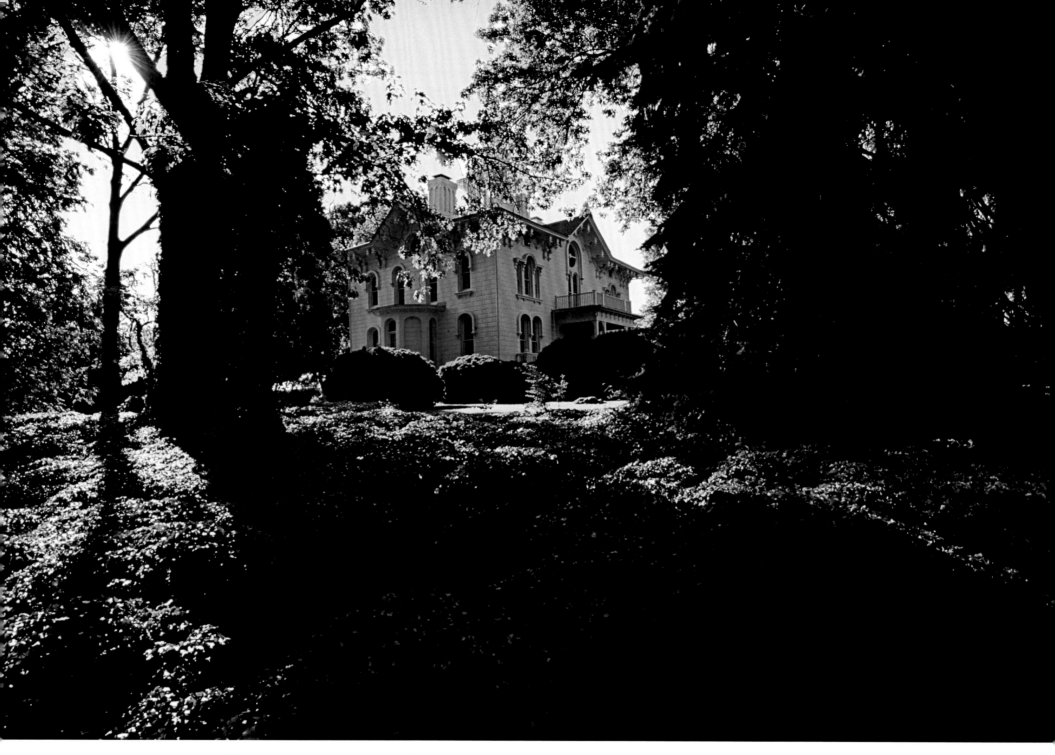

The Italianate Mayhurst Inn majestically crowns a knoll south of Orange Court House, overlooking the Orange and Alexandria Railway. Here Confederate Lieutenant General Ambrose P. Hill and his family spent the winter of 1863–64, and here Hill's infant daughter, Lucy Lee Hill, was christened in a ceremony attended by General Lee, her godfather and namesake. Currently operated as a quality bed and breakfast, the home retains its antebellum charm.

good [George] Washington than any man living," a Confederate wrote home. "He is the only man living in whom they would unreservedly trust all power for the preservation of their independence."

The general was fifty-seven years old—fifteen years Grant's senior—and his cropped beard had gone almost entirely gray. Although Lee's bearing seemed strikingly unlike that of the plebeian Grant, the two men shared aggressive military temperaments and delighted in surprising their foes. A master at conducting offensive operations, Lee displayed an uncanny knack for turning seemingly impossible situations his way. His most brilliant successes had been against armies that outnumbered him better than two-to-one, coincidentally the same numerical advantage that Grant held over him this spring.

The Army of Northern Virginia had suffered through a hard winter in camps south of the Rapidan River. But wayward soldiers began returning as spring advanced, and new recruits poured in from the Deep South. By the end of April, Lee commanded a force of nearly sixty-four thousand soldiers. Facing an enemy almost twice as numerous and much better supplied, Lee's troops nonetheless held important advantages. Most were veterans, and new men were generally assigned to veteran outfits, where they could fight alongside experienced troops. Lee's soldiers knew every road and path and displayed the élan of men defending their native soil. Each spring Union invaders advanced on Richmond, and each spring the Army of Northern Virginia drove them back, often against daunting odds. Reminiscing years later, a Virginian who had fought with that army reflected, "The thought of being whipped never crossed my mind."

Early morning sun shimmers through an ancient pane in the cupola atop Mayhurst Inn. The name Rodger, etched in the window's lower corner, was likely left by a soldier on guard duty.

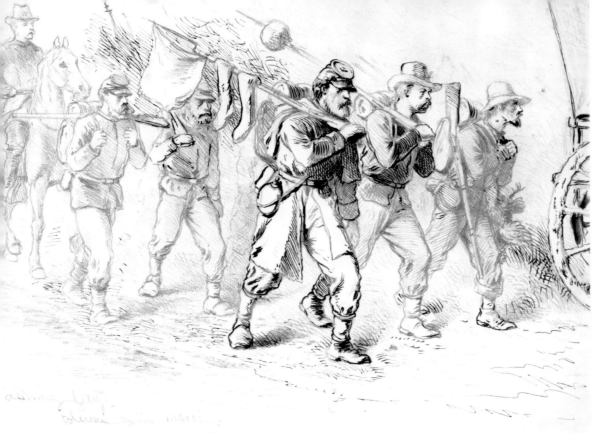

Union soldiers marching to battle. From the Library of Congress.

But several concerns troubled Lee. One was his health. Assisted by only a small staff, the rebel commander had immersed himself in the minutiae of command, often retiring late and rising early. "I am becoming more and more incapable of exertion, and am thus prevented from making the personal examinations and giving the personal supervision to the operations in the field which I feel to be necessary," the general admitted after Gettysburg. Writing one of his sons during the spring of 1864, Lee confessed a marked diminution in strength that he feared rendered him "less competent for duty than ever."

Another concern was his complement of top generals. Lee's army, like Meade's, had three infantry corps whose heads exhibited an exasperating blend of strengths and weaknesses. Lieutenant General James Longstreet, a full-bearded Georgian who had contributed mightily to Lee's earlier successes, commanded the Confederate 1st Corps. Old Pete, as Longstreet was called, was Lee's senior general and trusted adviser, but his recent stab at managing an expedition in Georgia and Tennessee had accentuated a disturbing streak of independence and pettiness. Heading Lee's 2nd Corps was Lieutenant General Richard S. Ewell, an eccentric, one-legged Virginian in questionable health. At Gettysburg, Ewell had appeared reluctant to initiate offensive operations; whether that hesitancy was a passing phase or the sign of a more deep-seated fault was not yet clear. Most troubling to Lee was Lieutenant General Ambrose Powell Hill, or Little Powell, as the commander of the Confederate 3rd Corps was known. A native of Culpeper County, Virginia, the aggressive Hill had excelled early in the war, heading a division. Elevation to corps command, however, had left him flustered, sapping his spontaneity and flair. Like Ewell, Hill was also wracked with ill health—in his case a disabling condition apparently brought on by a youthful bout of venereal disease.

Even Lee's mounted arm presented cause for concern. Lee relied on his cavalry to screen his army's whereabouts and ferret out the enemy's location. But at Gettysburg, the flamboyant commander, Major General James Ewell Brown "Jeb" Stuart, had failed to act with his accustomed care, leaving Lee to grope blindly for the Yankee army deep in enemy territory. Lee felt strong affection for Stuart, whom he regarded almost as a son, but recognized that he would require close supervision during the impending campaign.

It was clear by mid-April that Grant meant to launch his major effort in the Old Dominion. Ever aggressive, Lee preferred to seize the initiative and attack, as a Confederate victory in Virginia might compel Lincoln to recall his forces in defense of Washington. "If I am obliged to retire from this line," Lee predicted, referring to his hold on the country below the Rapidan, "either by flank movement of the enemy or want of supplies, great injury will befall us."

As the curtain of gray clouds lifted during the last week of April, Lee prepared for the inevitable onslaught. Unable to go

on the offensive, he adopted a defensive strategy, resolving to attack the Federal army as soon as it ventured across the river. At all costs, he was determined to avoid falling back to Richmond; retreating would destroy his ability to maneuver and deny him the trump card in his deck of military tricks.

Thus was the stage set for the Civil War's decisive campaign. In later years, popular historians touted Gettysburg as the turning point of the war. But by the spring of 1864, Lee had largely repaired his Gettysburg losses of ten months before. Ensconced in his Rapidan fastness, he faced Grant with only slightly fewer men than he had taken into Pennsylvania, and they were in fighting trim. Supplies were short, but Lee's lean veterans would lose no battles because of hunger or shortages of ammunition. "I don't have any fears but what we will give the Yanks the worst whipping they have got if they do attempt to take Richmond," a southerner penned to his family.

On May 2, Lee ordered his generals to Clark's Mountain, a commanding eminence with a bird's-eye view of the Federal camps. Several hundred feet below, a shimmering line marked where the Rapidan meandered in a gentle arc from left to right. Earthworks scarred the banks, and Union pickets clustered just across the river. Farther back, at Culpeper, Stevensburg, and Brandy Station, all plainly visible from the mountain, spread cities of huts and white conical tents housing the Army of the Potomac. Threading into Culpeper from the distant horizon, the Orange and Alexandria Railroad crossed the Rapidan to the left of Clark's Mountain and rolled off toward Gordonsville and its junction with the Virginia Central Railroad.

Raising his field glasses, Lee studied the Union camps. The bustle confirmed that the enemy was preparing to move. But what route would he take? Slicing around Lee's left offered open country for maneuver but posed serious supply problems for the Union army. To Lee's right and east, the country was familiar to the invaders, and they could bring in provisions from Fredericksburg and points along the coast as they advanced south. Logic favored a Federal strike downriver, and Lee said so, pointing east and stating that in his opinion the Army of the Potomac would cross at Germanna and Ely's fords.

But despite his prophetic language, Lee felt uncomfortable acting on his estimate of Grant's plans and decided to keep his army dispersed across a broad area. Ewell's and Hill's corps manned the Rapidan fortifications in front of Orange Court House, and rebel cavalry patrolled the country beyond the infantry, prepared to sound an alarm if the Federals tried to sweep around the fortified river line. At the first hint of a hostile move, Lee meant to concentrate his force rapidly in the direction of the enemy, catching them as they crossed the river or shortly afterward.

Concerned that he might have to detach part of his army to fend off threats in the Shenandoah Valley and below Richmond, Lee directed Longstreet to remain near Mechanicsville, a few miles south of Gordonsville and almost fifteen miles south of Orange Court House and the main body of Lee's force. From there, Longstreet had ready access to rail lines and could rush to the Valley, to Richmond, or, if circumstances required, to Lee's Rapidan line.

It rained hard the night of May 2, and a windstorm blew through the valley of the Rapidan, twisting tents into knots and sending tree limbs crashing through the camps of both armies. The next day, Lee's scouts watched dust clouds gather over the Union side of the river. Wagons were moving, and the glint of rifle barrels disclosed troops marching downriver.

After dark, a Confederate sergeant atop Clark's Mountain saw flickers across the campfires on the plain below that seemed to indicate the passage of troops. The sergeant strained to make out the direction of march but could not tell whether the soldiers were heading east, toward Germanna and Ely's Fords, or

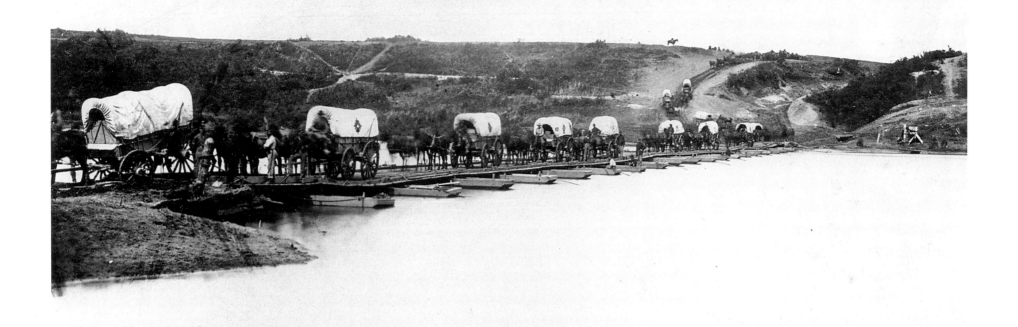

Union 6th Corps wagons crossing the Rapidan at Germanna Ford on May 4, 1864. From the Massachusetts Commandery, Military Order of the Loyal Legion of the United States, United States Army Military History Institute.

west toward Liberty Mills. Lee ordered his corps commanders to prepare to advance by daylight and waited for the first sign of dawn.

The movements spotted by the rebel lookouts heralded the opening of Grant's offensive. After dark on May 3, two Union columns started downriver toward the Rapidan fords. Brigadier General James H. Wilson's cavalry division, followed by Warren's 5th Corps, made for the closest crossing at Germanna Ford. Near dawn on May 4, Wilson's lead elements ventured into the chill water, trading sporadic fire with North Carolina

troopers picketing the far bank and driving them back. Next came bridge-builders, who floated pontoons into the river, attached wooden stringers, and lay boards crosswise to make bridges capable of supporting troop columns, artillery, and wagons. Workers cut a switchback up the far bank, and soon Warren's infantry was rattling across two pontoon bridges, mounting the steep rebel side of the river, and disappearing into the Wilderness along Germanna Plank Road. Sedgwick's 6th Corps followed close behind.

Five miles downriver, Brigadier General David McM.

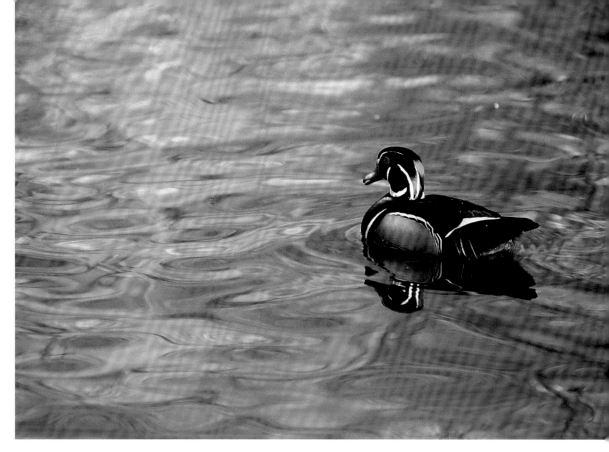

Gregg's division of Union horsemen, followed by Hancock's 2nd Corps, reached Ely Ford and crossed the Rapidan virtually unopposed. It was a fresh spring day, bright with sunshine. Blue-clad soldiers filled the roads, and canvas wagon tops threaded sinuous white lines through the forest. The Army of the Potomac was on the move, and it was heading directly into the Wilderness.

In midafternoon Hancock's soldiers settled into camps around Chancellorsville, near the Wilderness's eastern reaches. A few miles west, near Wilderness Tavern, Warren's men began lighting their cooking fires. Immediately north of Warren's encampments rose smoke from fires kindled by Sedgwick's Corps. Burnside's independent command, bringing up the rear, camped north of the river. "The crossing of the Rapidan effected," Grant wrote Washington. "Forty-eight hours now will demonstrate whether the enemy intends giving battle this side of Richmond."

As signal flags atop Clark's Mountain alerted Lee to the magnitude and direction of the Union army's advance, the Virginian faced a difficult decision. Grant was crossing downriver to avoid the Rapidan fortifications. By remaining dormant, Lee would forfeit the initiative and render the river defenses useless; falling back would only move the inevitable battle closer to Richmond and diminish the Confederate army's room to maneuver.

From Lee's position near Orange Court House, three roads, like fingers extending from a hand, ran east toward the Wilderness and the Union army. The northernmost route, called the Orange Turnpike, ran just below the Rapidan; a few miles south was the Orange Plank Road, and a few more miles south was Catharpin Road. Determined to strike Grant in the Wilderness, Lee decided to thrust Ewell's 2nd Corps out the Turnpike and Hill's 3rd Corps out the Orange Plank Road, pinning the Federals in the forest. While Ewell and Hill detained the massive

Union force, Longstreet was to slip below the forest's southern fringe and veer north into the exposed end of the enemy line. If all went as Lee planned—and if the Union generals obligingly panicked when Lee's veterans appeared on their flank—Grant would share the fate of his predecessor Joseph Hooker, who had suffered defeat on this same ground almost exactly a year earlier.

The risks of Lee's plan were obvious. Until Longstreet arrived the next day, Ewell and Hill would be locked in mortal combat with a foe that outnumbered them better than three-to-one. Each corps would have to wage its own battle, one on the turnpike and the other on the plank road, separated by miles of intractable woodland, with no hope of reinforcements. If Grant discovered that Lee had divided his army, he could focus irresistible pressure against one rebel wing, defeat it, and then turn to destroy the other wing. Under that grim scenario—a possibility by no means far-fetched—the Army of Northern

A wood duck navigates the Rapidan River at Germanna Ford. On the morning of May 4, 1864, Union engineers constructed two pontoon bridges here and carved a switchback up the river's steep southern bank to facilitate the passage of artillery and wagons into the Wilderness. An aide watching the soldiers file across the twin bridges and disappear into the Wilderness mused how strange it would be if each man destined to die in the impending campaign wore a large badge announcing his fate.

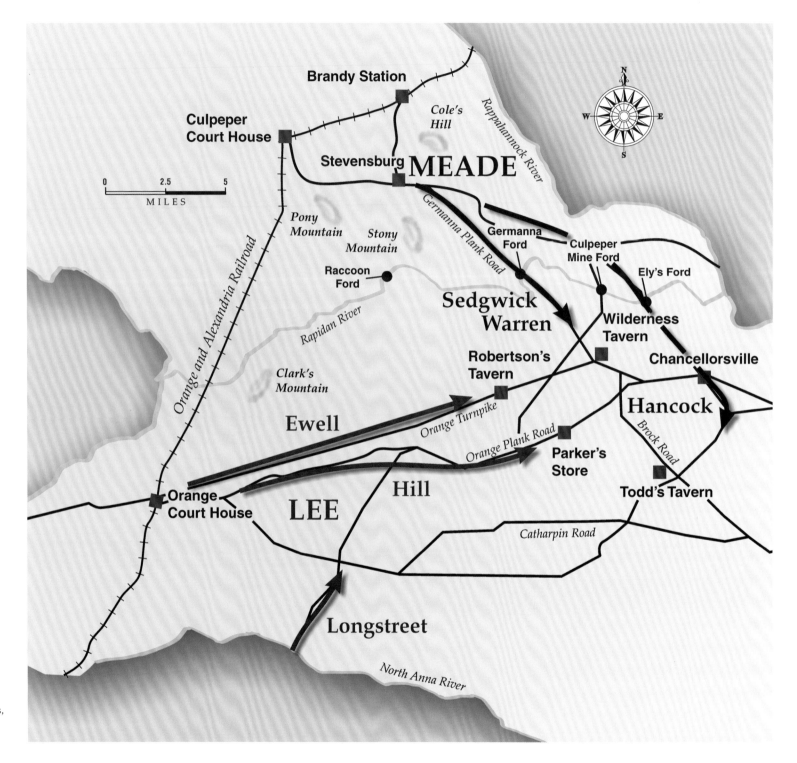

Movements to the Wilderness,
May 3–4, 1864

Virginia would collapse, Richmond would fall, and the Confederacy would be doomed.

Unknown to Lee, mistakes by Grant's cavalry aided the Confederate strategy. Unimpressed by Meade's desire to maintain a strong cavalry screen, Sheridan gave the critical assignment of patrolling the roads toward Lee to James Wilson, his least-experienced general heading his smallest division. Misunderstanding what was expected of him, Wilson mounted tentative probes toward the Confederates, found nothing, and moved on, camping for the evening on the Orange Plank Road at Parker's Store.

Shortly after nightfall, Ewell's Confederates reached Robertson's Tavern and stopped for the night only two miles from Meade's pickets. A few miles south, on the Orange Turnpike, Hill's men advanced to New Verdiersville, west of Wilson's campground at Parker's Store. And nearly thirty miles away, Longstreet's troops marched through the night, headed toward the Wilderness.

Unaware of Lee's approach, Grant's soldiers reflected on their fight there the previous spring. One man found the remains of a horse that had been shot from under him, and another located a comrade's skull, pierced through the head. Sitting on low mounds where their friends had been buried, veterans related how the Wilderness had caught fire, and how wounded men had burned to death in flaming underbrush. "I am willing to take my chances of getting killed," a soldier confessed, "but I dread to have a leg broken and then to be burned slowly; and these woods will surely be burned if we fight here." A man pried a skull from a shallow grave and rolled it across the ground. "That is what you are all coming to," he predicted, "and some of you will start toward it tomorrow." Lee, the veterans thought, would attack Grant in the Wilderness. And Lee, they agreed, would hold the advantage.

Gathering around a campfire near Germanna Ford, Grant, Meade, and their staffs prepared to retire, ignorant of the fact that two of Lee's corps had advanced within striking distance. The generals congratulated themselves on having crossed the Rapidan under the very nose of the enemy. Feeling no urgency—they had, after all, received no reports that Lee might be near—they decided to use the next morning to regroup and start their movement toward the Confederates. A great Union victory seemed in the making.

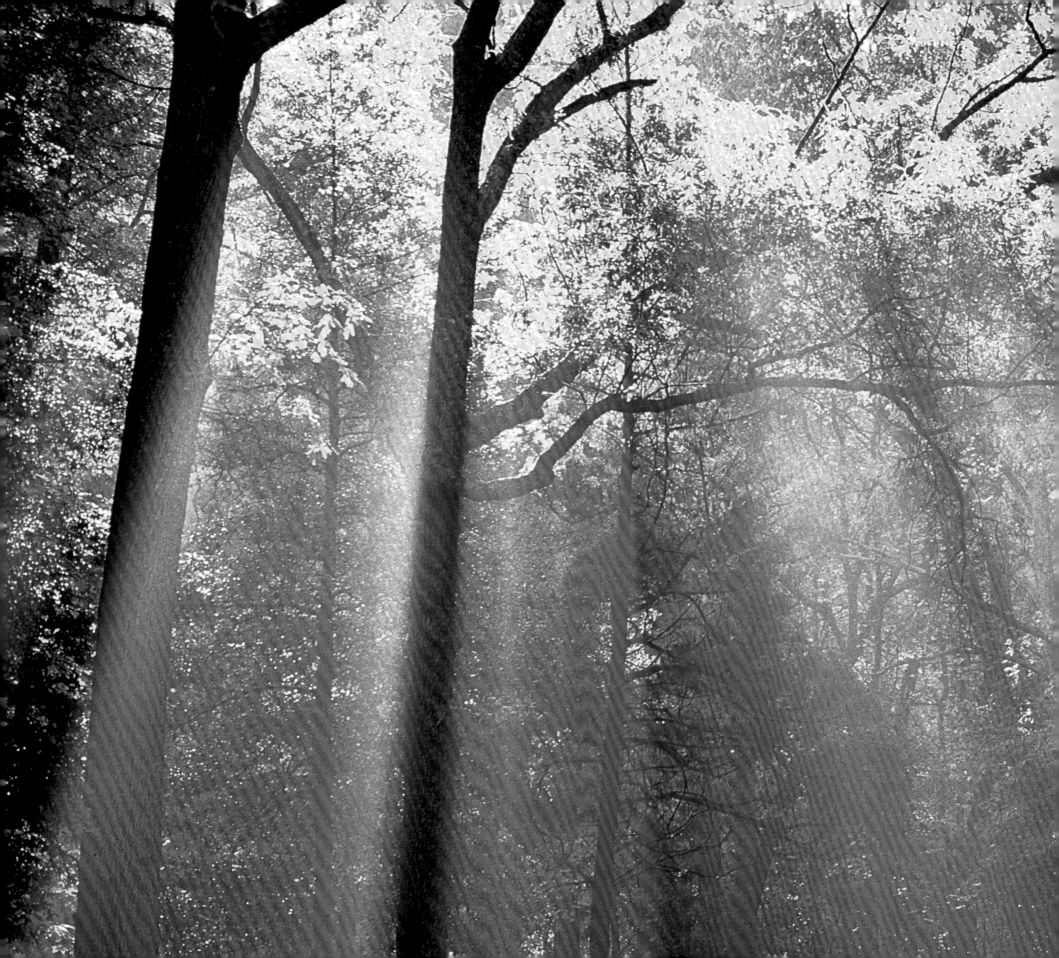

## 2

# The Battle of the Wilderness

Lee was up well before daylight on May 5, eager to exploit the opportunity Grant had given him. Mounting his horse Traveller, he joined Hill at the head of the 3rd Corps on the Orange Plank Road. A few miles to the north and east, Ewell's men set off along the Orange Turnpike. As the army advanced, the turnpike and the plank road diverged, increasing the distance between the two Confederate wings. Couriers rode across the widening cleft, keeping Lee posted on developments.

Oblivious to Lee's approach, Meade busily oriented the Army of the Potomac in a convex line facing west. Hancock, comprising the Union formation's southern wing, was to advance along Catharpin Road toward Shady Grove Church; Warren, in the center, was to follow a wagon road cross-country to Parker's Store on the Orange Plank Road; and Sedgwick, on the right, was to march to Wilderness Tavern and push west along the Orange Turnpike, supported by Burnside. Once the Union troops had moved into their new line, they were to push toward the rebels and battle.

After a two-mile march, Ewell's lead elements reached a stubble-filled clearing called Saunders' Field, named after the family that had formerly farmed the area. Eight hundred yards away, on the field's far side, they spotted Union pickets thrust out from Wilderness Tavern. Warren had just mounted his dapple gray horse when a courier galloped up in a cloud of dust and announced that rebels were materializing at Saunders' Field. Concerned, the lanky general forwarded the information to Meade.

Riding cross-country, a courier from Ewell located Lee on the Orange Plank Road. The Confederate commander advised against hazarding a battle just yet; he did not want to provoke a "general engagement," he stressed, until Longstreet had arrived, which could not happen before dark. It was not readily apparent to Ewell how to pin Grant in the Wilderness while avoiding battle, but preparing a strong defensive line struck him as a good way to start. Deploying his soldiers along the western margin of Saunders' Field, he extended his line into the woods on each side of the clearing. His Confederates stacked logs and tree limbs into low barricades and piled dirt against the front, facing toward the enemy.

Meade's desire to please Grant made him unusually aggressive this clear spring morning. On learning that rebels had appeared unexpectedly on the Orange Turnpike, he directed Warren to pre-

*Opposite:* Crepuscular rays pierce the Wilderness's canopy on a bright fall day. Although the extent of the modern Wilderness resembles that of the thick forest in 1864, the character of the woods has changed from impenetrable second growth to more mature woodland. Overgrown with thickets of switch and chinquapin, the tangle of vegetation in the mid-nineteenth century had few negotiable roads, clearings were scarce, and visibility rarely exceeded a few hundred feet.

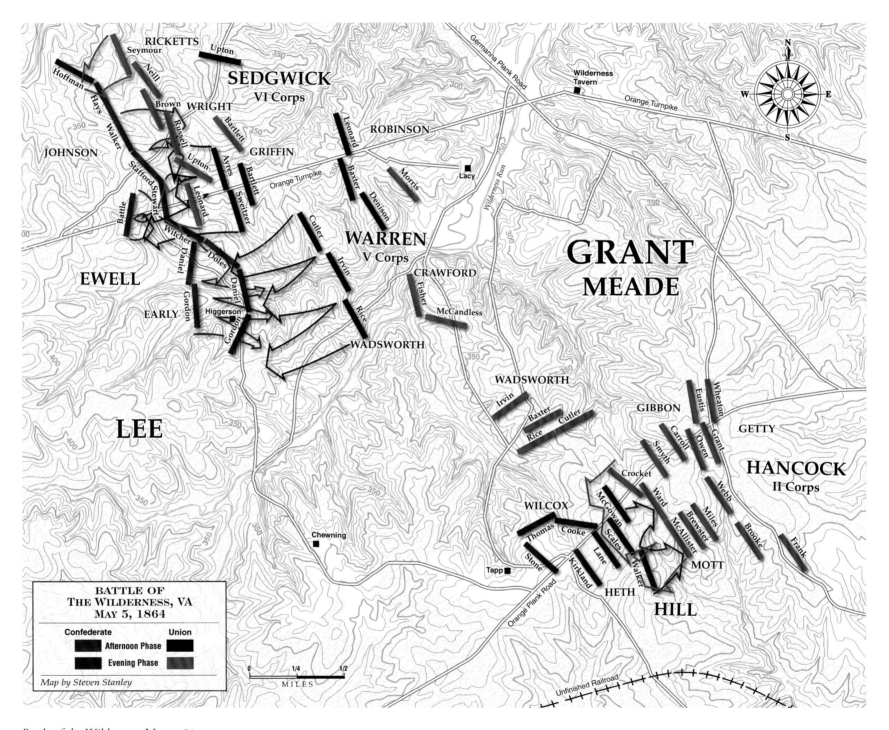

RICKETTS
Seymour
Upton

Hoffman
Hays
Neill
Brown
WRIGHT

SEDGWICK
VI Corps

Leonard
ROBINSON

Walker
Russell
Bartlett
GRIFFIN

JOHNSON
Stafford
Stewart
Upton
Ayres
Bartlett
Baxter
Morris
Lacy

Leonard
Sweitzer
Orange Turnpike
Denison

Battle
Witcher
Daniel
Doles
Cutler

EWELL
Daniel
Irvin
WARREN
V Corps
CRAWFORD

Gordon
Fisher
Gordon
Higgerson
McCandless

EARLY
Gordon
Rice

WADSWORTH

GRANT
MEADE

WADSWORTH
Irvin

LEE
Baxter
Cutler
Wheaton
Rice
GIBBON
Eustis
Grant
GETTY

Smyth
Carroll
Owen
HANCOCK
II Corps

Crockett
Ward
Webb

WILCOX
McGowan
Brewster
Miles

Thomas
Cooke
Scales
McAllister
Chewning
Stone
Lane
Walker
MOTT
Brooke

Kirkland
Frank
Tapp
HETH

HILL

**BATTLE OF**
**THE WILDERNESS, VA**
**MAY 5, 1864**

Confederate | Union
Afternoon Phase
Evening Phase

Map by Steven Stanley

0    1/4    1/2
MILES

Battle of the Wilderness, May 5, 1864

pare to attack and notified Grant of his action. "If any opportunity presents itself of pitching into a part of Lee's army," Grant wrote back in approval, "do so without giving time for disposition."

Time for deploying, however, was precisely what Warren needed. Most of his troops had already started off along the wagon road toward Parker's Store, and bringing them back risked an impossible traffic jam. Instead, Warren tried to form a battle line across the eastern edge of Saunders' Field and into the woods south of the clearing, facing Ewell's barricades. Companies and regiments lost contact with one another in the thick foliage and mazelike ravines, where they were unable to get their bearings. Officers tried to restore order by shouting, but their efforts only added to the confusion. Resorting to compasses, some troops attempted to navigate the Wilderness like mariners on a choppy sea.

His attention fixed on the Orange Turnpike, Meade had forgotten all about the Orange Plank Road. Around 9:00, he received a disturbing dispatch reporting sporadic firing from the south, and the true state of affairs became painfully clear. Lee was advancing on at least two fronts, and the Federals were poorly situated to counter. Beset by rebel columns popping up phantomlike, the Union offensive seemed to be unraveling.

Setting up camp next to Meade on a knoll near the Orange Turnpike, Grant directed Meade to rush soldiers toward the Orange Plank Road. As aides dashed off with this latest round of orders, Grant sat on a stump and lit a cigar. There was nothing more that he could do to prepare for the fight, and the dense foliage prevented him from seeing what was happening. Taking out a penknife, he picked up a stick and began whittling. Absentmindedly, he shredded his new cloth gloves along with the stick, smoking and reviewing dispatches from the battlefronts.

Deep in the heart of the Wilderness, the Orange Plank Road passed along the southern edge of a ragged clearing that was home to Catherine Tapp, a fifty-nine-year-old widow who lived there with several children, a granddaughter, and a laborer. Overgrown with broom grass and saplings, the forty-acre meadow was known locally as Widow Tapp's Field. Lee chose that clearing for his headquarters: it was three miles due south of Saunders' Field, where Ewell was girding to fight Warren's thousands, and it was about a mile shy of the intersection where the Orange Plank Road crossed the Brock Road, a major north-south route. Hill's lead division under Major General Henry Heth had not yet reached the intersection, and Lee did not expect the enemy to relinquish the critical junction without a fight.

Nearing the Brock Road, Heth's men discovered that a Union force headed by Brigadier General George W. Getty of the 6th Corps had occupied the intersection and was bracing to hold the southerners in check. Halting west of the intersection, Heth's troops dug in along a low ridge cut by gullies. Only a few hundred yards of saplings and undergrowth separated the Union and Confederate pickets, who shot at the slightest flicker of movement.

Lee felt relieved. Half the daylight hours had passed, and his plan seemed to be working. Ewell and Hill had pinned Grant in the Wilderness. If the northerners continued to dawdle, Lee would have time to wedge some of Hill's troops into the gap between the divided portions of his army and unite them in a continuous line. But if Grant threw his weight against either wing of Lee's force, a Confederate collapse would be inevitable. Not since Sharpsburg had the Army of Northern Virginia faced a more palpable risk of disaster.

Whittling and fretting at his knoll by the Orange Turnpike, Grant was nearing the end of his patience. It was afternoon, and still Warren had not attacked. Ranging along high ground, Ewell's rebels were now firmly ensconced behind log and earthen barricades, and their artillery was rolling into

A spiderweb at Widow Tapp's Farm captures the spirit of Lee's decision to fight Grant in the Wilderness. Outnumbered more than two to one, Lee decided to ensnare the Union army in the dense foliage with part of his army and to strike the southern end of the Union line with his remaining troops. His objective was to repeat his previous year's success at Chancellorsville and drive the Union army back across the Rapidan River.

place and taking aim across Saunders' Field. In the six hours that had passed since Ewell's appearance, the Confederates had made the clearing a death trap.

Pressured mercilessly by Grant and Meade, Warren relented and ordered his men to attack without waiting for Sedgwick's corps to arrive in support. Striding into Saunders' Field in neat lines of blue, Warren's troops shifted to close gaps cut by rebel musketry. When they reached the swale midfield, Ewell's artillery chimed in. A second Federal line came up, stepping over corpses and injured soldiers and opening to let hollow-eyed troops from the first line stumble back. A regiment from New York, resplendent in colorful sashes and leggings, crossed the swale and mounted the slope toward the Confederates. Blasts poured down from Ewell's ridge, and the air seemed filled with death. "The regiment melted away like the snow," a New Yorker reported in disbelief: "Men disappeared as if the earth had swallowed them up."

Saunders' Field became the slaughter pen that Warren had feared. Northerners hunkered in the swale, where the roll of ground afforded protection so long as they stayed down, and bodies dotted the slope from the ravine to Ewell's line. A few Federals made it into the woods, where gun smoke floated through the underbrush and the constant rattle of musketry

amplified the forest's disorienting effect. Order evaporated as the battle disintegrated into desperate fights at close quarters between clusters of men.

The rebels counterattacked, ramming into pockets of disheartened Yankees and driving them back. The receding blue wave gave Ewell's marksmen excellent targets, making the retreat as deadly as the advance. A few troops tried to dash to their respective sides of the field and were shot down. Injured men called for water, but no one dared to rescue them. Then the dry stubble ignited, and thick black smoke rolled across Saunders' Field, creating a nightmarish scene as wounded men tried to hobble to safety, using their muskets as crutches or gouging their elbows into the ground to pull their bodies along. Soldiers burned to death, in some cases because flames reached the cartridge boxes at their waists and ignited the powder. Some soldiers too injured to escape chose to kill themselves rather than suffer death in the flames. Heaps the size of men's bodies lay charred beyond recognition in areas blackened by the conflagration.

In little over an hour, the fighting—at least the organized part of it—was over. Repulsed at Saunders' Field, Warren's men huddled in the tree line on the clearing's eastern edge, throwing up low mounds of dirt and logs in imitation of Ewell's troops on the field's far side. Ambulances and wounded men on foot packed the Orange Turnpike all the way back to Wilderness Tavern, where surgeons assembled under trees, hacking off arms and legs. Piles of severed limbs rose higher by the minute.

Shortly after Warren's battle quieted, Sedgwick's 6th Corps arrived. Emerging slightly north of Warren, the fresh troops found themselves engaged in a nasty fight against the uppermost end of Ewell's formation. With Warren out of the fight, Ewell was able to shift units northward, where the thickets nullified the Union edge in numbers and permitted him to hold his own. Combat died down about four in the afternoon, and Sedgwick

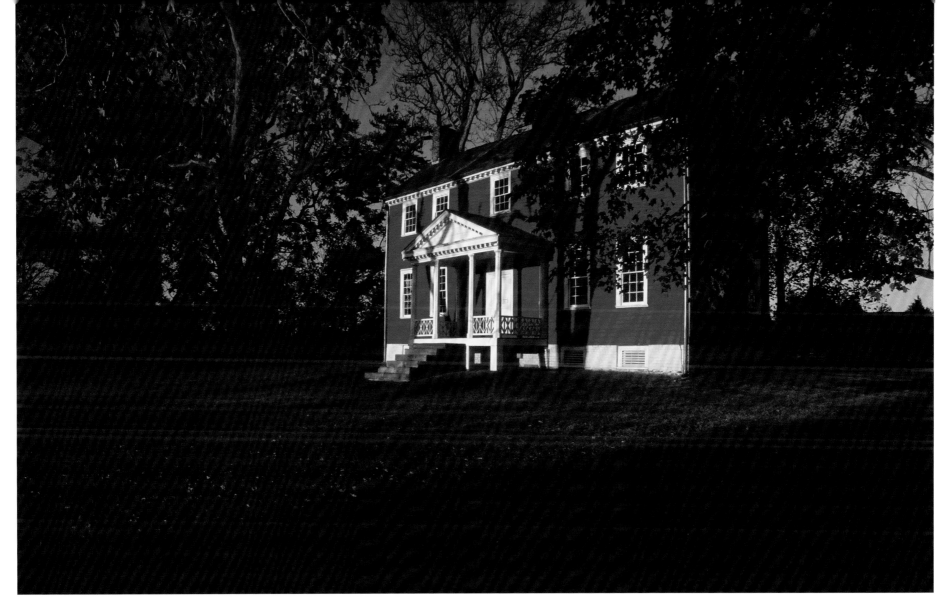

began entrenching on Warren's right. Aided by favorable terrain and by the failure of northern generals to coordinate their assaults, Ewell had performed his defensive assignment to perfection.

As combat waned in the Saunders' Field sector, Grant pestered Meade to attack along the Orange Plank Road. Getty was in place, but he did not want to advance until supporting troops from Hancock's outfit arrived. The Union 2nd Corps's progress, however, had been slow. At four o'clock, his patience exhausted, Meade ordered Getty to attack, with or without Hancock. Once

Poised on high ground west of Wilderness Tavern, J. Horace Lacy's modest summer home, Ellwood, served as headquarters for Union Major General Gouverneur K. Warren's 5th Corps during the Battle of the Wilderness. Grant and the Army of the Potomac's commander, Major General George Gordon Meade, established their headquarters on a neighboring knoll. Owned by the National Park Service, Ellwood presently is staffed by volunteers from the Friends of the Wilderness Battlefield.

again, Union headquarters' impatience had concocted a recipe for disaster.

Federals waded into the Wilderness, brushing through branches and vines and stumbling over logs and stumps hidden in the undergrowth. Heth's pickets heard them coming and

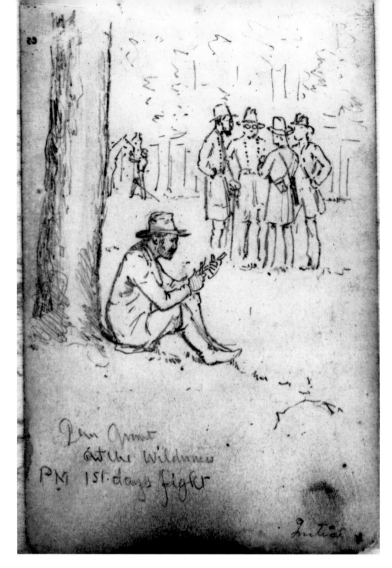

Grant whittling and laying his plans on May 5, 1864. Drawing by Charles W. Reed, from the Library of Congress.

dropped back to the elevated ground that marked the main rebel line. Muskets flashed, and sheets of lead tore into the Union ranks. Lying down, the Federals fired back through the haze at indistinct flashes, their lips black with powder from tearing open paper cartridges with their teeth.

Tramping feet heralded Hancock's approach, and the fresh soldiers stepped into the forest, passing shell-shocked men dragging wounded companions back. As evening shadows stole over the Wilderness, the woods immediately west of the Brock Road intersection witnessed a scene of unrelieved slaughter. "There seemed to be as many dead men in our front as we had men engaged," a rebel soldier remarked. Reflected a witness: "A butchery plain and simple it was, unrelieved by any of the arts of war in which the exercise of military skill and tact robs the hour of some of its horrors. It was a mere slugging match in a dense thicket of small growth, where men but a few yards apart fired through the brushwood for hours."

Monitoring developments from Widow Tapp's farm, Lee ordered Hill to throw another division into the fight. Grant, however, now understood that Lee had divided his army and

that neither portion could be very large. Hancock and Getty had fastened Little Powell in place; why not, reasoned the Union commander, forward troops from the turnpike sector to strike the exposed northern end of Hill's line?

Meade chose Brigadier General James S. Wadsworth, the wealthiest man in the Union army and certainly the oldest general to hold elevated command, to lead the new attack. Wadsworth headed south, burrowing through a mile of intractable wilderness. At the same time, Hancock launched his best division under his most aggressive commander, Brigadier General Francis Channing Barlow, against the front of Hill's line. Just as the full weight of Barlow's attack registered, word reached Hill of Wadsworth's approach. The only Confederate reserves were 150 Alabama troops guarding prisoners in the rear, and Hill directed them to stem Wadsworth's advance. It was nearly dark, Wadsworth's men were exhausted from thrashing about in the blackening woods, and a mob of screaming Alabamians was the last thing they wanted to contend with. Wadsworth's movement ground to a halt near Hill's thinly guarded flank, and Barlow's offensive ran out of steam at the same time. It was simply too dark for anyone to see.

The night of May 5–6 was a scene of horror. The hostile forces entrenched themselves where they stood, making little effort to straighten their lines or bring order out of the tangle of barricades and entrenchments. Neither army had shovels, so soldiers gouged the earth with bayonets, cups, spoons, and even their hands. Stabs of flame from skirmish fire periodically lit the darkness, cries from wounded men made sleep impossible, and sharpshooters in the no-man's-land between the armies kept everyone on edge. "There was no moon to light the clearing," a Union man remembered, "only dim stars, and the air was hazy and pungent with the smoke and smell of fires yet smoldering. We couldn't see the wounded and dying, whose cries we heard all too clearly; nor could our stretcher bearers go out and find

them and bring them in; the opposing lines were near, and the rebels were fidgety, and quick to shoot."

Lee had begun the day hoping that Ewell and Hill could pin Grant in the Wilderness, and they had not disappointed him. He had also expected that Longstreet would arrive by the next morning and swing into the Union army's vulnerable southern flank. The Federals, however, were bound to renew their assaults, and if Hill collapsed, the Confederate army would be endangered. Reconsidering his plan, Lee directed his

Ruins of the Chancellor home, burned during the Battle of Chancellorsville in the spring of 1863, mark the Union 2nd Corps's campground of May 4, 1864. While most of the Army of the Potomac crossed the Rapidan at Germanna Ford, Hancock's troops crossed downriver at Ely's Ford and bivouacked on the Chancellorsville battlefield. Many of Hancock's soldiers passed the evening looking for mementos of their earlier fight.

War Horse to shift onto the plank road and come up in support of Hill.

Riding cross-country, an aide located Longstreet at Richard's Shop, ten miles away, and delivered Lee's orders to reach the battlefront by daylight. Calculating his marching distance,

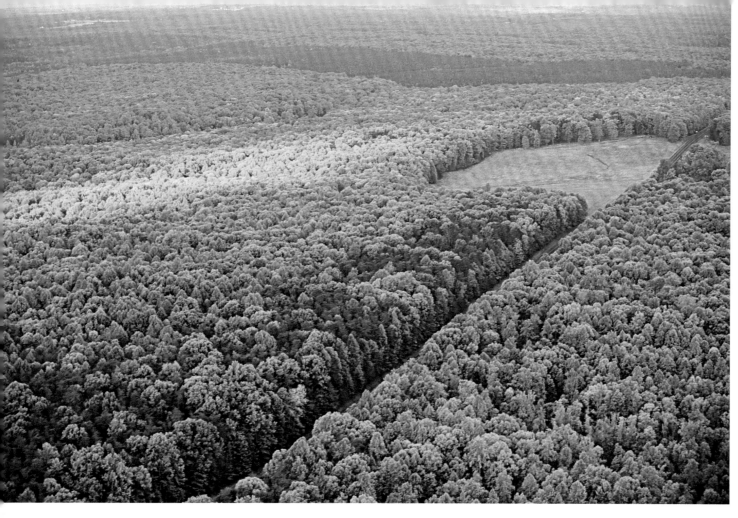

The Orange Turnpike cuts a deep trough through the Wilderness from the site of Warren's Union encampments to Saunders' Field. Photographed during the first week of May, this aerial image highlights the challenges faced by both armies in the Battle of the Wilderness. Coming from the west, Ewell's troops deployed on the far side of the clearing and erected barricades of timber and fence rails. Warren's attack at 1:00 p.m. on May 5, 1864, opened the battle.

evening, they again asked Hill for permission to rectify their lines. "Damn it, Heth, I don't want to hear any more about it," Hill exploded. "The men shall not be disturbed!" But their persistence had not fallen on deaf ears. After midnight, Hill paid a visit to Lee, and the army commander repeated his orders that Little Powell was to keep his men in place until Longstreet arrived. "We could not sleep," an aide remembered, "but waited for news of Longstreet; for we knew that at the first blush of the morning the turning attack on our right would open with overwhelming numbers, and, unsupported, the men must give way."

On their knoll near Wilderness Tavern, Grant and Meade gathered around a campfire to discuss the day's events. Grant thought that the fight had involved little more than jockeying for position. He now understood, however, that he was battling Ewell on the turnpike and Hill on the plank road. Longstreet remained a wild card, as his whereabouts were as yet unknown to the Union generals.

Longstreet decided to let his men rest until 1:00 a.m. before setting out for the Wilderness. Acting on assurances that Longstreet would arrive by morning, Lee firmed his new plans. Ewell was to keep the Federals busy on the Orange Turnpike, he instructed, and as soon as Longstreet appeared, Hill was to pull back to Catherine Tapp's farm and reach north, filling the void between the Confederate force's two wings. With his army united and fighting defensively, Lee hoped to complete his stalemate of Grant in the Wilderness.

Worried that their troops were unprepared for a concerted attack, Hill's division heads made their way to Widow Tapp's Field and found Hill sitting on a camp stool by a fire. The corps commander assured them that Lee had promised Longstreet's fresh troops would arrive before dawn. Later that

Ignoring his promise to leave Meade free to fight his own battles, Grant voiced strong ideas about the next step. There must be no more random attacks. While the better part of Warren's and Sedgwick's corps assailed Ewell at Saunders' Field, Hancock's augmented force was to grind forward and crush Hill with overwhelming numbers. To ensure Lee's destruction, Burnside was to drive between the two Confederate wings and turn south into Hill's fleeing troops, wrecking what remained of the Confederate 3rd Corps. The plan represented an inge-

nious concentration of Union might; the trick was whether the generals could pull it off.

Near 1:00 a.m., Longstreet started his men toward the Wilderness. He was unfamiliar with the road, however, and a guide sent by Lee lost his way. Trying to make up for lost time, Longstreet ordered his divisions to double up and march abreast. Five o'clock approached, and Hill's troops listened intently to small arms fire bristling to the north, in Ewell's direction. The battle was starting up along Saunders' Field. Then came occasional rifle shots as Union skirmishers started through the forest on both sides of the plank road. The firing grew heavy, signaling that thousands of soldiers were tramping through the woods, shooting as they came. The Union offensive had begun, and Longstreet had not yet arrived.

Swarms of Union troops overwhelmed Hill's lines, and the fractured Confederate 3rd Corps broke for the rear. The Army of Northern Virginia was accustomed to tight scrapes, but it now faced its most serious crisis; Longstreet had not arrived, and Hill's troops were unable to hold their ground. The only organized Confederate resistance was a stand of sixteen artillery pieces at Widow Tapp's Field under Lieutenant Colonel William T. Poague, a twenty-eight-year-old Virginian. At Poague's direction, the gunners loaded their cannon with canister capable of inflicting tremendous carnage against troops at close range.

Lee sat astride Traveller, an island of resolve in a sea of soldiers flowing rearward. The Confederate commander took pride in his capacity to remain calm, but he was visibly shaken. Unwilling to watch passively while his army disintegrated, he rode into the mob of soldiers. "Go back, men! You can beat

Confederate earthworks lining the western edge of Saunders' Field, in a postwar photograph. From the Massachusetts Commandery, Military Order of the Loyal Legion of the United States, United States Army Military History Institute.

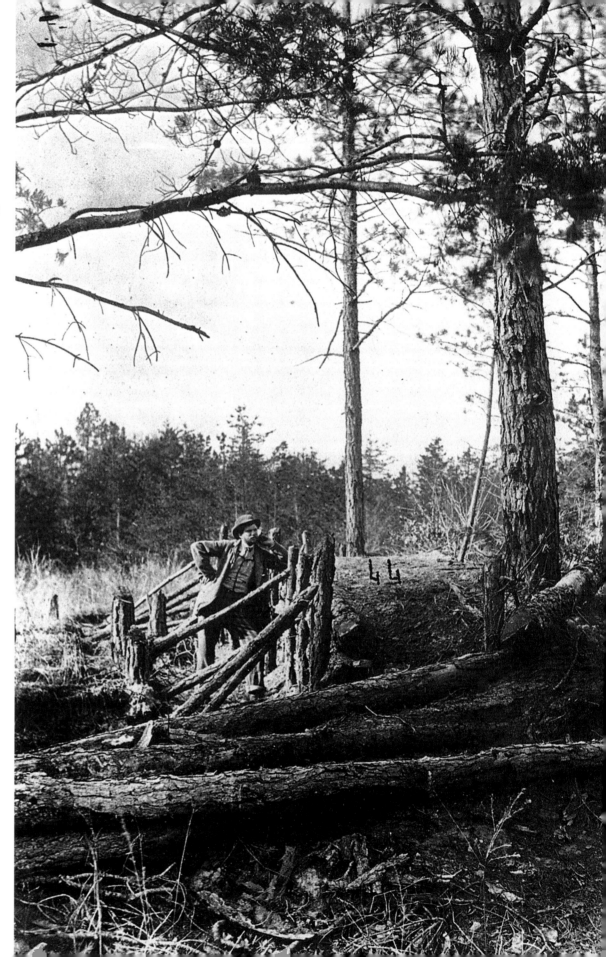

Dry cornstalks carpet the ground near Saunders' Field, scene of one of the Civil War's more macabre vignettes. During the fighting, muzzle flashes ignited stubble such as this; many wounded men were unable to crawl to safety and burned to death. "What a medley of sounds," a participant recalled: "the incessant roar of the rifle; the screaming bullets; the forest on fire; men cheering, groaning, yelling, swearing, and praying!"

IN THE FOOTSTEPS OF GRANT AND LEE

those people," an onlooker remembered hearing him shout. Distraught, Hill helped the gunners load their weapons. Tongues of flame spit from sixteen cannon, sending fistfuls of iron balls into the approaching northerners. Smoke drifted across Widow Tapp's Field, obscuring the view, but the gunners kept firing—fifty discharges by one estimate, whirring some three thousand iron slugs across the clearing.

But a battery could not hold back an army. As Lee waited in silence on Traveller, peering into the smoke and chaos, a single thought dominated his mind. "Why does not Longstreet come?" an aide heard him ask. If help did not appear soon, Lee would be killed or captured, dooming his army and his cause. "This was one of the most anxious times I felt during the war," one of Hill's staffers admitted. "The minutes seemed like hours, and the musketry was getting uncomfortably near and everything looked like disaster."

Longstreet's Corps, ten thousand men strong, were marching eight men abreast. They were exhausted, having covered thirty-five miles in forty hours, but the distant growl of artillery served as a potent antidote to weariness. One man remembered the march as a race and a run. Glancing up from the dusty road, an Alabamian noticed the sun rising above the Wilderness, blood red from battle smoke.

"Here's Longstreet!" Hill's men cried at the sight of the gaunt figures striding purposefully toward the front. "The old War Horse is up at last! It's all right now." When the general rode past, the artillerists broke loose with their loudest yells. "Like a fine lady at a party," a witness wrote years later, "Longstreet was often late in his arrival at the ball, but he always made a sensation and that of delight, when he got in, with the grand old First Corps, sweeping behind him, as a train."

Riding into Widow Tapp's Field, Longstreet sized up the situation. Union skirmishers were approaching, followed by troops arrayed in a battle line. A counterattack had to be made at once, and the War Horse acted decisively, steadying his men as they arrived. Soldiers from Texas and Arkansas lined up behind Poague's cannon, where a gentle roll of ground sheltered them from the enemy's view. "Keep cool, men, we will straighten this out in a short time—keep cool," Longstreet exhorted the troops. Unable to contain his excitement, Lee stood high in his stirrups, swung his hat, and cried, "Texans always move them!"

To the men's surprise, Lee turned Traveller toward the enemy and started riding with them. "Go back, General Lee, go back!" soldiers shouted, but Lee continued on, eyes to the front. "Lee to the rear!" the men chanted, slowing their pace. "Lee to the rear!"

Still Lee continued on. "We won't go on unless you come back," the men demanded, determined to stop their beloved commander's folly, but still he ignored their pleas. A tall, bearded officer firmly seized Traveller's bridle, and several of his companions stood in front of the animal, forming a human barricade. "Can't I, too, die for my country?" a staffer heard Lee mutter under his breath as he rode to the rear.

With piercing yells, Longstreet's troops charged across Widow Tapp's Field. Skirmishers in the fore of the Union line scattered, clearing the way for soldiers coming behind them to open fire on the Confederates. Another volley sounded, bringing down more figures in gray, but the survivors kept marching straight into the enemy. Harder the War Horse pounded, and when the musketry finally abated, his Confederates had driven the Federals from the field. This was Longstreet's proudest hour. Through an impressive feat of arms, he had reversed the battle's momentum and broken the Union offensive.

During a lull, Lee's chief engineer, Major General Martin Luther Smith, reconnoitered south of the Orange Plank Road and stumbled onto the trace of an unfinished railroad, planned before the war as a rail line between Orange Court

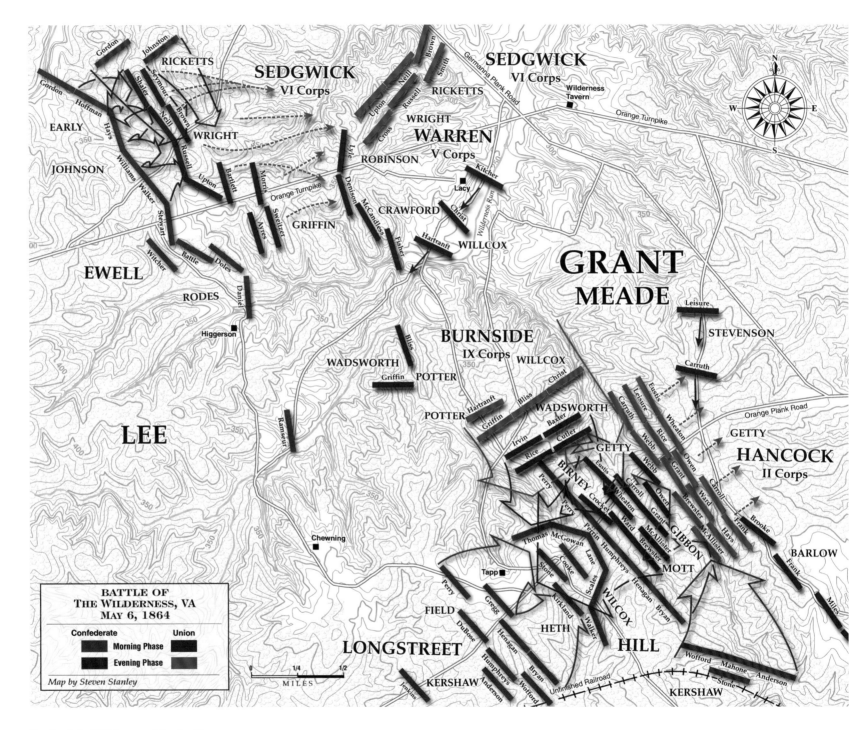

Battle of the Wilderness, May 6, 1864

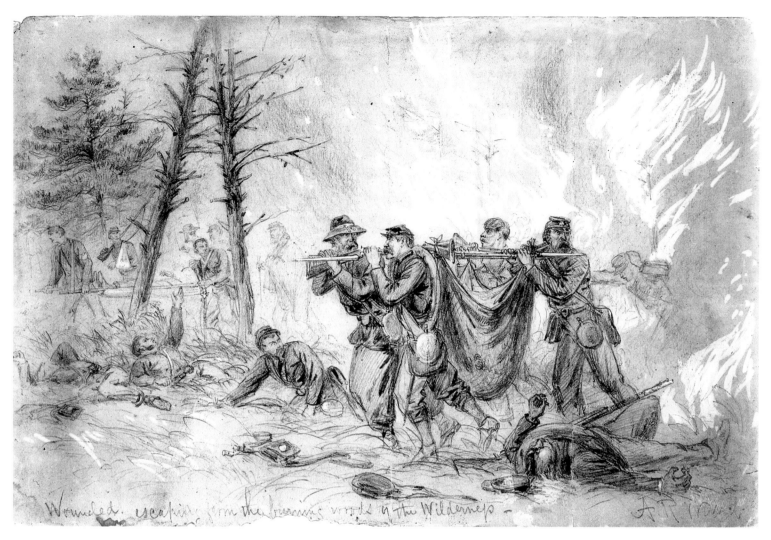

Wounded Union soldiers escaping from the burning Wilderness. Drawing by Alfred R. Waud, from the Library of Congress.

House and Fredericksburg. The corridor had been cleared, but no tracks had been laid. By 1864, the unfinished railway grade was little more than a path through the forest.

Around ten o'clock that morning, the engineer approached Longstreet with a plan. The lower end of the Union army had come to rest in woods a few hundred yards north of the unfinished railroad grade, enabling the Confederates to advance troops along the jungle path and hit the unprotected Union flank. To multiply the damage, Longstreet decided to also assail the front of the Federal formation along the axis of the Orange Plank Road. Hit from two directions, the Union force was bound to collapse, and a vigorous pursuit might well drive the invaders across the Rapidan and give Lee the victory that he sought.

Assembling a handful of brigades, Longstreet sent them through the jungle to the point designated by Smith. In an astonishing oversight, Hancock had neglected to strengthen his exposed flank or to post pickets, and the Confederate attack

Hoarfrost wraps Saunders' Field in a glistening winter coat. Visible in the middle of the photograph is the swale that sliced diagonally across the field. Union soldiers wounded in Warren's aborted attack on May 5 sought shelter in the gully from Confederates firing into their ranks from high ground along the clearing's western margin. The rebels counterattacked but were driven back, leaving men of their own in the gully. Sharing whiskey from their canteens, the Yankees and rebels in the swale made themselves "as sociable and comfortable as the situation would permit," a southerner recalled.

IN THE FOOTSTEPS OF GRANT AND LEE

came as a complete surprise. As the Union line collapsed, Longstreet hurled the rest of his corps forward and achieved precisely the result he had desired. "You rolled me up like a wet blanket," Hancock admitted to Longstreet after the war.

The morning's despair turned to jubilation as Longstreet rode onto Orange Plank Road, accompanied by his headquarters cavalcade, several generals, and fresh troops from South Carolina under young Brigadier General Micah Jenkins, one of Lee's most promising brigade commanders. Someone jokingly remarked that the uniforms of the new men were so dark that they looked like Union garb.

Just ahead, a cluster of Virginians in the fore of the flanking party crossed the plank road, realized they had outdistanced their supporting units, and circled back. Moving into the roadway, they spied several men on horseback accompanied by soldiers wearing what appeared to be enemy uniforms. Fearing that Federals had slipped into their rear, the Virginians opened fire. "Steady men, for God's sake steady," Jenkins hollered and tumbled from his mount, a ball through his brain. A minie ball tore through Longstreet's neck and came out his right shoulder. Dazed, the War Horse turned and tried to ride back, flopping from side to side as though about to fall. His aides dismounted, quieted his horse, and lifted him to the ground. Laying him under a tree, they called for Dr. Dorsey Cullen, the corps's medical director.

Longstreet's wounding seemed like an ill omen. Almost precisely a year before and within this same wilderness, Stonewall Jackson had been mortally wounded in an accidental shooting by his own soldiers. The parallel with Longstreet's shooting was uncanny, because Jackson, like the War Horse, had been cut down while executing a brilliant turning movement. "A strange fatality attended us!" one of General Lee's aides later observed. "Jackson killed in the zenith of a successful career; Longstreet wounded when in the act of striking a blow that would have

rivaled Jackson's at Chancellorsville in its results; and in each case, the fire was from our own men. A blunder! Call it so; the old deacon would say that God willed it thus."

With the movement's mastermind incapacitated, the Confederate counterattack ground to a halt. An unaccustomed quiet settled over the woodland while Hancock pulled his forces back to the Brock Road and reorganized them in a line along the roadway, facing west. Anticipating that Lee might attack, the northerners cleared the land in front of their position and stacked the felled trees into chest-high barricades.

Lee did not disappoint them. At a quarter after four, screaming rebels repulsed Hancock's pickets and burst into the cleared killing zone in front of the Federal barricades. Union muskets unleashed a volley at close range—"heavy fire that

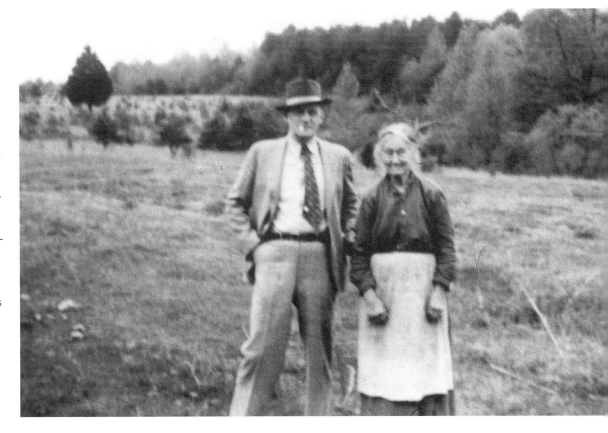

Dr. A. M. Giddings and Phenie Tapp, who was four or five years old during the Wilderness fight, posing on Widow Tapp's Farm in 1937. From M. J. Martich Private Collection.

A lone cannon marks where Lieutenant Colonel William T. Poague posted his sixteen-gun battery across Widow Tapp's Field to protect General Lee's headquarters. Early on May 6, 1864, Hancock's wing of the Union army routed Hill's troops to the east and stormed into the clearing, threatening to capture Lee and his staff. Firing canister into the approaching enemy, the twenty-eight-year-old Poague delayed Hancock's advance long enough for Lieutenant General James Longstreet's Confederate 1st Corps to reach the field and repel the attackers.

made the bark fly from the saplings," a participant recalled. The front Confederate rank was obliterated, but the next line of attackers dropped to their knees not thirty yards from the Federals and began shooting back. Near the plank road, the barricades caught fire and billowed thick, resinous pine smoke into the defenders. With a determined yell, Confederate soldiers catapulted over the smoldering barriers, appearing, a northern man thought, like devils leaping through the flames. The breach was in front of a massed stand of Union artillery, and the gunners opened at close range with double-shotted canister. Pellets hissed into the attackers, and Union reinforcements rushed in from other parts of the line, closing the break almost as quickly as it had opened. With a shout, Hancock's men vaulted over their wooden fortifications and charged into the demoralized Confederates, driving them back through the woods.

While the Confederates retired from the Brock Road and its flaming barricades, Lee's generals on the Orange Turnpike initiated yet another offensive. Near dark, Brigadier General John B. Gordon quietly moved troops near the far northern end of the Union line. It just so happened that the Yankees occupying this important real estate were novices from New York who had spent most of the war manning the forts at Washington. They had just stacked their muskets and started cooking when Gordon's men descended on them like a pack of wild dogs.

Couriers rushed to Grant's headquarters with news of the disaster, but the general refused to panic. Pulling up a camp

The abandoned railroad grade south of the Orange Plank Road bores a leafy tunnel through the Wilderness. The woodland path looks today about the same as it did on May 6, 1864, when Longstreet surprised Hancock with a daring flank attack. The unfinished railway was completed in 1877. Owned by the Potomac, Fredericksburg, and Piedmont Company, the narrow-gauge line was known locally as the "Poor Folk and Preachers" Railroad and carried passengers well into the 1920s. Its tracks removed, the right-of-way has reverted to its wartime appearance.

Brigadier General James S. Wadsworth's image on a memorial looks somberly out over the site of the general's mortal wounding on May 6, 1864. Commanding a division in the Army of the Potomac, the New York politician was one of the oldest generals in the Union army and among its most popular. Attempting to rally his troops in the face of Longstreet's flank attack, Wadsworth was shot from his horse and died two days later in a Confederate field hospital.

stool, he lit a cigar and directed that reinforcements be sent to the endangered point. "General Grant, this is a crisis that cannot be looked upon too seriously," a frenzied officer warned, obviously unnerved by Grant's calm demeanor. "I know Lee's methods well by past experience," the man continued. "He will throw his army between us and the Rapidan, and cut us off completely from our communications." Standing, Grant removed the cigar from his mouth and spoke his mind. "Oh, I am heartily tired of hearing about what Lee is going to do," he said. "Some of you seem to think he is suddenly going to turn a double somersault, and land in our rear and on both of our flanks at the same time. Go back to your command, and try to think what we are going to do ourselves, instead of what Lee is going to do."

The danger had indeed been exaggerated. Nightfall and the Wilderness' disorienting effect took the steam out of Gordon's attack, and Union reinforcements expelled the attackers, ending the crisis and bringing the Battle of the Wilderness to a close.

Two days of combat had exacted a shocking toll. Grant had lost some 18,000 soldiers, and Lee about 11,000. Aides noted that Grant had whittled incessantly, absent-mindedly carving twigs to sharp points and snapping them in half. He also completed the destruction of his cloth gloves. A staffer counted twenty cigars smoked by Grant on the second day of battle, a record that he never again equaled, and a secondhand report had the general throwing himself onto his cot and giving vent to his feelings "in a way which left no room to doubt that he was deeply moved."

Lee was grimly satisfied. His aggressiveness had cost him close to 20 percent of his army, but he had stopped Grant. In narrow terms, the Wilderness was a Confederate victory, but the longer outlook was disturbing. Grant had fought with persistence unusual for Union generals in Virginia. A few more battles like the Wilderness, and Lee's army would be whittled away like one of Grant's sticks. And Grant still held the stra-

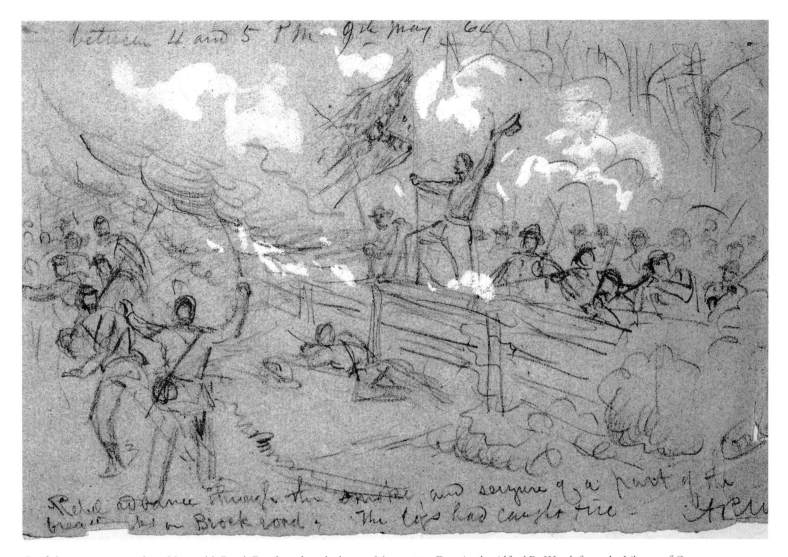

Confederate troops attacking Hancock's Brock Road earthworks late on May 6, 1864. Drawing by Alfred R. Waud, from the Library of Congress.

tegic edge; locked in place by the larger Union force, Lee was unable to launch the grand maneuvers that had characterized his warring in the past. The next move was up to Grant, and Lee could only trust that his own reflexes were sharp enough to counter.

While the generals laid their plans, soldiers suffered through another grueling night. Undergrowth burst into flame, and blazes crackled through the pines. Wounded men called from between the lines and sharpshooters fired at shadows moving in the flickering glare. One of Grant's aides summed up the feeling of the men of both armies. "It seemed," he wrote of those two terrible days in the Wilderness, "as though Christian men had turned to fiends, and hell itself had usurped the place of earth."

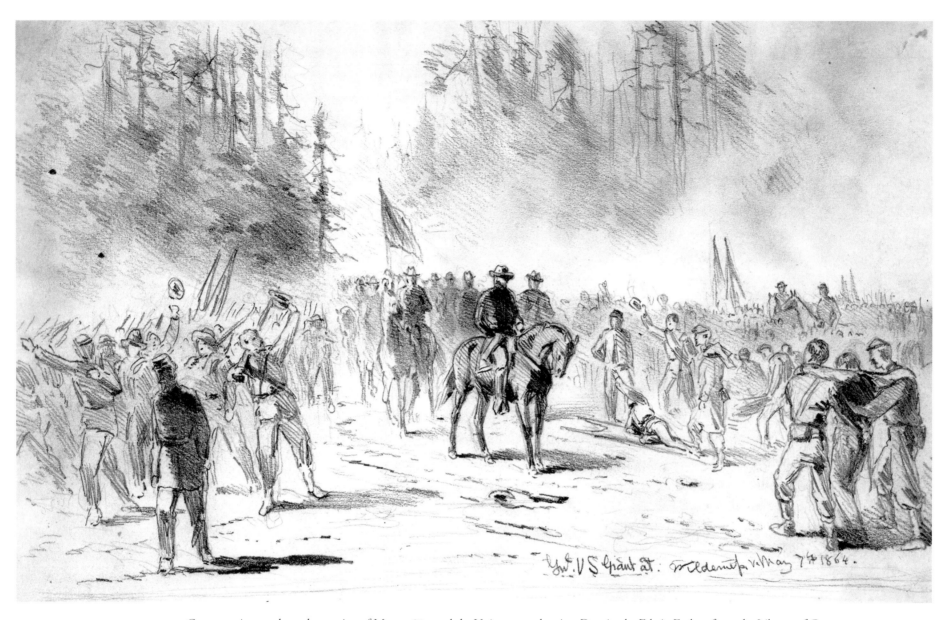

Grant turning south on the evening of May 7, 1864, and the Union army cheering. Drawing by Edwin Forbes, from the Library of Congress.

# 3
# The Battles at Spotsylvania Court House

Grant rose early on May 7 and strode briskly from his tent near the Lacy house, looking not at all like a general who had just lost a battle. There was no point, he concluded, in continuing to butt heads with Lee in the Wilderness. The rebels were firmly entrenched, and more attacks would only result in senseless repetitions of a failed strategy. Better, Grant decided, to give up fighting in this hostile woodland and focus on maneuvering Lee onto ground more favorable to the Union army.

After consulting his maps, Grant determined to leave the Wilderness and head south. His immediate objective was Spotsylvania Court House, an important road junction ten miles below the Wilderness. It was Grant's expectation that once the Federal army seized the crossroads, Lee would have no choice but to follow to protect Richmond, giving the Federals the match on open ground that they wanted.

All day, the Union army prepared to march. Some soldiers speculated that Grant intended to retreat, following the example set by his predecessors. Others predicted that he meant to steal a march on Lee.

At his headquarters in Catherine Tapp's field, Lee worked to divine Grant's intentions from scattered bits of intelligence. Taking a cautious approach, he decided to hold most of his troops in the Wilderness until Grant showed his hand. Since the Union army already controlled the main north-south artery—the Brock Road—Lee ordered his artillerists to hack a new trail through the woods as an alternative route for the Confederates in case Grant moved toward Spotsylvania Court House.

The Army of the Potomac began threading out of the Wilderness that night. The commander in chief wore a regulation army hat, a plain blouse and trousers, and a pair of muddy cavalry boots that looked very unmilitary. When he turned his horse onto the Brock Road, the soldiers broke into cheers. "On to Richmond," they cried, clapping and pitching their hats into the air. "Afterwards," an officer reminisced, "in hours of disappointment, anxiety, and doubt, when the country seemed distrustful and success far distant, those nearest the chief were wont to recall this midnight ride in the Wilderness, and the verdict of the Army of the Potomac after Grant."

Not long after Grant set off, Longstreet's successor, Major General Richard H. Anderson, withdrew the Confederate 1st

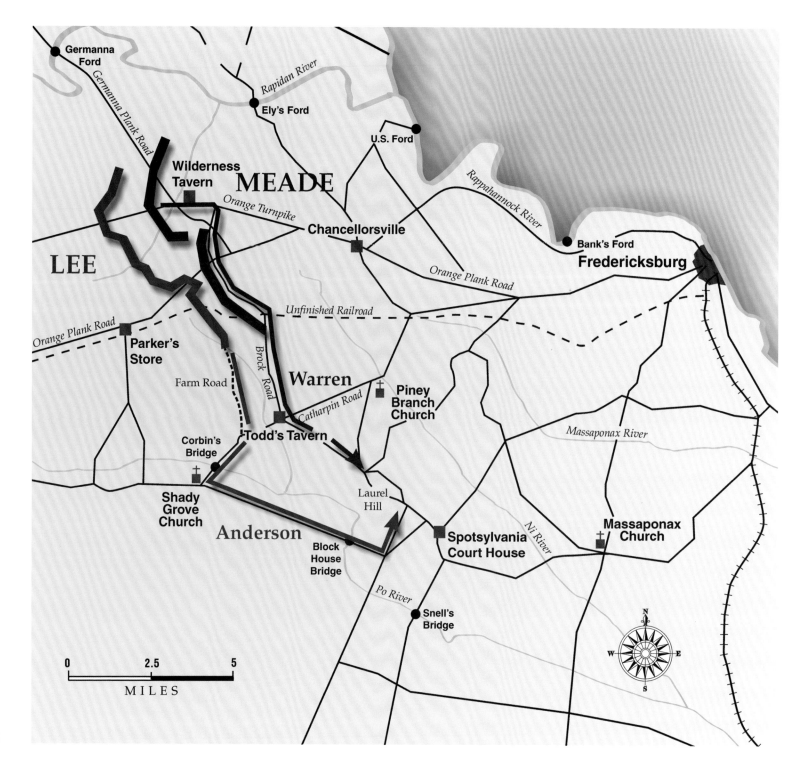

Germanna
Ford

Rapidan River

Ely's Ford

U.S. Ford

Rappahannock River

Wilderness
Tavern

MEADE

Orange Turnpike

Chancellorsville

Bank's Ford

Fredericksburg

LEE

Orange Plank Road

Orange Plank Road

Unfinished Railroad

Parker's
Store

Brock Road

Farm Road

Warren

Catharpin Road

Piney
Branch
Church

Massaponax River

Corbin's
Bridge

Todd's Tavern

Shady
Grove
Church

Anderson

Laurel
Hill

Block
House
Bridge

Spotsylvania
Court House

Ni River

Massaponax
Church

Po River

Snell's
Bridge

0    2.5    5

MILES

N
W    E
S

Movements to Spotsylvania
Court House, May 7–8, 1864

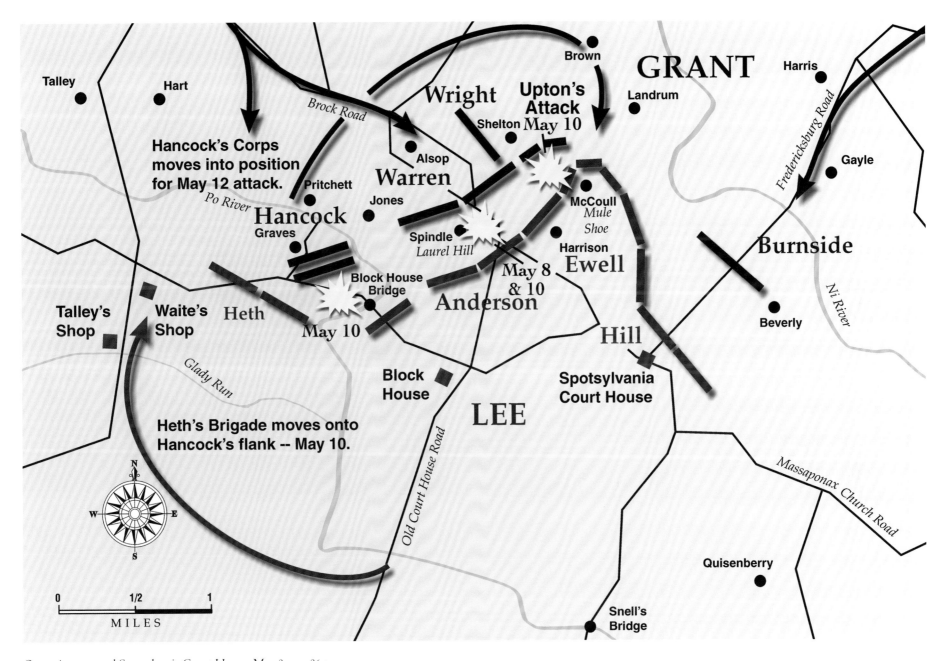

Talley

Hart

Brown

**GRANT**

Harris

Landrum

**Wright**

**Upton's Attack May 10**

Shelton

Gayle

*Brock Road*

**Hancock's Corps moves into position for May 12 attack.**

Alsop

**Warren**

Pritchett

*Po River*

Jones

McCoull
*Mule Shoe*

**Hancock**

Graves

Spindle
*Laurel Hill*

**Burnside**

Harrison
**Ewell**

May 8 & 10

**Talley's Shop**

**Waite's Shop**

**Heth**

Block House Bridge

**Anderson**

May 10

Beverly

*Glady Run*

*Ni River*

**Hill**

**Heth's Brigade moves onto Hancock's flank -- May 10.**

Block House

**LEE**

**Spotsylvania Court House**

*Fredericksburg Road*

*Old Court House Road*

*Massaponax Church Road*

N
W E
S

Quisenberry

0    1/2    1
MILES

Snell's Bridge

Operations around Spotsylvania Court House, May 8–12, 1864

Hay bales march across the Spindle farm a mile and a half north of Spotsylvania Court House. On May 7, 1864, Sarah Spindle and her family woke to the sound of Jeb Stuart's Confederate cavalrymen streaming past their farmhouse and deploying on a low ridge to the south. At 8:00 a.m., Grant's foremost troops under Warren charged across the field in an attempt to break the rebel line and clear the road to Spotsylvania Court House.

Corps from the Wilderness and started along the narrow trail carved through the forest. On the right of the Confederate line, someone raised a shout. More soldiers took up the call and passed it man to man to the line's far end, five miles away. The chorus of voices no sooner died than another shout rippled along the Confederate line, and then a third. "It seemed to fill every heart with new life, to inspire every nerve with might never known before," a southerner remembered.

The Union host jostled south all night. At the same time, Anderson's soldiers pursued back roads and trails, putting as much distance as possible between them and the smoldering Wilderness. Shortly before daybreak, the Confederates reached the Po River, a narrow stream two miles from Spotsylvania Court House. There, near Block House Bridge, Anderson let his men rest.

Jeb Stuart's cavalrymen meanwhile struggled to delay Grant's advance, fighting on foot behind barricades of fence rails and logs. Despairing that his cavalry would never push the rebels aside, Meade gave the job of clearing the road to Warren, who had initiated the Battle of the Wilderness with the disastrous assault at Saunders' Field. The Union 5th Corps battered south, overrunning the southern cavalrymen by sheer weight of numbers.

A mile and a half north of Spotsylvania Court House, Stuart's riders prepared for a final stand. Retreating across the farm of the Spindle family—Sarah Spindle was eating breakfast in her house, along with several of her children—the Confederate troopers lined up along a low ridge called Laurel Hill. Stuart, resplendent in his plumage, helped stake out the position, and he chose the ground well, giving his rebel cavalrymen an unobstructed view across Mrs. Spindle's field, in the direction of the Yankees.

From their bivouac, Anderson's soldiers listened to the din from Warren's and Stuart's rolling fight. Suddenly couriers pounded up requesting reinforcements and artillery support, and Anderson's troops hurried to the cavalrymen's assistance. Clambering up the back side of Laurel Hill, Anderson's lead elements piled behind the makeshift barricades tossed up only moments before. Stuart directed them into place—"cool as a piece of ice, though all the time laughing," an observer recalled.

It was 8:30 a.m. on May 8, and already the air felt oppressive, as though it were midsummer. Warren's battle lines were snaking into Mrs. Spindle's field, brittle corn stalks crunching underfoot, when the Confederates opened fire. The volley was horrific, tearing into the Yankees, who had no place to hide. A bullet sent shards of bone and gristle through the leg of Brigadier General John C. Robinson, who was spearheading the Union attack, and one Federal brigade lost three successive commanders in as many minutes. "At points where the enemy's fire was most concentrated," a northerner recollected, "the drone of bullets blended into a throbbing wail, like that of a sonorous telegraph wire pulsing in a strong wind, punctuated by the pert *zip* of the closer shots."

Desperate to gain the ridge, Warren pumped more troops into the fight. But fresh soldiers only provided denser targets for the rebel riflemen and for a battery of Confederate artillery that jangled up and spewed canister into Warren's ranks. Appalled at the turn of events—his corps was being annihilated—Warren seized a flagstaff and tried to rally his soldiers as they stampeded back.

Federal sharpshooters took cover in Mrs. Spindle's house and outbuildings and began picking off the Confederates posted on Laurel Hill. Anderson's artillery was now in place, and the Confederates responded by lobbing incendiary shells into the house, catching it on fire. "And then I saw a sight I never wanted to see again," a southerner recounted. Sarah Spindle, her hair streaming behind her, ran from the burning

Spiraling grass surrounds a marker—the oldest on the battlefield—designating the farthest point reached by Union troops in their failed attack across the Spindle farm. Northerners mistakenly named the ridge "Laurel Hill" where Stuart's Confederates, reinforced by Confederate infantry from the 1st Corps, placed their line. The real Laurel Hill was several miles away, but the name stuck. "Never mind cannon! Never mind bullets!" Warren exhorted his men. "Press on and clear this road. It's the only way to get your rations."

structure with her children and sought refuge in the Confederate lines.

While Anderson hurried more troops onto Laurel Hill, Lee forwarded the rest of his army from the Wilderness to the emerging battlefront. Grant determined to keep hammering and during the hot and sultry afternoon brought up the rest of the Union army. Toward evening he sent Sedgwick's corps forward, hoping to slip it past the eastern end of Anderson's position. But just as the Federals started to charge, Ewell's corps arrived from the Wilderness, glided into place next to Anderson, and repulsed Sedgwick with ease, securing Lee's hold on Spotsylvania Court House. Everything had gone right for the Confederates this bloody 8th of May.

Lee's engineers labored all night to lay out a defensive line. Anderson's corps held Laurel Hill, on the Confederate left; Ewell's corps fastened onto the right end of Anderson's formation and extended the line eastward; and early on May 9, Hill's troops tramped in from the Wilderness and tacked onto the eastern end of Ewell's entrenchments, digging a stretch of fortifications that dipped to the south. By the end of the day, the Army of Northern Virginia occupied a continuous six-mile array of earthworks covering Grant's approaches to Spotsylvania Court House.

Lee's engineers made ingenious use of terrain, building entrenchments along high ground, clearing the land in front, and heaping tangled mounds of tree limbs and brush against the face of the fortifications, pointed ends toward the enemy. Rather than arranging the entrenchments in straight lines, they angled them to mimic the ground's contours, creating angles and pockets that subjected attackers to overlapping fire from several directions.

Grant's men also dug, running their earthworks roughly parallel to those of the rebels. "If anyone got any sleep," a Union man remembered of his sojourn near Spotsylvania Court House, "it was in very short naps in line on the ground with their guns by their sides, or in their grasp, ready to meet threatened attacks which came almost hourly." Wounded men on Mrs. Spindle's farm cried piteously for water, but no one called a truce, and the field remained a killing zone. Sharpshooters made life miserable by shooting at any sign of movement. Soldiers generally—but not sharpshooters—honored an unwritten code that forbade firing on a man who was relieving himself. "I hated sharpshooters, both Confederate and Union," a soldier remembered, "and I was always glad to see them killed." On May 9, a Confederate marksman shot Sedgwick in the face, making him the highest-ranking general killed at Spotsylvania Court House. One of Sedgwick's division commanders, Brigadier General Horatio G. Wright, assumed command of the Union 6th Corps.

Grant spent the next three days launching a flurry of offensives in an attempt to break through Lee's frowning battlements. The men of both armies had been relieved to get out of the Wilderness, with its deep-woods combat and consuming fires. Spotsylvania Court House initiated them into the dark, numbing hell of trench warfare.

Late on May 9, Grant sent part of Hancock's 2nd Corps around the western end of Lee's line in an attempt to turn that Confederate flank. Hancock managed to get across the Po River, but darkness fell before he could complete the maneuver, and the Union 2nd Corps settled in for the night near Block House Bridge. "It was a great, and immense piece of luck for

Warren attempting to rally his troops during their assault against Laurel Hill on the morning of May 8, 1864. Drawing by Alfred R. Waud, from the Library of Congress.

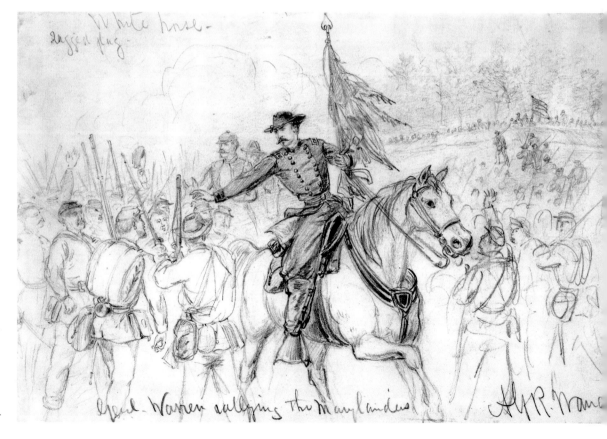

A ghostly tree haunts the site of Sarah Spindle's home. Annoyed by Union snipers who used the Spindle house as a base for firing into the Confederate line, southern artillerists lobbed an incendiary shell into the structure, burning it to the ground. "And then I saw a sight I never wanted to see again," a southerner recounted as he watched Mrs. Spindle run from the burning house with her children to seek refuge in the Confederate lines.

us," a Confederate officer later recorded. "Hancock had made his move across the Po late in the afternoon, giving us the night to meet him." Lee, seizing the opportunity to attack Hancock's isolated force, shifted a division under Henry Heth from the right end of his line to the left, where it stood poised to tear into the unsuspecting Federals the next morning.

An unusual quirk in topography complicated Hancock's assignment and aided Lee. Near the Block House Bridge, the Po turned sharply south. Hancock's objective—the flank of the rebel line—lay directly across the stream, and the rebels had the far bank well defended. Hancock spent the morning trying to find a way across until news arrived that rebels—Heth's

men—were closing to attack. Most of his corps got away safely, but the rearguard under Francis Barlow became embroiled in a nasty action with Heth and barely escaped across the Po on pontoon bridges. "Their right and rear enveloped in the burning wood, their front assailed by overwhelming numbers of the enemy, the withdrawal of the troops was attended with extreme difficulty and peril," Hancock reported.

Alert for an opening, Grant concluded that Lee must have pulled troops from his line to assemble the force pounding Hancock. To exploit this hypothetical weakness, he ordered an offensive against the entire Confederate formation that afternoon.

A unique component of Grant's new offensive was a charge led by Emory Upton, a fiery young colonel from upstate New York. Upton had studied the layout of Lee's line at Spotsylvania and thought he understood why the attacks were failing. Identifying a finger of woods that reached within two hundred yards of the Confederate line, Upton arranged twelve crack regiments into a compact formation comprised of four lines of troops. The men in the first line were to charge without pausing, leap onto the rebel earthworks, shoot and bayonet the defenders, and spread out along the battlements, pushing left and right to widen their lodgment. The second line was to pile in, followed by the third line, while the fourth line remained in the woods as a reserve. Once Upton had cleared the enemy troops from

A wartime road winds through the woods to the site of Colonel Emory Upton's famous attack. On the afternoon of May 10, 1864, Upton led twelve crack regiments down this road and formed them on the edge of a clearing three hundred yards from the Confederate earthworks. Rushing forward without pausing to fire or to succor the wounded, Upton's men overran the enemy entrenchments and secured a toehold in the rebel position. The failure of supporting troops to arrive in time doomed the venture, but Upton's near success inspired Grant to try a massive assault along the same lines two days later.

the breach, an entire Union division commanded by Brigadier General Gershom Mott was to charge into the opening and complete the business of ripping Lee's army in half.

The charge, initially scheduled for 5:00 p.m., was postponed for an hour. Shortly after 6:00 p.m., Upton's troops, tightly packed and marching quickly as instructed, stepped from their woods and started toward the rebel works. "I felt my gorge rise, and my stomach and intestines shrink together in a knot, and a thousand things rushed through my mind," a Union man remembered of those moments. Bursts of smoke dotted the

Confederate earthworks at Spotsylvania Court House. From the Library of Congress.

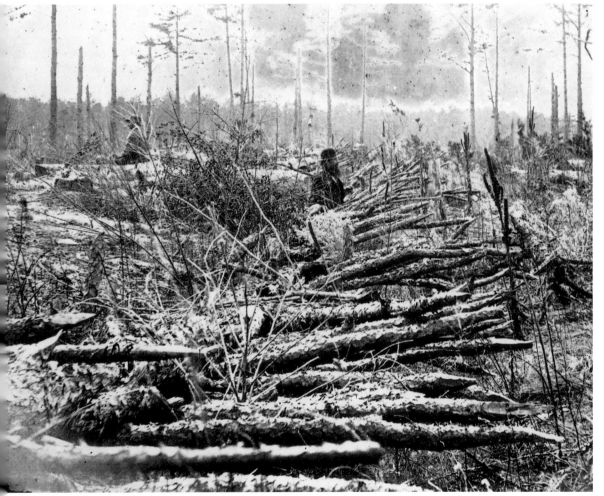

earthworks ahead, and dirt puffed up where bullets struck the ground, but Upton's front line did not stop. "Forward," cried Upton, who was running with his soldiers. Northerners clawed their way up the face of the ramparts and leaped into the defenders, stabbing with their bayonets and swinging their muskets like clubs.

Spreading left and right, Upton's troops widened the cleft according to plan, allowing the second and third lines to pour in. Georgians defending the broken segment of works fought back viciously but were overwhelmed by the weight of Upton's numbers. Ewell rode toward the tumult, excitedly barking orders and pulling on his moustache. "Don't run, boys," he called to troops who were falling back. "I will have enough men here in five minutes to eat up every damn one of them!" Lee also started toward the fight, turning back only when his aides promised to make sure the ground was recovered.

Upton's success depended on the appearance of Mott's reinforcements. The order postponing the attack, however, had never reached Mott; assuming that the offensive was still scheduled for five o'clock, he had started his advance early and was repulsed with severe loss. With no hope of reinforcements, Upton's soldiers climbed back over the rebel earthworks and sought shelter against the outer face of the barricades, where they contemplated the unpleasant choice of surrendering or fleeing across the field swept by Confederate guns. Many elected to run the gauntlet of enemy fire, dragging wounded comrades with them. Of the nearly five thousand soldiers who had made the charge with Upton, more than a thousand did not return. The grand venture had been a failure, through no fault of the colonel's. "I cried like a whipped spaniel," a participant admitted.

That evening, Grant considered Upton's failed offensive as he nursed a cigar and studied the embers in his campfire. Once more, as in the Wilderness, the Army of the Potomac had let him down. Generals had faltered, orders had gone astray, and

Meade had neglected to achieve even the semblance of coordination. Upton's attack, however, raised a glimmer of hope. The New Yorker had demonstrated conclusively that Lee's line could be broken if an assault were pressed swiftly. If reinforce-

Ground fog gently fills the hollows in front of the Confederate Mule Shoe at sunrise. On the misty morning of May 12, 1864, some twenty-five thousand soldiers from Hancock's Union 2nd Corps charged across this ground, bent on taking the Confederate stronghold by surprise. "The fog was so dense we could not see in any direction," a Confederate remembered of those tense moments, "but soon we could hear the commands of officers to the men, and the buzz and hum of moving troops."

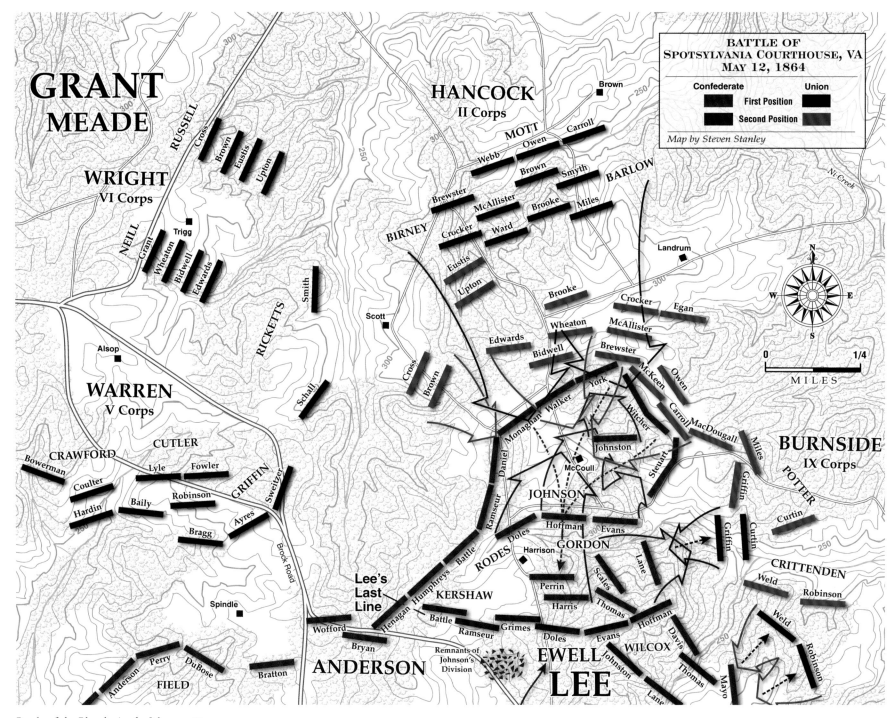

GRANT
MEADE

WRIGHT
VI Corps

WARREN
V Corps

RUSSELL

NEILL

RICKETTS

Cross
Brown
Eustis
Upton

Grant
Trigg
Wheaton
Bidwell
Edwards

Smith

Schall

CRAWFORD
CUTLER

GRIFFIN

Bowerman
Coulter
Hardin

Lyle
Baily
Robinson
Bragg

Fowler

Sweitzer
Ayres

Alsop

Spindle

Brock Road

Anderson
Perry
DuBose
Bratton
FIELD

Wofford
Bryan

ANDERSON

HANCOCK
II Corps

MOTT
Webb
Owen
Brown
Brewster
McAllister
Crocker
Ward
Brooke
Eustis
Upton

BIRNEY

Scott

Carroll
Smyth
Miles

BARLOW

Brook
Crocker
Egan
Wheaton
McAllister
Edwards
Bidwell
Brewster
McKeen
Owen
Cross
Brown

Monaghan
Walker
York
Witcher
Carroll
MacDougall
Daniel
Johnston
McCoull
Steuart

Landrum

JOHNSON

Ramseur
Hoffman
Doles
Harrison
Evans
GORDON
Battle
RODES
Perrin
Scales
Lane
Harris
Thomas

Lee's
Last
Line

Henagan
Humphreys
KERSHAW
Battle
Ramseur
Grimes
Doles
Evans
Hoffman
WILCOX
Davis
Thomas
Mayo
Lane

Remnants of
Johnson's
Division

EWELL
LEE

Johnston

BURNSIDE
IX Corps

POTTER
Griffin
Curtin
Griffin
Curtin

CRITTENDEN
Weld
Robinson

Weld

Robinson

Miles

BATTLE OF
SPOTSYLVANIA COURTHOUSE, VA
MAY 12, 1864

Confederate          Union
First Position
Second Position

*Map by Steven Stanley*

N
W        E
S

0                    1/4
MILES

Ni Creek

Battle of the Bloody Angle, May 12, 1864

ments had appeared at the right time to exploit Upton's initial success, would not the outcome have been vastly different? The prospects set Grant to thinking. What if the assaulting force were larger? What if he sent in not a brigade, but an entire army corps? What if he magnified the element of surprise and attacked just before sunrise? And what if the reserve force consisted not of a division, but of two entire corps?

Here, concluded Grant, was a recipe for success. A cavalryman at headquarters overheard the Union commander discussing the possibilities with his aides. "A brigade today," Grant emphasized. "Will try a corps tomorrow."

Near the center of Lee's position, rebel engineers had bent the rebel line to the north, jogged it eastward, and then headed it off to the south, tracking a stretch of high ground. The result was a large bulge half a mile wide and half a mile deep pointing toward the Federals. The protuberance resembled a mule shoe, and the soldiers began calling it by that name. In military parlance, the Mule Shoe was a salient, a feature that was notoriously difficult to defend. Lee and his engineers, however, decided to hold on to the position because it occupied high ground that they were loath to relinquish. To strengthen the salient, Lee directed Ewell to pack it with artillery, thirty pieces in all.

Grant selected the Mule Shoe for his next attack and assigned Hancock's corps—more than twenty thousand soldiers,

nearly double the number of men involved in Major General George E. Pickett's famous charge at Gettysburg ten months before—to storm it at first light. Simultaneously Wright's and Burnside's corps, totaling forty thousand or so soldiers, were to plow into the Mule Shoe's eastern and western legs while Warren's corps pinned Anderson's rebels at Laurel Hill. Crushed by irresistible numbers, Lee's troops would have no choice but to scatter or face destruction.

The sky darkened on the afternoon of May 11, and rain extinguished campfires and flooded battle trenches. Troops stretched tent flies over sticks for shelter, but the efforts afforded scant relief. "The wind was raw and sharp, our clothing wet, and we were just about as disconsolate and miserable a set of men as ever were seen," a waterlogged warrior reported.

A cannon stands in wintry splendor at the apex of the Confederate salient at Spotsylvania Court House. Alerted that an attack might be imminent, Lee ordered artillery like this into the bulge in his line that the soldiers had dubbed "the Mule Shoe." Overrunning the Confederate defenses, Hancock's troops captured most of the guns and some three thousand enemy soldiers. Among those imprisoned was the Confederate Major General Edward "Alleghany" Johnson, who shared breakfast shortly afterward with his prewar friends Grant and Meade.

Toward evening, Hancock's corps started from the western end of Grant's line to the Brown family fields, across from the Mule Shoe's head. Usually an astute judge of his opponent's intentions, Lee misread reports of mounting enemy activity and concluded that Grant was preparing to retreat, probably toward Fredericksburg. Aggressive as ever, Lee wanted his army poised to harass Grant during his withdrawal. To facilitate his pursuit, he ordered the cannon extracted from the Mule Shoe and brought back nearly two miles to main roads at Spotsylvania Court House. Acting on a fatal misapprehension of Grant's intentions, Lee weakened the very sector of his line that the Union commander had targeted for a massive offensive.

The night was black and rainy as Hancock's weary soldiers wound along a labyrinth of country roads and trails. The marching column kept breaking in the darkness, and officers flailed about, cursing as they tried to reunite the pieces. No one on the Union side knew how strongly the rebel earthworks were manned, and even the half-mile stretch between the staging area at the Brown house and the Mule Shoe was a mystery. When one of Hancock's generals sarcastically inquired whether he might encounter a thousand-foot ravine that would swallow up his troops, no one could tell him. "For heaven's sake, at least face us in the right direction so that we shall not march away from the enemy and have to go round the world and come up in their rear," an officer quipped.

Mud-spattered soldiers filed into the Brown house fields all night. Half a mile south loomed the head of the Mule Shoe, manned by Major General Edward "Alleghany" Johnson's Confederate division of about forty-five hundred troops. By midnight, persistent reports from his outposts convinced Johnson that Grant was preparing to attack, and he asked Ewell for his guns back. Persuaded by Johnson's urgency, Ewell sent a dispatch ordering the guns returned and informed Lee of Johnson's misgivings. Ewell's note puzzled Lee, as he still believed

A cannon looks out over the Union approaches to the Mule Shoe. Recapturing a portion of his line, Lee held the formation against sustained assaults for more than twenty hours while his troops prepared a new position a mile to the rear. Union mortars lobbed shells in curving arcs into the earthworks, and artillery pounded at point-blank range. Trenches brimmed with water "as bloody as if it flowed from an abattoir," a survivor recalled, and corpses sprawled several layers deep in mire. Not until three o'clock the next morning did Lee complete his new defenses and relinquish the Mule Shoe to the enemy.

Aides roused Alleghany Johnson from his sleep and warned that enemy soldiers were approaching. Mounting the Mule Shoe's earthen walls, the general strained to see across the fields. "The fog was so dense we could not see in any direction," a Confederate remembered of those tense moments, "but soon we could hear the commands of officers to the men, and the buzz and hum of moving troops."

Hancock's attack caught the Confederates unprepared. Form and order dissolved as Hancock's compact mass swarmed onto the earthworks. Johnson cut a stirring figure, limping atop the breastworks, clothes torn, ferociously brandishing his walking stick in a vain attempt to stem the Union onslaught. In parts of the salient, stunned defenders gave up with scarcely a fight; other places witnessed terrific hand-to-hand combat as Federals battered their way along the trench line behind the works. Three thousand stunned Confederates fell prisoner, along with the guns that had rolled in from Spotsylvania Court House.

Twenty thousand Federal troops were now shoehorned into the tip of the salient. Men milled about, seizing prisoners, collecting mementos from abandoned rebel camps, and tossing their hats into the air as they cheered their success. In an attempt to maintain the initiative, Hancock rode to the front, urging his officers to regroup and pursue the defeated enemy. But the offensive was stymied.

Confederate leadership within the Mule Shoe was also in shambles. Johnson was a prisoner, and volatile Richard Ewell, his superior, seemed beside himself, cursing and whacking retreating soldiers across their backs with his sword. "How can you expect to control these men when you have lost control of yourself?" Lee demanded, adding: "If you cannot suppress your excitement, you had better retire."

It was Lee's good fortune that his reserve force was in the hands of John Gordon, the lanky, thirty-two-year-old Georgian

A clover marks the spot where the Union 2nd Corps—whose insignia was a trefoil—fought desperately to maintain its hold on the Mule Shoe. Brutal hand-to-hand combat centered near a bend in the Mule Shoe that came to be called the Bloody Angle. "Here was nothing of glamour, but unmitigated slaughter, a Golgotha without a vestige of the ordinary pomp and circumstances of glorious war," a soldier remembered of the fighting.

that Grant intended to retreat. Out of an abundance of caution, however, he, too, ordered the artillery returned to the salient by daylight.

Not until 4:00 a.m. did a rider slosh into the artillery camps near Spotsylvania Court House and deliver the orders. The road was only faintly illuminated by the first glow of dawn as the guns started toward the front, horses straining and wheels slipping in muddy ruts.

The downpour slowed to a drizzle shortly before dawn, and a fine mist drifted over the fields around Mr. Brown's home, collecting as fog in low-lying hollows. "To your commands," Hancock directed, and orderlies brushed swiftly into the yard. The charge—the grand offensive aimed at bringing three years of war to a close—was to begin.

who had spearheaded the evening attack in the Wilderness. Rallying his troops in the center of the Mule Shoe, Gordon spied Lee turning his horse toward the enemy, intending to lead the charge as he had in the Wilderness. A sergeant took Traveller's bridle and began walking the horse and rider through the troops. "Lee, Lee, Lee to the rear," soldiers chanted. "Forward, men. Forward!" Gordon cried, and his example proved contagious. Fighting like demons, Gordon's forces overran the surprised northerners and drove them out of the eastern sector of the Mule Shoe.

As Lee saw it, his best option was to abandon the Mule Shoe and prepare a new line on high ground a mile to the rear, near the home of the Harrison family. To buy time, part of his army would have to hold off the entire Union offensive. Gordon had driven the invaders out of the Mule Shoe's eastern segment, but the situation on the Mule Shoe's western leg and across its apex remained dangerous. Here massive numbers of northern soldiers had overrun the heart of Ewell's line, and Grant was ordering up artillery.

Lee's task was clear. His army's survival required driving the enemy from the Mule Shoe's western leg and apex and holding them in check until he could construct a new line in the rear.

In past battles, Lee generally delegated responsibility to his subordinates. Longstreet, however, had been seriously wounded in the Wilderness, Hill was sick, and Ewell seemed incapable of exerting intelligent leadership. It was up to Lee to select the units to send in and to direct them where to go.

A few stones are all that remain of the Harrison house. Abandoning the Mule Shoe, Ewell's corps took up a new line in the woods behind the Harrison place. Early on May 18, Grant, attempting again to puncture Lee's Spotsylvania line, launched a surprise attack that Ewell handily repulsed with little more than artillery. Concluding that Lee's defenses were impregnable, Grant turned once more to maneuver.

Fog enshrouds a monument to the 1st Massachusetts Heavy Artillery regiment commemorating the novice soldiers' brave stand on May 19, 1864, against an attack by Ewell's veteran Confederates. Posted on the Harris family farm near the northern end of the Union line, the "band-box soldiers," as the green-horns were derisively called, took severe losses but managed to hold on until experienced reinforcements arrived and broke Ewell's assault.

Lee first sent Brigadier General Stephen Dodson Ramseur, commanding a North Carolina brigade, toward the Mule Shoe's western leg. Advancing through a veritable blizzard of musketry, the North Carolinians drove the northerners from the earthworks in front of them and wedged into a short sector of trenches. To Ramseur's right, the trench line dipped gently downhill for about a hundred yards, then rose another hundred yards to a slight crest, marking the beginning of the Mule Shoe's broad, flat apex. From this point of high ground, later called the Bloody Angle, Union troops could fire down along the length of the western leg. Simply put, whoever controlled the elevated piece of land would command the earthworks that Lee so desperately needed to occupy.

Coming to Ramseur's assistance were Alabama troops led by Brigadier General Abner Perrin. Buffeted by intense fire, they piled into fortifications next to Ramseur, closer by yards to the foot of the high ground at the angle and even more vulnerable to the deadly plunging fire. Then came Mississippians under Brigadier General Nathaniel H. Harris; Union musketry forced them to seek cover in entrenchments to the right of the Alabamians, extending the segment of recaptured earthworks still closer to the Bloody Angle.

Grant ordered Wright's corps into the fight, jamming rank after rank of Union soldiers against the outer face of the fortifications. A few feet away, separated from the enemy by low walls of earth and timber, huddled the three beleaguered rebel brigades, bullets slamming into them from straight ahead and from the right. Desperate to capture the angle, Lee ordered Brigadier General Samuel McGowan's South Carolina brigade into the fray. Taking severe losses, McGowan's men drove the Federals from their commanding position and secured a toehold on that important piece of real estate.

It was now about nine in the morning. Determined to recapture the angle, the Union high command launched a welter of counterattacks. Grant also brought out Coehorn mortars—short, stubby tubes that heaved shells in high, curving arcs behind the Confederate line—and Union gunners rolled cannon in front of the angle and fired at point-blank range. Shells punched smoking holes through the earthen mounds, killing everyone on the far side.

The plain in front of the angle, however, was fast becoming a field of dead men in blue, many pulverized into mush that resembled jelly more than corpses. New Federal troops marched up to fill gaps only to discover dead men stacked so closely that

A Confederate killed during fighting at Harris Farm on May 19, 1864. From the Library of Congress.

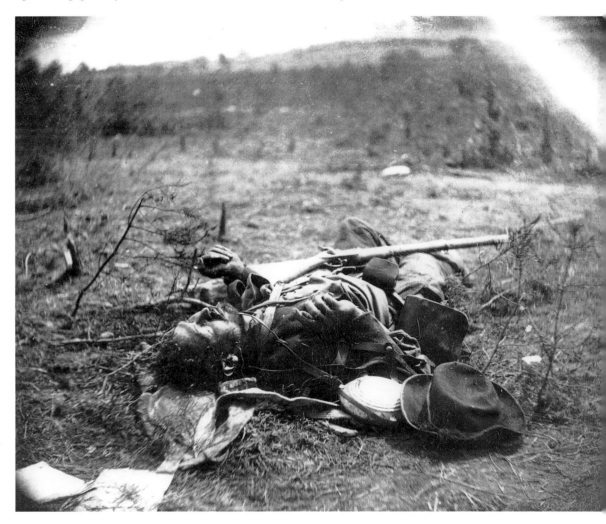

they could not move into place. Soldiers broke under the strain and stood erect, firing slowly and deliberately until Confederate balls cut them down. The scene on the rebel side was equally horrific. Trenches brimmed with water "as bloody as if it flowed from an abattoir," a survivor recalled. Wounded men drowned in muck, and bodies lay several layers deep in the trenches, some floating in the foul mire. Occasionally a wounded soldier would regain consciousness, crawl from under a corpse, and begin fighting again.

Soldiers who lived through the experience described it in fragmentary, ghoulish snippets. "Here was nothing of glamour, but unmitigated slaughter, a Golgotha without a vestige of the ordinary pomp and circumstances of glorious war," a participant remembered. Another man remained haunted by scenes of "bloodshed surpassing all former experiences, a desperation in the struggle never before witnessed, of mad rushes, and of as sudden repulses, of guns raised in the air with the butts up and fired over log walls, of our flag in shreds." Indelibly etched in another warrior's memory was the sight of his rain-soaked companions, "their faces so begrimed with powder as to be almost unrecognizable; some standing ankle deep in red mud, firing, while the edge of the ditch was lined with others sitting and loading as fast as possible and munching hard bread, the crumbs of which were scattered around their smutty mouths and besprinkled their beards." Veterans later festooned battlefields such as Sharpsburg and Gettysburg with monuments to their valor. Few of them had any desire to return to Spotsylvania County, much less to the place they called the Bloody Angle.

Night brought no appreciable slackening of fire, and the same four rebel brigades that had recaptured the works that morning held grimly on. "No man thought of eating or even taking a drink of water," a Confederate claimed. "Indeed, no man thought at all," he added. "That function seemed to be suspended." Life had resolved into a matter of killing and

dying, a slow-motion dance conducted in a ghoulish paste of mud and corpses.

An oak twenty-two inches in diameter provided a telling gauge of the intensity of musketry focused against the Bloody Angle. All day and into the evening, minie balls skipped over the top of the fortifications and hit the tree, which stood immediately behind the Confederate line. Leaves and small branches disappeared first, followed by the larger limbs. So many balls flattened against the side of the trunk facing the Federals that it seemed encased in lead. Sometime after midnight, the tree toppled, whittled through by multiple rifle shots as surely as if it had been chopped by a woodsman's axe.

Near dawn on May 13, word arrived that Lee's new line was finished, and the Mule Shoe's defenders passed whispered commands to retire noiselessly from the works. "Exhausted, hungry and worn out for want of sleep, we were a sorry looking crowd," a South Carolinian remembered. "Everyone looks as if he had passed through a hard spell of sickness, black and muddy as hogs," one of Ramseur's warriors seconded. All would have agreed with the assessment of a dazed participant: "With blackened faces and crisped hands, from lying in the water so long; our clothes stained with red mud and blood, we marched out of this place where more than one-third of our men lay dead to sleep forever."

The sun rose over a scene of carnage that shocked even hardened veterans. The previous day's fighting had gained Grant a few acres of bloodstained Virginia soil. Tactically the Union commander had gained nothing, and Lee now faced him from his strongest position yet.

Grant had no intention of abandoning the initiative. From his new line below the Mule Shoe, Lee's entrenchments covered the approaches to Spotsylvania Court House along Fredericksburg Road and terminated a short distance past the court house town near Massaponax Church Road. On the night of May 13–14, Grant dispatched Warren and Wright to the far southeast of his line to assail the unprotected southern end of Lee's works and break through to the rebel rear, precipitating the collapse of the Confederate formation. But darkness, rain, and mud slowed the nighttime march and played havoc with Grant's timetable. By 4:00 a.m., the time set for the attack, Warren had only twelve hundred bleary-eyed soldiers in place, and Wright's men were mired several miles to the rear. "Owing to the difficulties of the road have not got fully into position," Grant informed Washington, adding that "bad weather may prevent offensive operations today."

Unknown to Grant, his ruse had worked. As a Confederate artillerist later observed, Grant had "devised an attack which would have had a fair chance of taking us quite by surprise, had he been able to make it." But Grant, fearing that Lee must have discovered his ploy and shifted troops to meet it, called off the assault. Not until midafternoon did Lee fully realize his peril and direct Anderson to rush a division to the southern Confederate flank. By nightfall—due to Grant's failure to exploit his temporary advantage—Lee was able to close the back door to Spotsylvania Court House that had stood ajar all day.

Continuing rain turned the roads around Spotsylvania Court House into quagmires and precluded movement for several days. Finally, on May 17, the weather cleared and Grant hit upon another plan. Lee, he observed, had shifted the weight of his army south to counter the Union buildup in the battlefield's southern sector. The last thing that Lee expected, Grant reasoned, was an attack from the north, across the abandoned Mule Shoe. So once again, under cover of darkness, Grant rearranged his army—this time mirroring his deployment of May 13–14 by withdrawing Warren and Wright from the southern end of his line and sending them north.

Early on May 18, most of Wright's and Hancock's soldiers

*Opposite:* The grave of an unknown Confederate soldier weathers a wintry blast in the Spotsylvania Confederate Cemetery at Spotsylvania Court House. Some six hundred Confederates killed in the battle were buried here after the war. Union dead from the battle rest with their compatriots in the Fredericksburg National Cemetery in nearby Fredericksburg. Fighting in different armies for different causes, rebels and Yankees remain apart even in death.

charged from the Mule Shoe's apex toward the new line that Lee had established along high ground above the Harrison house. "The appearance of the dead who had been exposed to the sun so long, was horrible in the extreme as we marched past and over them," a Union man recollected. Grant had caught Lee by surprise, but Ewell's soldiers occupying this section of line had constructed an impregnable bastion. High dirt barricades ran along the ridge, replete with elevated towers for sharpshooters, and in front spread row on row of felled trees, their sharpened branches forming an impenetrable barrier toward the enemy. Artillery waited behind the Harrison house, eager to play on the Federals as they moved across the open ground, and more pieces controlled a ravine in front of Ewell's position.

Confederate artillery greeted the advancing blue-clad soldiers. "Heads, arms and legs were blown off like leaves in a storm," a Union man remembered. "The whole morning's work was a deed of blood," another northerner recalled. Finally Grant called off the attack, deeming it "useless to knock our heads against a brick wall," Meade wrote home.

When the shooting quieted, rebels ventured out to examine the execution. "Few men were simply wounded," a gunner noted. "Nearly all were dead, and literally torn into atoms; some shot through and through by cannon balls, some with arms and legs knocked off, and some with their heads crushed in by the fatal fragments of exploding shells." Ewell, whose soldiers had been badly handled by the same foe the previous week, gloried in their revenge. A rebel recalled how they affectionately patted the tubes of the artillery pieces, doting over them as one might treat a beloved pet.

May 18 was a bad day for Grant all around. The failed assault had demonstrated once and for all that Lee's Spotsylvania line could not be broken. Disheartening news also arrived from Grant's supporting armies. Sigel had been defeated at New Market in the Shenandoah Valley and was retreating north. And

Butler had been repulsed at Drewry's Bluff, south of Richmond, and was withdrawing into the tongue of land between the James and Appomattox Rivers known as Bermuda Hundred. Not only had Grant lost the advantage of his multiple offensives, but Sigel's and Butler's defeats had freed Confederate troops to reinforce Lee. The campaign that had started two weeks before with so much promise seemed about to collapse.

The Union commander, however, remained undaunted and began a new plan to flank Lee out of his Spotsylvania line. His preparations were interrupted when Ewell, on the afternoon of May 19, launched a reconnaissance-in-force aimed to cut the Union supply line along the Fredericksburg Road and to harass the Federal force's northern flank. The northerners guarding the road belonged to heavy artillery regiments that had recently arrived from forts around Washington. Novices at fighting rebels, they were stationed on the Harris and Alsop farms, where Ewell caught them unawares and scored an initial breakthrough, severing Grant's umbilical cord. "Being novices in the art of war," an experienced Union man remembered of a heavy artillery regiment, "they thought it cowardly to lie down, so the Johnnies were mowing them flat."

Veteran Union troops rushed to the endangered area, and the influx of fresh Federals turned the tide of battle. Concerned that he would be cut off and overwhelmed, Ewell retreated, bringing the Battle of Harris Farm to a humiliating end for the Confederates. Union losses were high, but the heavy artillerists won accolades. "After a few minutes they got a little mixed," a battle-worn warrior explained to a newspaperman, "and didn't fight very tactically, but they fought confounded plucky—just as well as I ever saw the old Second [Corps]."

While Grant and Lee sparred around Spotsylvania Court House, their cavalry arms engaged in a heated string of battles born of Meade's and Sheridan's simmering feud. The crusty

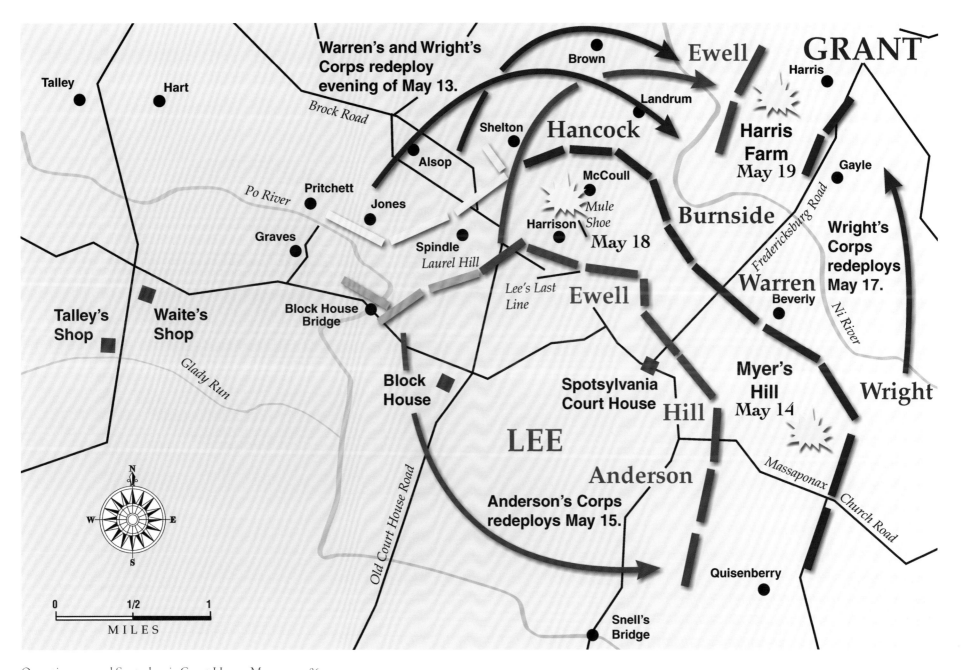

Operations around Spotsylvania Court House, May 13–19, 1864

army head blamed Sheridan for botching his assignment in the Wilderness and for failing to brush the rebel horsemen aside during the advance toward Spotsylvania Court House. On May 8, following a bitter shouting match, Sheridan stomped from Meade's tent. Expecting Grant to support him, Meade reported Sheridan's insubordination to Grant, but his timing could not have been worse. Exasperated over Meade's inability to defeat Lee's smaller force, Grant sided with Sheridan, whom he viewed as displaying a much-needed aggressive spirit. The cavalry commander wanted to take off after Stuart, and Grant gave him permission to do so.

Sheridan enthusiastically plotted a campaign to destroy the rebel mounted force. His idea was to head south with the entire Union cavalry corps, riding slowly but deliberately toward Richmond, enticing Stuart to come after him. Somewhere near Richmond, he and the plumed cavalier would meet and have their battle.

Early on May 9, Sheridan's troopers started toward the Confederate capital. Stuart responded as Sheridan had predicted and dispatched three brigades in pursuit. Catching up with Sheridan near Beaver Dam Station, Stuart the next day split his available force, dispatching a brigade to harass Sheridan's rear while Major General Fitzhugh Lee's division tried to get in front of the Union horsemen and cut them off. Fitzhugh Lee won the race and on May 11 deployed along Telegraph Road near a dilapidated hostelry called Yellow Tavern, on the outskirts of Richmond and athwart Sheridan's route. Sheridan launched an inconclusive attack during the morning, driving back part of Fitzhugh Lee's command. Heavily outnumbered,

A stone marking the site of Jeb Stuart's mortal wounding reaches skyward in a minuscule park surrounded by one of modern Richmond's burgeoning subdivisions. Erected by Virginia's postwar governor and Stuart's former division commander Fitzhugh Lee in 1888, the monument stands on a hillside adjacent to the wartime trace of Telegraph Road.

Stuart nonetheless took a stand. That afternoon, in a charge spearheaded by the flamboyant Brigadier General George A. Custer, Sheridan's troopers overran Stuart's position and mortally wounded the rebel cavalry chief. Under cover of darkness, the defeated Confederates filtered toward Richmond along back roads and byways.

The next day—May 12, while Lee was fighting Grant at the Bloody Angle—Stuart died of his wounds. "Thus has passed away, amid the exciting scenes of this revolution, one of the bravest and most dashing cavaliers that the 'Old Dominion' has ever given birth to," a Virginian mourned.

Sheridan continued his advance toward Richmond, which was defended by a few raw units of home guards and government clerks. Crossing a tributary of the Chickahominy River, Sheridan discovered that he had fallen into a trap; ahead loomed a string of forts protecting Richmond, bristling with siege guns and invulnerable to attack, and behind came the gathering remnants of Fitzhugh Lee's defeated cavalry division, blocking the Chickahominy crossings that were now in Sheridan's rear. The only way out for the Federals was to force a passage across Meadow Bridge, a twin span carrying a wagon road and a railroad across the Chickahominy. A Union man observed that with the city's fortifications on one side and Fitzhugh Lee's cavalry "holding the strong and easily defended position at Meadow Bridge before us—this and the pelting rain and howling thunder all conspired to make things gloomy."

Once again, Custer came to Sheridan's rescue and sent his men darting across the railway span, where they leapt single file from tie to tie, timing their steps to avoid projectiles from Lee's artillery screaming around them. Other troopers waded across the marshy river to emerge on the Confederate bank and open fire with their seven-shot carbines. When they had secured a bridgehead on Fitzhugh Lee's side of the Chickahominy, more Federals poured over, opening the way for Sheridan's escape.

Free of the trap, the Federal force rode south to the James River and the safety of Union gunboats supporting Butler.

The Richmond Raid, as Sheridan's expedition came to be called, was rightfully touted as a success, made even more conspicuous by Grant's failures at the Wilderness and Spotsylvania Court House. The Union troopers' morale soared, matched by corresponding despondency on the Confederate side. But lost in the euphoria of victory was the import of Sheridan's absence during the grinding combat at Spotsylvania Court House. By taking virtually all of the Union riders with him, Sheridan had left Grant blind. Stuart, on the other hand, had left Lee enough troopers—three veteran brigades—to reconnoiter Union positions and screen the movements of his infantry. In the bigger context of the campaign, Grant's release of Sheridan with the entire Union cavalry arm was a blunder that cost the Federals dearly.

Postwar view of Jeb Stuart's grave at Hollywood Cemetery in Richmond. From the Library of Congress.

The Ni and Po rivers merge in swampy lowlands to form the upper branch of the Mattaponi River near Guinea Station. The river system played a crucial role in Grant's maneuvers from Spotsylvania Court House to the North Anna River. By first marching east, then swinging south along the arc of the river, the Federals would avoid a nettlesome river network that offered the rebels excellent defensive positions.

# 4
# The North Anna Operations

Grant's and Meade's relationship had deteriorated sharply in the two weeks since the Army of the Potomac had crossed the Rapidan. Meade's fumbling management had persuaded Grant to keep major battlefield decisions for himself, leaving Meade to handle matters ordinarily relegated to staff officers. The Pennsylvanian's letters home bristled with hurt. "If there was any honorable way of retiring from my present false position, I should undoubtedly adopt it," he wrote his wife, "but there is none and all I can do is patiently submit and bear with resignation the humiliation." The letters of Meade's aides were especially venomous, deriding Grant as a "rough, unpolished man" of only "average ability, whom fortune has favored." Grant's staffers in turn considered Meade a hindrance and complained that he was uncommitted to the spirit of their boss's offensives. "By tending to the details he relieves me of much unnecessary work, and gives me more time to think and mature my general plans," was Grant's excuse for keeping the Pennsylvanian on.

Despite the setbacks at Spotsylvania Court House, Grant persisted in his grand strategic objective and looked to ma-

neuver for a solution. "This was no time for repining," he later wrote. The Union drive toward Spotsylvania Court House, disappointing in its outcome, had underscored Lee's reluctance to let the Federals slip between his army and Richmond. Perhaps the time was again ripe to exploit Lee's solicitation for his capital. Grant's need to preserve his communication with the tidal rivers recommended a shift east and south of Lee, following the pattern set in the Wilderness and Spotsylvania operations. The Union general identified Lee's next likely defensive position as the North Anna River, twenty-five miles south. His choices were to race Lee to the North Anna—a venture rendered problematical by the Potomac Army's disappointing track record thus far in the campaign—or to entice Lee from his Spotsylvania earthworks by feigning toward the river and pouncing on the rebels when they followed.

Grant's analysis took into account the terrain that he would have to traverse. Telegraph Road offered the Federal army the most direct path south but required it to cross the Ni, Po, and Matta rivers, risking opposition at each stream; a few carefully positioned Confederates could delay Grant's progress while Lee's main body pursued parallel roads and

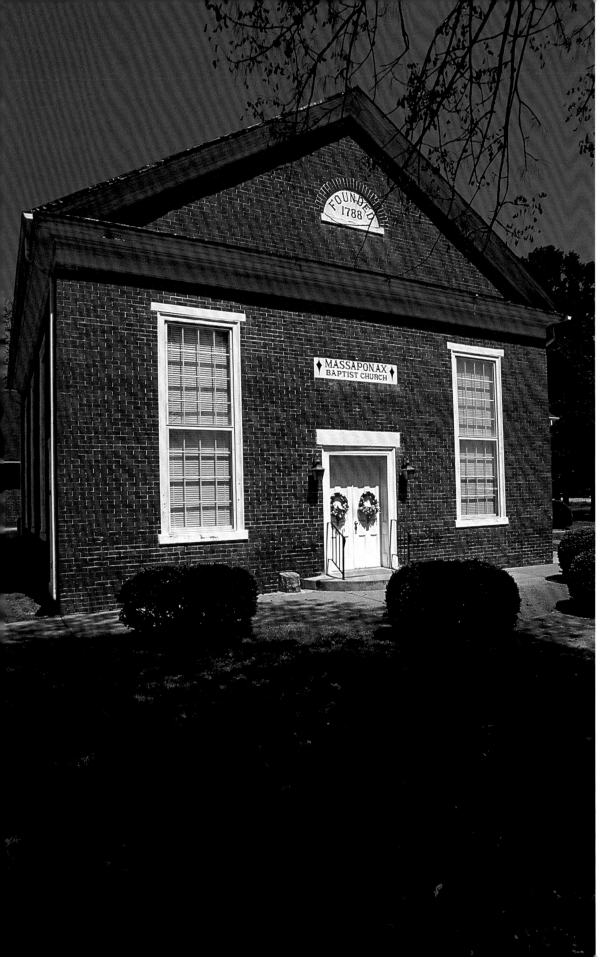

beat him to the North Anna. A few miles east of Telegraph Road, the Ni, Po, and Matta merged to form the Mattaponi, which flowed due south. By swinging east from Spotsylvania Court House, Grant saw that he could circumvent the bothersome streams, then descend along the Mattoponi's far side. He would cross only open terrain, and the river system would work to his advantage, shielding him from attack. In the inevitable race south, Lee, not Grant, would have to cross the irksome tributaries.

To lure Lee into the open, Grant decided to send Hancock on a twenty-mile march southeastward through Bowling Green. Once there, the lone Union corps ought to pose too great a temptation for Lee to resist. When Lee left his entrenchments to attack Hancock, Grant would send the rest of his army south along Telegraph Road to crush the rebels. In sum, Hancock would serve first as bait to entice Lee into the open, then become the anvil against which Grant would hammer his opponent. If Lee ignored the bait, Hancock would simply continue to the North Anna River, clearing the way for the rest of the Union army to follow.

Dispatching Hancock toward Bowling Green advanced another of Grant's objectives. During the fighting at Spotsylvania Court House, provisions had traveled by boat down the Chesapeake Bay from Washington to docks at Belle Plaine, north of Fredericksburg, and on to the army by wagon. As the army moved south, Port Royal on the Rappahannock River became

Strategically situated on Telegraph Road near the turnoff to Guinea Station, Massaponax Church served as Grant and Meade's headquarters during the maneuvers of May 21, 1864. The pastor had moved to Virginia from Philadelphia before the war and had become, a Union cavalryman noted with disdain, "strong 'Secesh.'"

*Opposite:* Massaponax Church on May 21, 1864, as the Union army evacuates Spotsylvania Court House. From the Library of Congress.

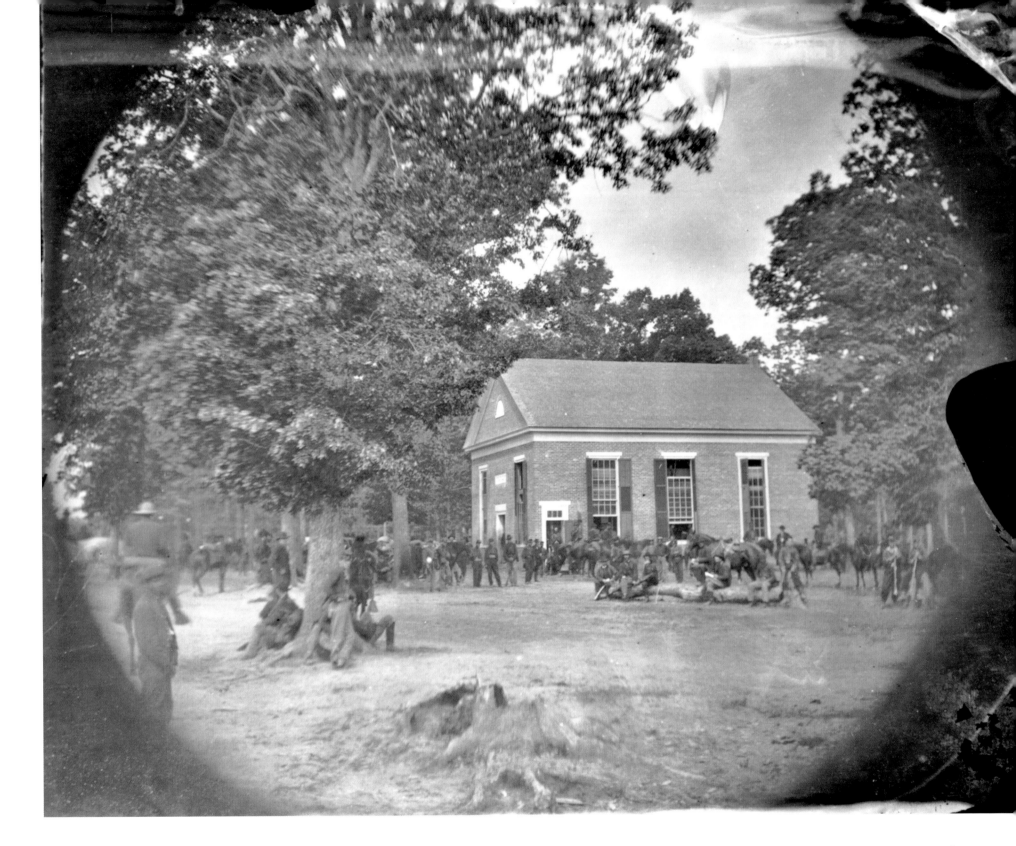

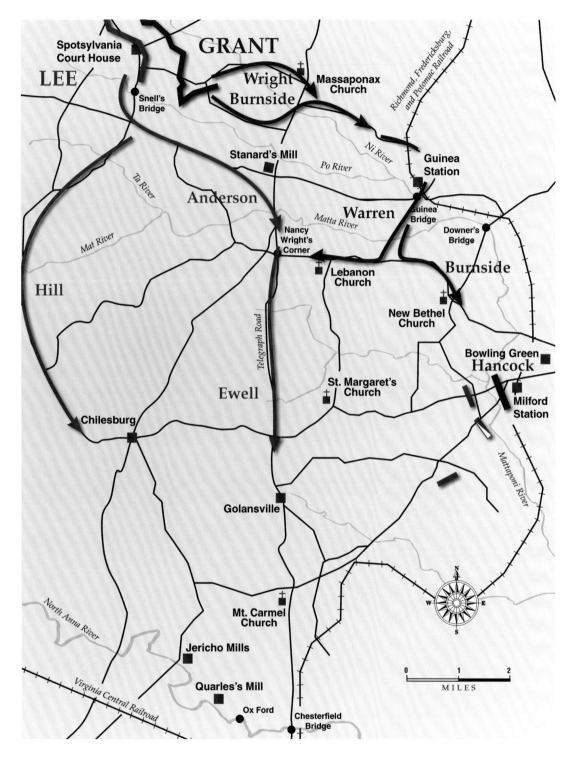

the next logical depot. Ships could reach the town from Chesapeake Bay, and a good road ran to Bowling Green, near Grant's potential routes.

During the night of May 20–21, Hancock began his diversionary march. Tramping through Guinea Station, the Union 2nd Corps crossed the Richmond, Fredericksburg, and Potomac Railroad and pressed on to Bowling Green, capital of Caroline County. After a rousing reception by the town's black populace, the troops angled west across the Mattaponi River and dug in a few miles past Milford Station, twenty miles southeast of the armies at Spotsylvania Court House. At the same time, Grant moved Warren's Corps back to Telegraph Road at Massaponax Church, positioned to pounce on whatever force Lee sent against Hancock.

As May 21 progressed, Lee learned of the Union movements and erroneously concluded that the enemy meant to march south along Telegraph Road on a beeline to Richmond. To counter Grant's expected move, Lee rushed Ewell east to Stanard's Mill, where Telegraph Road crossed the Po. The bold deployment threw a monkey wrench into Grant's plan by closing the route to the Federals and severing Hancock from the rest of the Union army.

At his headquarters at Massaponax Church, Grant began to worry. He had heard nothing from Hancock—rebel cavalry controlled the countryside toward Milford Station—and Ewell's Confederates were digging in across Telegraph Road. Concerned that Hancock might be in danger, Grant directed the rest of his troops to evacuate their earthworks in front of Spotsylvania Court House. Warren was now instructed to follow Hancock's route to Bowling Green while the remainder of the army—Burnside's and Wright's corps—pushed south on Telegraph Road in an effort to overwhelm Ewell. Once again,

Movements toward the North Anna River, May 20–22, 1864

an operation that Grant had begun as an offensive thrust was assuming a decidedly defensive tone.

Riding well ahead of Warren's corps, Grant and Meade set up camp at Guinea Station, near the home of George Motley. Nightfall saw a Union army in disarray. Near Milford Station, Hancock, isolated from the rest of the Union force, sparred with a body of Confederates sent from Richmond to reinforce Lee. On Telegraph Road, Burnside probed south but was brought up short by Ewell's defenses at Stanard's Mill. Turning around, Burnside's men became entangled with Wright's troops in their rear, creating a messy traffic jam. Warren's corps meanwhile followed in Hancock's footsteps, stopping for the night at Guinea Station. Some of the 5th Corps circled back toward Telegraph Road and encamped near Nancy Wright's Corner, within earshot of the critical highway.

Lee still had no clear idea of Grant's intentions, but the signs suggested a Union move south. The next defensive line was the North Anna River, and Lee started that way, sending Ewell and Anderson along Telegraph Road and Hill along other roads to the west. All night, Confederates tramped through Nancy Wright's Corner, passing the sleeping soldiers manning Warren's outposts. Lee, unaware of the Union army's proximity, unwittingly placed his troops in tremendous peril. And Grant, oblivious to the fact that Lee was filing past his recumbent soldiers, let the Confederates go by unhindered. Never had Grant held a more favorable tactical advantage; by launching Warren into Lee's flank, he could have severed the Confederate column and opened the way for Burnside and Wright to maul its rear. This was the chance to catch Lee's army outside of its entrenchments that Grant had been seeking, and it slipped through his fingers. "Never was the want of cavalry more painfully felt," one

A figure drawn on the wall by a Union soldier joins other wartime graffiti in Massaponax Church, including inscriptions calling for "death to the traitors."

Grant and Meade reviewing a map at their temporary headquarters on May 21, 1864, in front of Massaponax Church, while 5th Corps wagons pass by on their way to Guinea Station. From the Library of Congress.

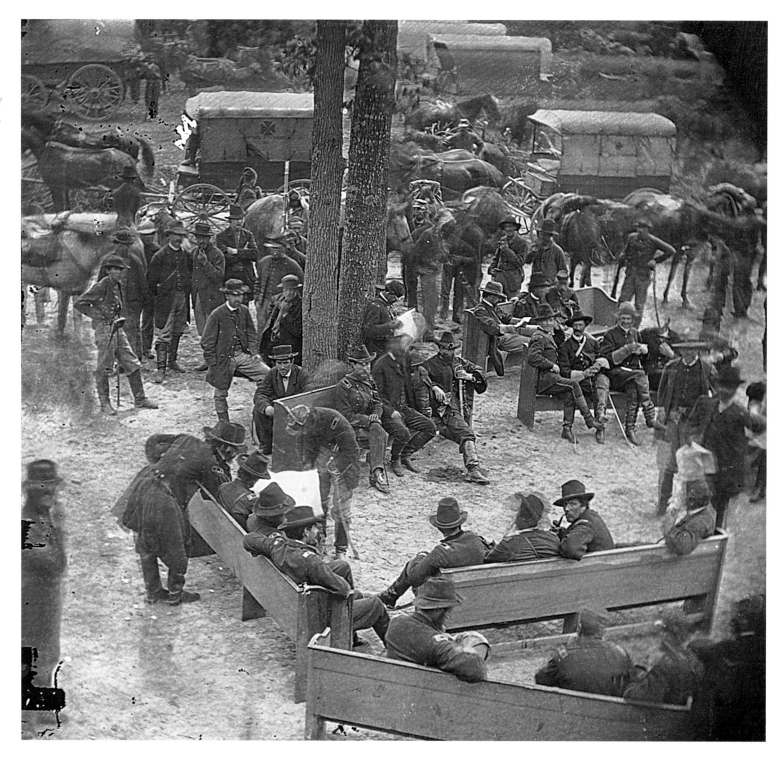

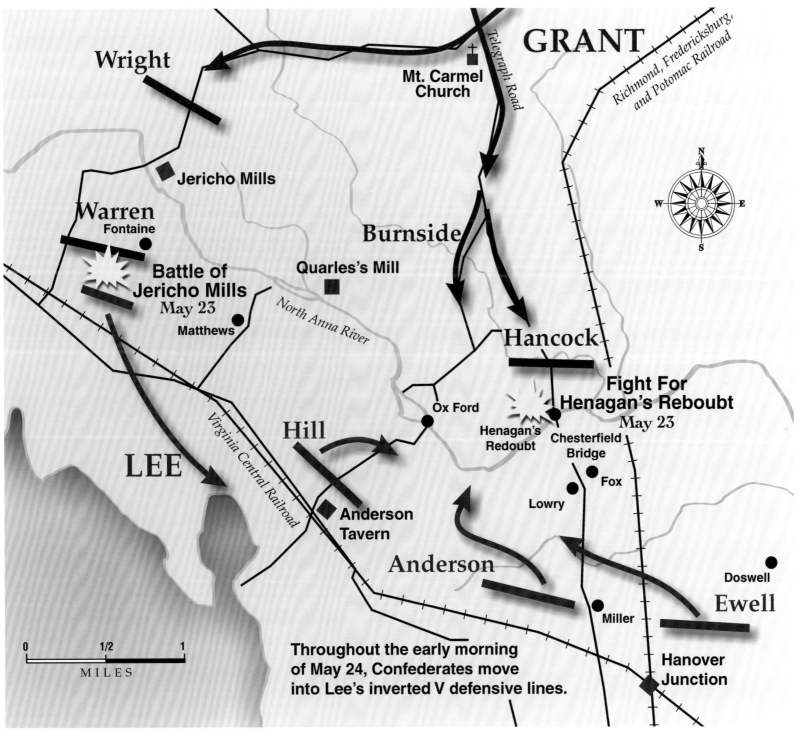

**GRANT**

Mt. Carmel
Church

*Telegraph Road*

*Richmond, Fredericksburg,
and Potomac Railroad*

**Wright**

Jericho Mills

**Burnside**

**Warren**
Fontaine

Quarles's Mill

**Battle of
Jericho Mills**
May 23

Matthews

*North Anna River*

**Hancock**

**Fight For
Henagan's Reboubt**
May 23

Ox Ford

Henagan's
Redoubt

Chesterfield
Bridge

**Hill**

*Virginia Central Railroad*

**LEE**

Anderson
Tavern

**Anderson**

Fox

Lowry

Doswell

**Ewell**

Miller

**Throughout the early morning
of May 24, Confederates move
into Lee's inverted V defensive lines.**

**Hanover
Junction**

0    1/2    1

MILES

of Warren's aides fumed when he learned of the mistake. "Such opportunities are presented once in a campaign and should not be lost."

The Army of Northern Virginia's fagged-out troops crossed the North Anna on May 22 and went into camp a few miles south of the river at Hanover Junction, where the Virginia Central Railroad from the Shenandoah Valley crossed the Richmond, Fredericksburg and Potomac line. Lee's concern was to protect this critical rail link and supply route.

Grant pushed south in Lee's wake. Unable to gather intelligence because Sheridan had not yet returned from his expedition toward Richmond, he felt cautiously ahead, spreading the Army of the Potomac across a band of countryside ranging from Telegraph Road to Milford Station. All day, the Union force edged toward the North Anna, with Warren, Wright, Burnside, and Hancock stretched from west to east along a moving front. That evening, Grant and Meade camped in the Tyler family yard north of Bethel Church. Visiting the Tyler home, Burnside asked Mrs. Tyler whether she had ever seen so many Yankee soldiers. "Not at liberty, sir," she answered, provoking a round of laughter at Burnside's expense.

Ensconced at the house of the Miller family south of the North Anna, Lee remained unsure about Grant's intentions. If the Union army advanced along Telegraph Road, Lee had chosen the right spot to intercept him. But if Grant followed a more easterly route, as Lee suspected he might, the Confederates would have to shift quickly to the east. And so Lee waited for signs of his adversary's plans.

Caroline County's byways sprang alive with blue-clad columns the morning of May 23. Warren pressed south along Telegraph Road, making directly for the North Anna; Wright followed closely behind; several miles east, Hancock abandoned his entrenchments near Milford Station and pursued roads to the southwest, while Burnside brought up the rear. Near noon, the Union army's scattered elements converged at Mount Carmel Church, a handful of miles above the river. Hancock continued south toward the main river crossing at Chesterfield Bridge while Warren took a side road west, intending to cross a few miles upstream at Jericho Mills. Wright was to follow behind Warren, and Burnside was to take another side road to Ox Ford, midway between Warren and Hancock. By day's end, the Army of the Potomac was slated to come together in a line along the river, with some or all of its troops across.

As Hancock's lead elements neared the North Anna, they came under fire from Colonel John Henagan's South Carolina brigade. Ensconced in a three-sided redoubt next to Chesterfield Bridge, Henagan's soldiers were the only Confederate infantrymen north of the river. At 5:30 p.m., Hancock's artillery opened fire and Major General David B. Birney's division launched a spirited charge. "The Confederate pickets fired, then ran to their fortifications, which instantly began to smoke in jets and puffs and curls as an immense pudding," a Federal recounted, "and men in the blue-coated line fell headlong, or backward, or sank into little heaps." Rebel artillery on the southern bank supported Henagan's redoubt in "one of the most savage fires of shell and bullets I had ever experienced," a Union man declared.

Sipping a glass of buttermilk, Lee watched the action from Parson Thomas H. Fox's porch, south of Chesterfield Bridge. When a round shot whizzed within feet of the general and lodged in the door frame, Lee finished his glass, thanked the parson, and rode away.

North of the river, Birney's men closed on Henagan's earthen fort from three directions. Union soldiers mounted the ramparts by climbing onto their comrades' backs and scaling bayonets thrust into the redoubt's face to form ladders. The swarm of Yankees overwhelmed the defenders, capturing many. Other rebels escaped by bolting across Chesterfield Bridge or

La Vista Plantation huddles in a wooded setting on the southern side of Guinea Station Road. On May 21, 1864, the larger part of the Union army tramped past La Vista and other plantations as it evacuated its Spotsylvania Court House line. Troops ransacked houses, destroyed libraries, and stole chickens and livestock. Today La Vista operates as an attractive bed and breakfast.

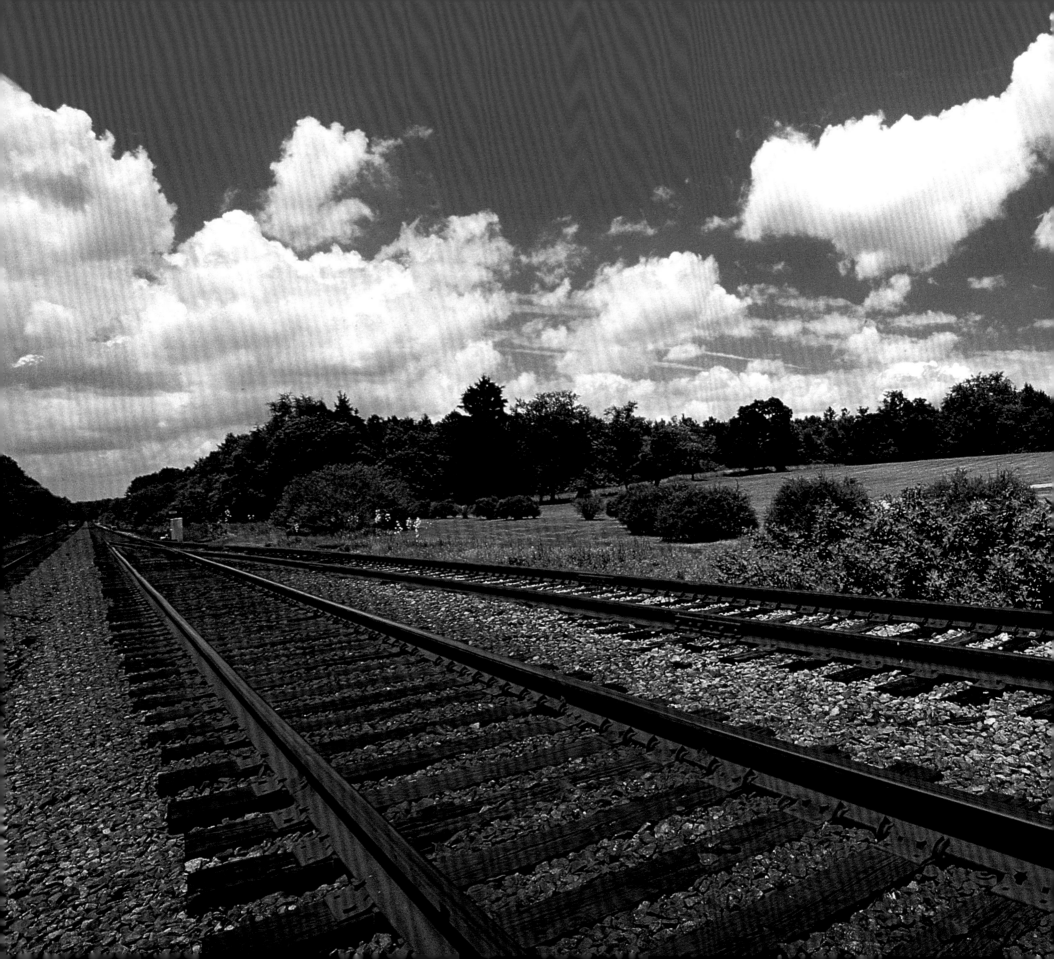

jumping into the river. In short order, the fort and the bridge were in Union hands.

Five miles upstream, Warren's corps, guided by an elderly former slave, dispersed a handful of mounted rebels at Jericho Mills and secured a lodgment on the southern bank. Engineers constructed a pontoon bridge, and by 5:00 p.m., the Union 5th Corps was streaming across and deploying in the neighboring fields. Skirmish fire crackled sporadically, but Warren did not expect trouble. His soldiers lay about carelessly, lighting fires in anticipation of eating. The woods were filled with pigs, brightening the prospects for dinner.

Confederate scouts discovered the interlopers but underestimated their numbers, reporting to Hill that only two Union brigades had crossed. Misled about the size of the Federal force, Hill decided to send a single division under Major General Cadmus Marcellus Wilcox to repel the invaders. As rebel yells echoed across the fields and musketry swelled to a roar, Warren's bummers, cooks, and sundry civilians accompanying the corps darted back toward the river for shelter.

Charging through a swarm of hogs, cattle, and chickens, Wilcox's troops threatened to overwhelm a stand of Union artillery under Colonel Charles S. Wainwright and cut off Warren's avenue of retreat. In the nick of time, Colonel Jacob B. Sweitzer's brigade poured "stunning volleys" into the flank of the rebel assault column, and Wainwright's guns opened. "Grape and canister from the smooth-bores, and conical bolts from the rifles went through the rebel ranks," a Union man reported. "I have seen patent mince-meat cutters with knives turning in all directions, but this double-angled line of fire exceeded them all." Their attack broken, Wilcox's men fell back to the railway.

Uncertain how many Confederates he faced, Warren elected not to press his advantage. Congratulations flowed freely in Union camps; Hancock had secured Chesterfield Bridge and

Guinea Station, on the Richmond, Fredericksburg, and Potomac Railroad, held special significance in two campaigns. Following his wounding at the Battle of Chancellorsville in May 1863, Confederate Lieutenant General Thomas J. "Stonewall" Jackson was brought to the Chandler family's outbuilding, where he died. A little more than a year later, the Army of the Potomac passed through on its way to the North Anna River. Here Grant and Meade watched their headquarters guard wage a spirited little action against Confederate cavalry.

75

BURNSIDE
IX Corps

GRANT
MEADE

WARREN
V Corps

CRAWFORD

Bates
Hardin
Fisher

North Anna River

Matthews

WILLCOX

Hartranft
Humphrey

Long Creek

Byrnes

Chandler

Marshall

Robinson

TYLER

CRITTENDEN

Ledlie

Ox Ford

Chesterfield
Bridge

HANCOCK
II Corps

POTTER

BIRNEY

Harris

Sanders

Weisiger

Lowrance

Lane

Thomas

Brown

Anderson
Tavern

Wright

Perry

Henagan

Humphreys

MAHONE

HILL

WILCOX

Griffin

Curtin

Brewster

Miles

Egan

Lowry

Pierce

Fox

Mott

GIBBON

McIvor

McKeen

Owen

McDougal

BARLOW

Smyth

Brooke

Davis

Walker

Kirkland

Archer

HETH

Corse

Barton

Kemper

Hunton

PICKETT

KERSHAW

ANDERSON

Bryan

Wofford

Bratton

Virginia Central Railroad

Little River

BRECKINRIDGE

Hoffman

Lewis

Toon

Evans York Terry

GORDON

Echols Wharton

FIELD

Gregg

DuBose

Anderson

Law Grimes

Richmond, Fredericksburg and Potomac Railroad

Doswell

Ramseur

Cox

Doles

Hanover
Junction

Battle

LEE

EWELL

**BATTLE OF
NORTH ANNA, VA**
MAY 24, 1864

Confederate        Union

Map by Steven Stanley

0        1/2
MILES

Telegraph Road

The North Anna Campaign, May 24, 1864

Warren had won a handy victory at Jericho Mills. But congratulations were scarce on the Confederate side. "We fell far short of our usual success, and infinitely below the anticipations with which we entered the battle," a southerner observed of the debacle at Jericho Mills. Lee recognized that he was in serious trouble, with a formidable portion of Grant's army on his side of the river threatening his western flank. Was it still possible to defend Hanover Junction, the Confederate commander asked an assemblage of his generals that evening? Was retreat the only recourse?

Meeting under a broad oak with his chief engineer Smith, Lee came up with an ingenious plan. The Army of Northern Virginia would deploy into a wedge-shaped formation, its apex touching the North Anna River at Ox Ford and each leg reaching back to a strong natural position. This massive salient had none of the drawbacks of the salient that had brought Lee to grief at Spotsylvania Court House; the Mule Shoe's blunt apex had fronted an open field, inviting attack, while the tip of the North Anna salient rested on precipitous bluffs and was unassailable. And with the Virginia Central Railroad connecting the two feet of the inverted V, Lee could shift troops from one side of the wedge to the other as needed.

Lee also saw that when the Federals advanced, his wedge would split their force in half. Then he could spring his trap, using a few troops to hold one leg while concentrating his army against the Federals facing the other leg. Lee had cleverly suited the military maxim favoring interior lines to the North Anna's topography and given his smaller army an advantage over his opponent.

All night, Lee's troops threw up earthworks that rivaled their best efforts at Spotsylvania Court House. Hill's 3rd Corps deployed along the ridge from Anderson's Tavern to Ox Ford, forming the rebel wedge's western leg, and Anderson's 1st Corps took up the formation's eastern wing, angling back toward Hanover Junction. Ewell tacked onto the eastern end of Anderson's line and placed the rest of his corps in reserve, where they were joined by a division under Major General John C. Breckinridge, fresh from its victory over Sigel in the Valley. "I was out the entire night," Lee's artillery chief wrote home, "aiding in choosing our line and adjusting positions."

May 24 began hot and muggy. Lee was ill with dysentery but tried to conceal his condition to avoid alarming his subordinates. A doctor noted that the general had not slept two consecutive hours since the Wilderness and was "cross as an old bear." Hill in particular received the brunt of the general's ire. "General Hill, why did you let those people cross here," Lee snapped in questioning his 3rd Corps commander about his dismal performance the previous evening at Jericho Mills. "Why didn't you throw your whole force on them and drive them back as [Thomas J. "Stonewall"] Jackson would have done?" Lee's reproach must have cut deeply, but Hill held his tongue.

To Grant, it seemed that the Confederates were retreating and had left only a small rear guard at Ox Ford. "The general opinion of every prominent officer in the army on the morning of the 24th," a highly placed official recalled, "was that the enemy had fallen back, either to take up a position beyond the South Anna or to go to Richmond." At daylight the entire Union army—the left under Hancock at Chesterfield Bridge, the center under Burnside at Ox Ford, and the right under Warren and Wright at Jericho Mills—made ready to push south.

As the day warmed, Grant and Meade rode to Mount Carmel Church. "If you want a horrible hole for a haunt," a staff officer carped, "just pick out a Virginia Church, at a Virginia crossroads, after the bulk of an army has passed by, on a hot, dusty Virginia day." Aides laid boards across the pews as desks and settled to work. The scene reminded an onlooker of a town hall peopled by men in dusty uniforms. "General Meade is of a

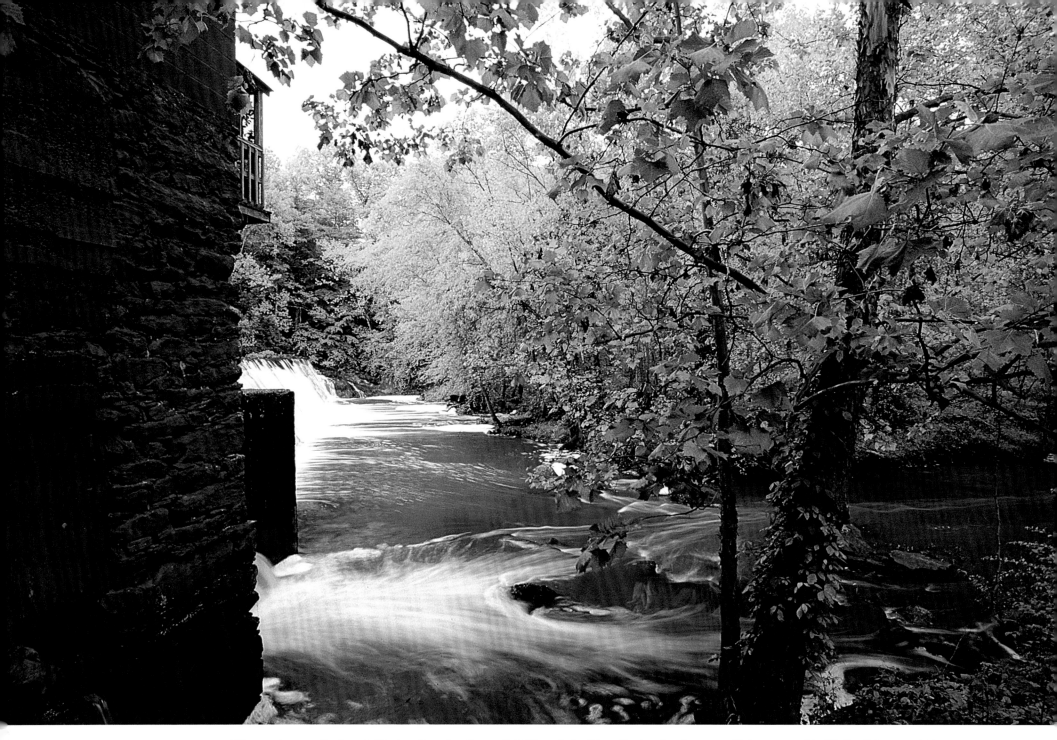

Water rushes past Roxbury Mill, site of wartime Stanard's Mill on the Po River. During the afternoon of May 21, 1864, Ewell's Confederate 2nd Corps took up a strong position along the south bank of the Po above Stanard's Mill, hoping to block Grant's advance along Telegraph Road. Major General Ambrose E. Burnside's 9th Corps tested Ewell's earthworks, deemed them too strong to attack, and doubled back to the Guinea Station Road. The remains of Confederate fortifications can still be found in the woods behind the mill house, which now accommodates visitors.

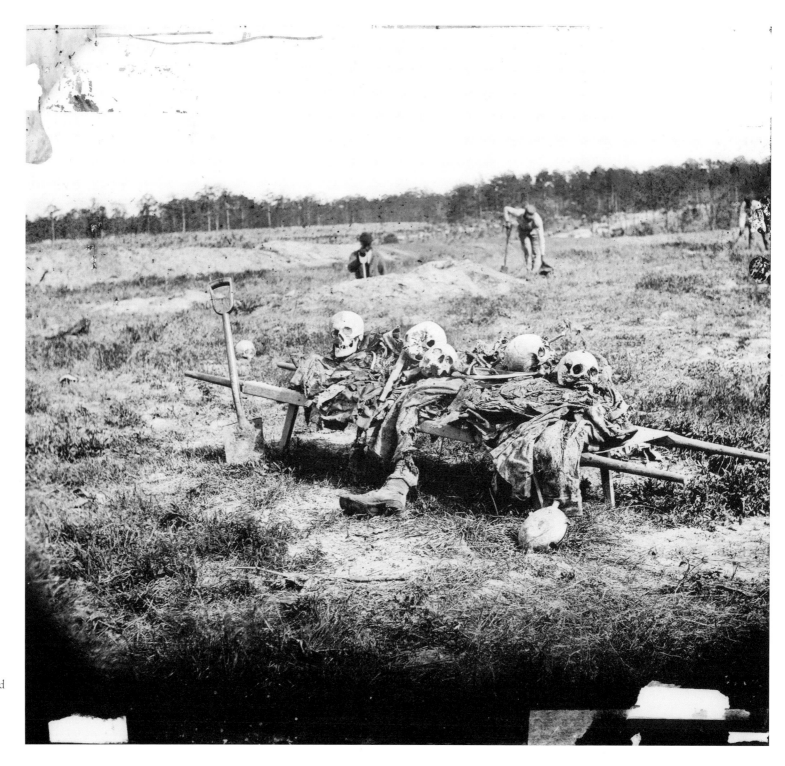

Workers collecting Union dead from the Cold Harbor battle-field after the war. From the Library of Congress.

perverse nature," complained an aide. "When he gets in a dis-
agreeable place, he is apt to stay there."

Encouraged, Grant prepared his morning dispatch to
Washington. "The enemy have fallen back from North Anna,"
he wrote. "We are in pursuit." Meade shot a letter to his wife
with the good tidings. The rebels had been maneuvered from
Spotsylvania Court House, he crowed, "and now [we] have
compelled them to fall back from the North Anna River, which
they tried to hold."

While Union commanders celebrated an apparent victory,
their soldiers met unexpected resistance. Assured by his superiors
that Lee had retired, Hancock started his troops across Chester-
field Bridge, but Confederate artillery contested their advance.
"Though the rebels kept up a constant fire of shot and shell the
crossing was effected without serious loss," a Union man wrote,
"which seemed miraculous, for one fair shot striking the bridge
would have been sufficient to render it impassible." Reaching Par-
son Fox's home, Hancock's Federals waited for the rest of their
companions to cross. "A family library, containing some very
rare and valuable works, was distributed through the corps," a
Yankee reminisced, "and the walls of the house were ornamented
with caricatures of Davis and the rebellion, and embellished
with choice and pithy advice to our 'erring sisters.'" Visiting the
Fox House later that morning, Hancock cut a stirring figure.
"Of magnificent physique, straight as a rail, and well groomed,
a flashing seal ring on one of his fingers, Hancock, then in the
prime of his life, was a fine looking officer," a soldier observed. "I
never wondered after that why they called him 'Superb.'"

A forked twig in the Po River at Roxbury Mill symbolizes Grant's quan-
dary after Ewell blocked his way south. Thwarted in his push along Tele-
graph Road, the Union commander elected to follow a circuitous route
through Guinea Station. Grant's detour enabled Lee to withdraw from
Spotsylvania Court House, take the direct road south, and beat the Union
army to the North Anna River.

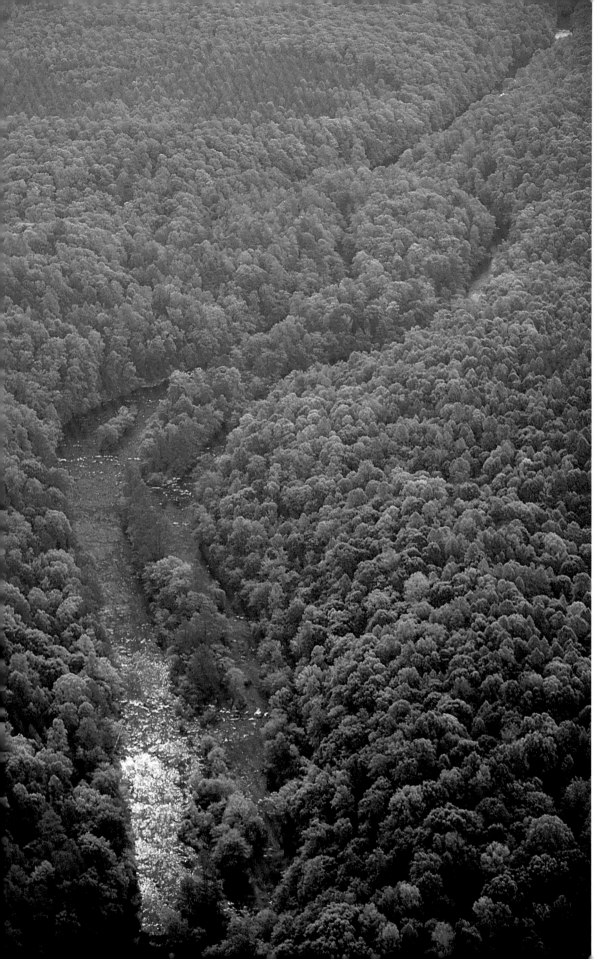

Early in the afternoon, Burnside sent a brigade under Brigadier General James H. Ledlie across the North Anna upriver from Ox Ford with orders to dislodge the rebels holding the heights. Reaching a field, Ledlie paused to assess the situation. The heights made impressive natural fortifications and were topped by earthworks occupied by a veteran rebel division under Brigadier General William Mahone.

A political appointee, Ledlie recognized that breaking the Confederate hold on Ox Ford would advance his career. He was also fond of whiskey, and several witnesses reported him drunk that day. His judgment clouded by ambition and alcohol, Ledlie decided to storm Mahone's works. Sending back for reinforcements, he learned that none were available, and a superior cautioned him not to attack "unless he [saw] a sure thing."

Ignoring the admonition, the besotted Ledlie rode into the field accompanied by an aide twirling a hat on the point of his sword. Two lines of soldiers advanced behind them, and dark clouds heralding rain gathered in the west. "Come on, Yank," rebels lining the works shouted, amazed that anyone would consider charging their stronghold. "Come on to Richmond." As a playful warning, a rebel sharpshooter put a bullet through the aide's hat.

In a drunken euphoria, Ledlie rode on, his men coming behind in orderly lines. Musketry exploded from the earthworks, and the formation lost alignment, dissolved into a blue mob.

The North Anna River courses through Virginia's spring greenery near Jericho Mills. On the afternoon of May 23, 1864, Warren's Union 5th Corps crossed the river here and bivouacked on fields a short distance south. An attack by Major General Cadmus M. Wilcox's division of Hill's Confederate 3rd Corps failed to dislodge the Federals, leaving Lee's army dangerously vulnerable.

*Opposite:* Union engineers preparing the crossing for the Union 5th Corps at Jericho Mills on the afternoon of May 23, 1864. From the Library of Congress.

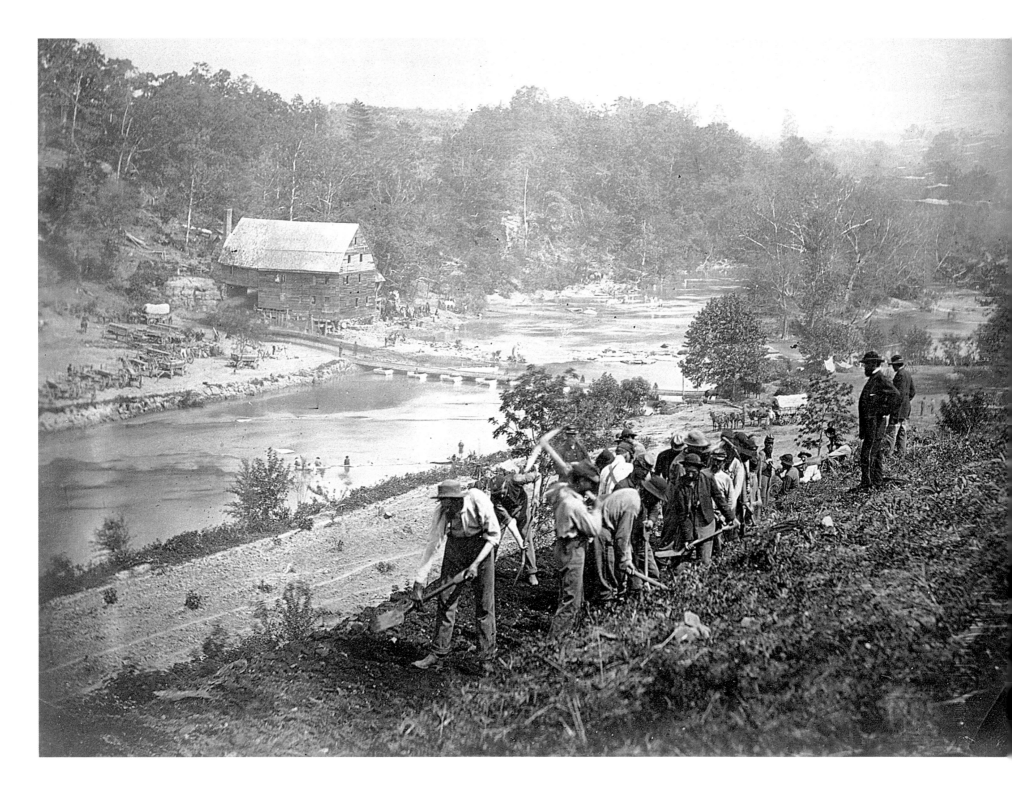

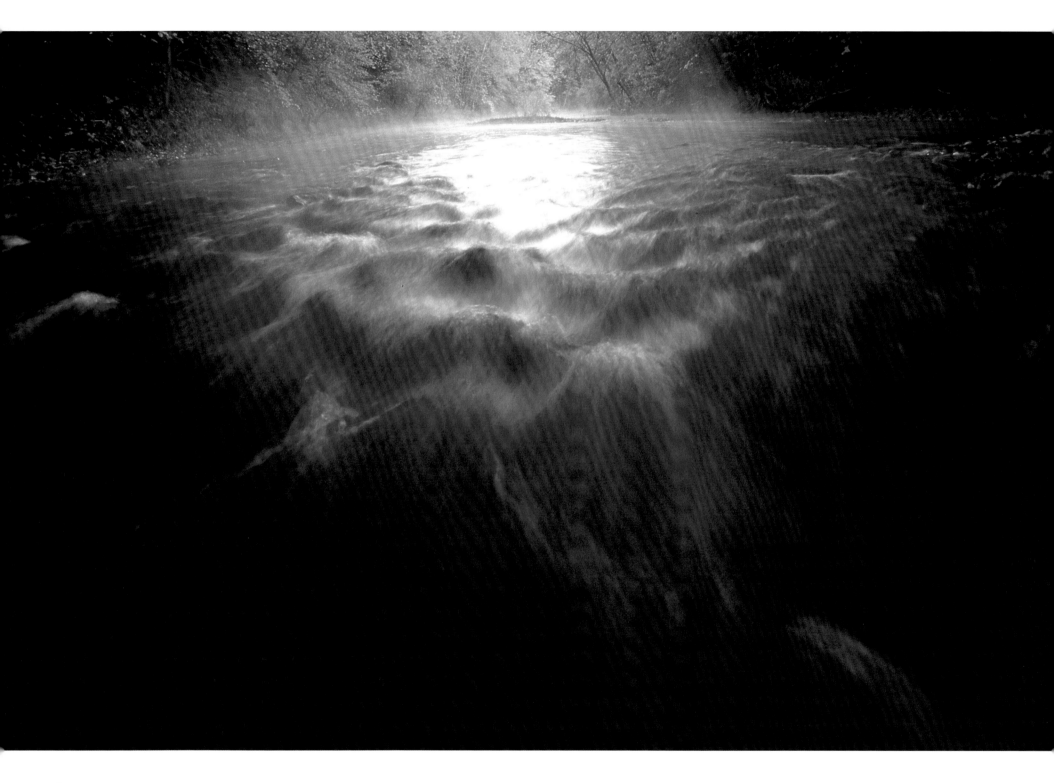

Artillery raked the field, rain fell in sheets, and Ledlie abandoned all pretense of command, leaving his men to their fates. The unequal fight sputtered on until the remnants of Ledlie's brigade were able to pull back to the protection of Warren's corps. "Nothing whatever was accomplished, except a needless slaughter," a Union officer observed, "the humiliation of the defeat of the men, and the complete loss of all confidence in the brigade commander who was wholly responsible." Astoundingly, Ledlie escaped censure and a few weeks later received command of a division, where he caused even greater mischief.

While Ledlie pursued his offensive, Hancock probed south from the Fox House. Driving back a thin line of Confederate pickets, he hit Anderson's strongly entrenched position on the wedge's eastern leg and was brought up short. More Federals marched south along the Richmond, Fredericksburg, and Potomac Railway east of Telegraph Road. Nearing Hanover Junction, they came under heavy fire from Ewell's Confederates and were forced to entrench. Ever optimistic, Hancock informed headquarters that his skirmishers were "pretty hotly engaged" but held onto the fiction that Lee's main body of troops had retreated. Assuming that he faced nothing more than a holding force in rifle pits, he promised to try to break through.

Lee's moment had come. His plan to split the Union army had worked, leaving Hancock isolated east of the Confederate position, Burnside north of the river at Ox Ford, and Warren and Wright several miles to the west, near Jerico Mills. Hill, holding the Confederate formation's western leg, could fend off Warren and Wright while Anderson and Ewell, on the eastern leg, attacked Hancock with superior numbers. "[Lee] now had one of those opportunities that occur but rarely in war," a Union aide later conceded, "but which, in the grasp of a master, make or mar the fortunes of armies and decide the result of campaigns."

The general, however, had become too ill to exploit his opportunity. Wracked with violent intestinal distress and diarrhea, he lay confined to his tent. "We must strike them a blow," a staffer heard Lee exclaim. "We must never let them pass us again. We must strike them a blow."

But the Army of Northern Virginia could not strike a blow. Lee was too ill to direct the complex operation, and his top echelon had been decimated. Anderson was new to his post and had much to learn; Ewell had forfeited Lee's trust at the Mule Shoe and again at Harris Farm; and Hill had exercised poor judgment at Jericho Mills. Jeb Stuart, whom Lee had given elevated command following Stonewall Jackson's mortal wounding at Chancellorsville, was dead. Physically unable to command and lacking a trusted subordinate to direct the army in his stead, Lee saw no choice but to forfeit his hard-won opportunity.

While Lee lay on his cot prostrated by sickness, Hancock made a final lunge. Pressing across the Doswell farm, he came under even stiffer fire than before and bivouacked on the rain-soaked battlefield. Warren's and Wright's soldiers, massed between Jericho Mills and the Virginia Central Railroad, also advanced but ran against Hill's entrenched position and threw up earthworks across from the rebels. "To raise a head above the works involved a great personal risk," a Union soldier remembered, "and as nothing was to be gained by exposure, most of the men wisely took advantage of their cover." Well entrenched, the Confederates considered the afternoon's work little more than a routine set of skirmishes. Nowhere had the Federals seriously threatened their line.

Near nightfall, Grant and Meade rode to the Fontaine house, south of the river. Grant had intended to continue his advance in the morning, but the day's reverses disturbed him. "The situation of the enemy," he wrote, was "different from what I expected." Better, he decided, to feel out the contours of the Confederate positions.

*Opposite:* The North Anna River tumbles across shallow rock ledges at Ox Ford. The narrow river has changed little since Burnside's Union 9th Corps and Hill's Confederate 3rd Corps faced off from opposite banks. Originally a crossing for a wagon road from Richmond to Fredericksburg, the ford stood at the apex of the ingenious wedge-shaped formation used by Lee to stop Grant on May 24, 1864.

Grant also took a long-overdue step toward creating a unified command. "To secure the greatest attainable unanimity in cooperative movements, and greater efficiency in the administration of the army," he announced, "the Ninth Army Corps, Major General A. E. Burnside commanding, is assigned to the Army of the Potomac."

The next morning—May 25—Union infantry probes confirmed that the rebel line commanded killing fields every bit as imposing as those at Spotsylvania Court House. "The conclusion that the enemy had abandoned the region between the North and South Anna, though shared yesterday by every prominent officer here, proves to have been a mistake," a highly placed Federal noted. "The situation," one of Meade's aides observed, was a "deadlock," with the two armies pressed closely together like "two schoolboys trying to stare each other out of countenance." Another Union man remarked that "Lee's position to Grant was similar to that of Meade's to Lee at Gettysburg, with this additional disadvantage here to Grant of a necessity of crossing the river twice to reinforce either wing."

A Union newspaperman observed that the "game of war seldom presents a more effectual checkmate than was here given by Lee." But the Confederate commander was stymied. Ensconced in his earthworks below the river with the Union army pressed

The remains of earthworks built by the Confederate 3rd Corps hug high ground along the left leg of Lee's wedge-shaped formation below the North Anna River. Among the best-preserved field fortifications built by either side during the campaign, these entrenchments are now the centerpiece of Hanover County's Ox Ford Battlefield Park.

*Opposite:* Chesterfield Bridge across the North Anna River, photographed from the south bank, with Henagan's redoubt visible in the distance at the center of the image. From the Library of Congress.

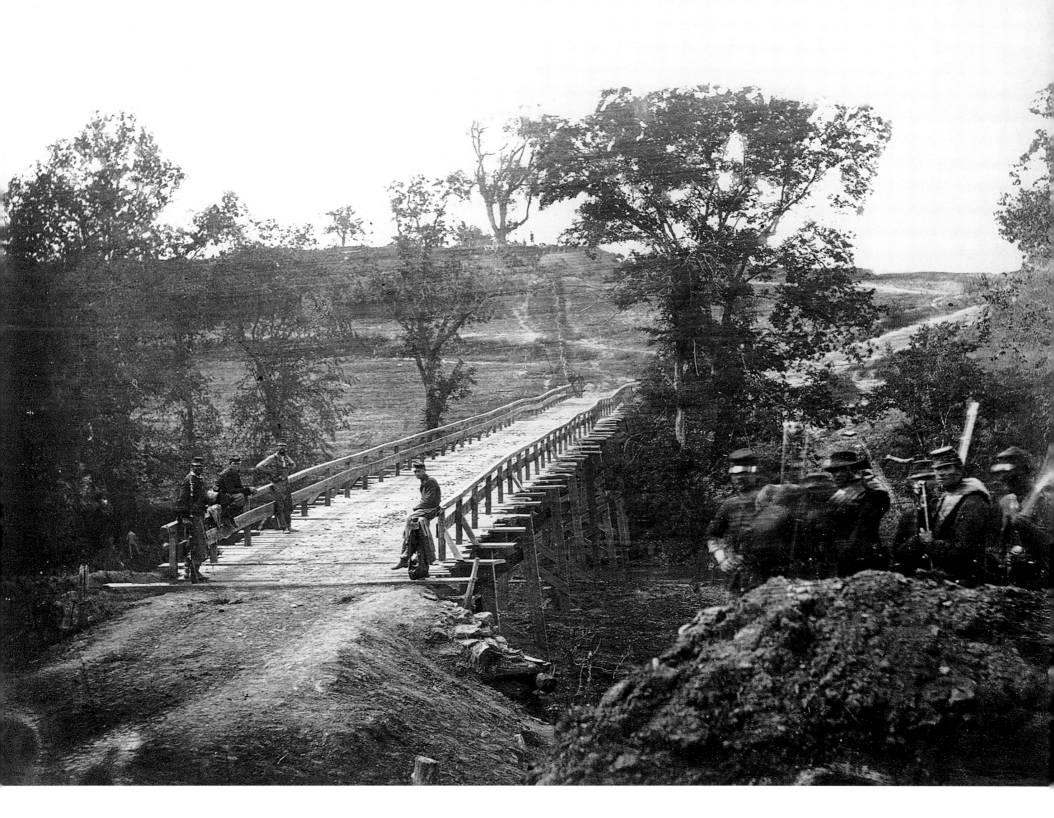

tightly against his formation, the only direction he could turn was south, toward Richmond. Having no other choice, Lee forfeited the initiative to Grant and awaited his enemy's next move.

That evening, Grant and Meade met with their generals to find ways to break the impasse. Some argued that a maneuver west of Lee would catch the rebels off guard. Grant, however, decided that his need to bring in supplies along the tidal rivers required keeping east of Lee. Virginia's geography also recommended an eastern shift. Below the North Anna, the Union army would face three formidable steams—Little River, New Found River, and the South Anna River—each running west to east and only a few miles apart. High-banked and swollen from recent rains, the rivers would afford the retreating Confederates ideal defensive positions. A few miles southeast of Lee's position, however, the rivers merged to form the Pamunkey. By moving east of Lee and sidling downstream along the Pamunkey, Grant would put the bothersome waterways behind him at one stroke. And White House, the highest navigable point on the Pamunkey, was ideally situated as Grant's next supply depot.

Another consideration favored swinging east. As the Federals followed the Pamunkey's southeastward course, they would slant progressively nearer to Richmond. Grant's most likely crossings—the fords near Hanovertown, thirty miles southeast of Ox Ford—were only eighteen miles from Richmond; once the Army of the Potomac was over the Pamunkey, only Totopotomoy Creek and the Chickahominy River would stand between them and the Confederate capital.

Having decided on his next move—withdrawing to the northern bank of the North Anna, driving nearly thirty miles downriver, and crossing the Pamunkey near Hanovertown—Grant penned an optimistic dispatch. The decisive battle of the war, he predicted, would be fought on the outskirts of Richmond, and he had no doubt about the outcome. "Lee's army is really whipped," he assured Washington. "The prisoners we

now take show it, and the actions of his army show it unmistakably. A battle with them outside of entrenchments cannot be had. Our men feel that they have gained the morale over the enemy and attack with confidence. I may be mistaken, but I feel that our success over Lee's army is already insured."

Grant's plan was not without its critics. "Can it be that this is the sum of our lieutenant general's abilities?" an artillerist asked. "Has he no other resources in tactics? Or is it sheer obstinacy? Three times he has tried this move, around Lee's right, and three times been foiled."

By everyone's estimate, the most hazardous phase of the operation would be disengaging from Lee. Not only were the armies pressed tightly together, but they were on the same side of the North Anna, with Grant backed against the stream. As soon as Lee discovered that the Federals were leaving, he was certain to attack, and the consequences could be catastrophic. The worst scenario involved Lee catching the Union force astride the river, unable to defend itself.

Grant's solution was to use his cavalry, recently returned from its expedition south, to mislead Lee about his intentions. On the morning of May 26, Wilson's mounted division was to ride west of the Confederates and create the impression that he was scouting the way for an armywide advance. While Wilson practiced his diversion, Brigadier General David A. Russell's division of Wright's corps was to recross the North Anna and march rapidly east, aiming to secure the Hanovertown crossings. After dark, the rest of the Potomac army was to steal from its entrenchments in a carefully orchestrated sequence. If everything went according to plan, the main Federal body would be streaming across the Pamunkey late on May 27 or early the next day.

May 26 saw more rain, forcing troops to hunker low behind earthworks slippery with mud and knee-deep in water. By noon,

Wilson's cavalry was crossing at Jericho Mills and setting out on its diversion. Reaching Little River west of Lee, Wilson's men put on a conspicuous show, firing artillery and scurrying over the stream on a fallen tree. "To complete the deception," a Union man remembered, "fences, boards, and everything inflammable within our reach were set fire to give the appearance of a vast force, just building its bivouac fires."

Russell's infantry meanwhile recrossed the North Anna and began a looping march toward the Pamunkey. All day, wagons carried the army's baggage over the river and returned for fresh loads. Lee pored over his field commanders' reports, searching for patterns that might reveal Grant's intentions. Sightings of constant wagon traffic persuaded him that the Union commander was planning some sort of movement, and Wilson's cavalry activity suggested that a shift west was in the making. From "present indications," Lee wrote the Confederate War Secretary, Grant "seems to contemplate a movement on our left flank." Wilson's ruse had worked to perfection.

Shortly after dark, Meade began evacuating his entrenchments in earnest, concealing his departure with clouds of pickets. "Such bands as there were had been vigorously playing patriotic music, always soliciting responses from the rebs with Dixie, My Maryland, or other favorites of theirs," a Union man noted. Soldiers marched along rain-soaked trails in the pitch black, slipping in mud "knee deep and sticky as shoemaker's wax on a hot day," a participant recalled. One hole sucked troops in to their waists, and rumor had it that a few unfortunates disappeared over their heads in viscous ooze and suf-

Lightning streaks the sky at Ox Ford, heralding a spring thunderstorm. Under similar weather conditions, Brigadier General James H. Ledlie decided on the afternoon of May 24, 1864, to assail the Confederate entrenchments near Ox Ford with his 9th Corps brigade. Well fortified with liquor, Ledlie set his troops to an impossible task. "Nothing whatever was accomplished, except a needless slaughter," a Union officer concluded of the affair.

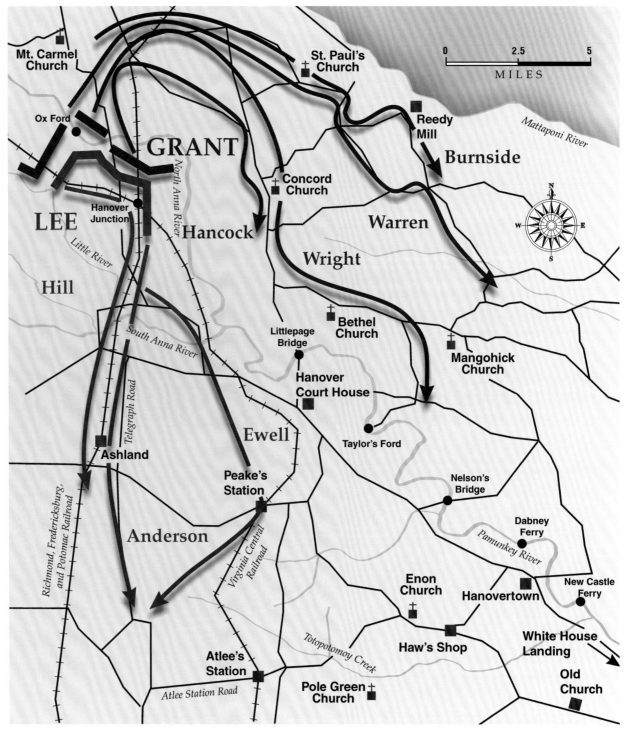

Mt. Carmel
Church

Ox Ford

GRANT

*North Anna River*

LEE

Hanover
Junction

*Little River*

Hill

Hancock

*South Anna River*

Wright

*Telegraph Road*

Ewell

Ashland

*Richmond, Fredericksburg, and Potomac Railroad*

Peake's
Station

Anderson

*Virginia Central Railroad*

Atlee's
Station

*Atlee Station Road*

St. Paul's
Church

Reedy
Mill

*Mattaponi River*

Burnside

Concord
Church

Warren

Bethel
Church

Littlepage
Bridge

Mangohick
Church

Hanover
Court House

Taylor's Ford

Nelson's
Bridge

Dabney
Ferry

*Pamunkey River*

Enon
Church

Hanovertown

New Castle
Ferry

*Totopotomoy Creek*

Haw's Shop

White House
Landing

Pole Green
Church

Old
Church

0    2.5    5
MILES

N

Disengagement from the North Anna River, May 26–27, 1864

focated. Miraculously, the last of the Federals were across the river by daylight. Engineers pulled up the pontoon bridges, and a Union rearguard set fire to Chesterfield Bridge in hope of delaying pursuit.

By sunup, Lee understood that the Federals had gotten away and were marching east. Uncertain of Grant's precise route, the Confederate general decided to abandon the North Anna line and shift fifteen miles southeast to a point near Atlee's Station, on the Virginia Central Railroad. This would place him southwest of Grant's apparent concentration toward Hanovertown and position him to block the likely avenues of Union advance.

In a masterful move, Grant had turned Lee out of his North Anna line in much the same manner as he had maneuvered the Confederate from his strongholds in the Wilderness and at Spotsylvania Court House. Seldom mentioned by historians, Grant's bloodless withdrawal from the North Anna and his shift to Hanovertown rank among the war's most successful maneuvers. But Lee's response was equally cunning, as it enabled him to confront Grant head-on along a new line of his selection, blocking the approaches to Richmond. The chess game between these two masters was about to resume with a vengeance.

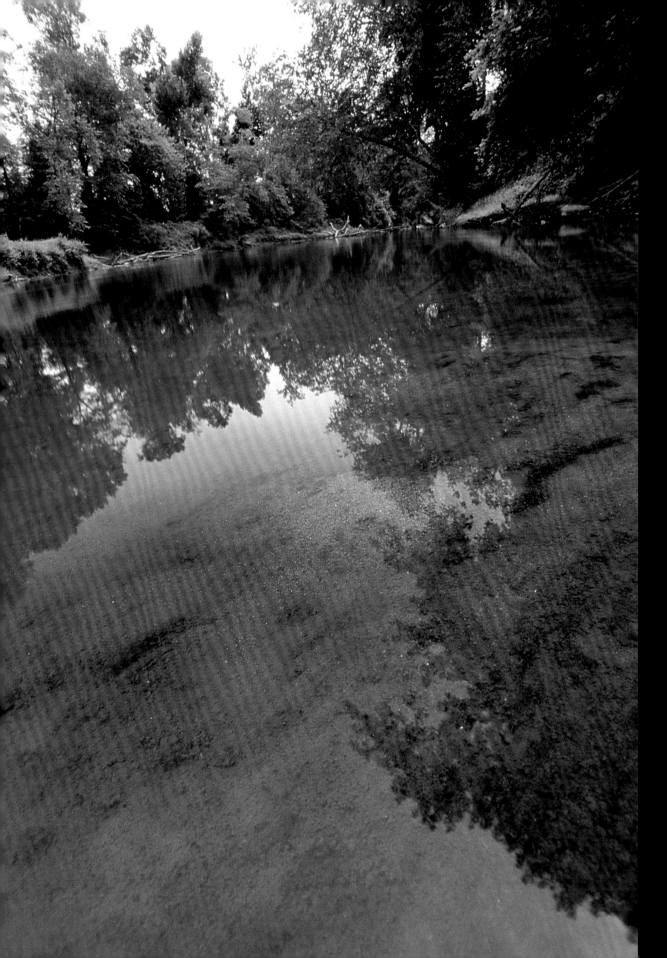

The Pamunkey River runs a gauntlet of trees at the site of Nelson's Bridge. Early on May 28, 1864, Wright's and Hancock's Union corps crossed the river here on pontoon bridges and took up a defensive line on high ground to the south, waiting for information about Lee's whereabouts. "Weather splendid, clear and cool," an observer wrote. "Troops coming up very rapidly, and in great numbers. The whole army will be beyond the Pamunkey by noon."

# 5
# Cold Harbor

Midmorning on May 27, Grant and Meade rode east through dense masses of troops. Infantry and wagons mingled on narrow, muddy roads in a horrific traffic jam. At places, Wright's and Warren's corps, the vanguards of Grant's columns heading toward the Pamunkey, trod side by side, and Hancock's troops marked time, waiting to close up the rear. "It seemed to me inextricable confusion," Warren's artillery chief carped. "We had already suffered all that flesh and blood seemed able to bear, on the road from Spotsylvania to the North Anna," a veteran recalled, "but I am persuaded that if all the regiments were to be summoned—the living and the dead—and notified that all their marches except one must be performed over again, and that they might choose which one should be omitted, the almost unanimous cry would be, 'Deliver us from the accursed march along the Pamunkey!'"

The generals and their staffs stopped for the evening at Mangohick Church. Built from old brick brought from England during colonial times, the prominent landmark was perfectly located for supervising the army's movement over the Pamunkey. The next morning, Wright and Hancock were to cross at Nel-

son's Bridge, and Warren and Burnside were to cross four miles downriver at Dabney Ferry. By afternoon on May 28, if all went as planned, the Union army would be south of the Pamunkey and girding for its next—and possibly last—battle against Lee.

While Union troops settled in for the night, Lee's Confederates completed a fifteen-mile march to Hughes' crossroads. Studying the possible routes that Grant might take, Lee decided to deploy behind Totopotomoy Creek, a slow-moving stream that emptied into the Pamunkey well downriver from Grant's probable crossings. Along much of its course, Totopotomoy Creek created broad, marshy floodplains, rendering it eminently defensible.

Sunrise on Saturday, May 28, revealed two armies in motion, each reaching blindly toward the other. Grant's goal was to put the Pamunkey behind him. An advance force of cavalry and part of Wright's 6th Corps had already secured a bridgehead south of the river, and the rest of the Union host was prepared to cross at Nelson's Bridge and Dabney Ferry. Ten miles away, Lee's troops were heading toward Totopotomoy Creek, where they hoped to halt Grant's progress.

The Union crossing progressed smoothly, but Meade re-

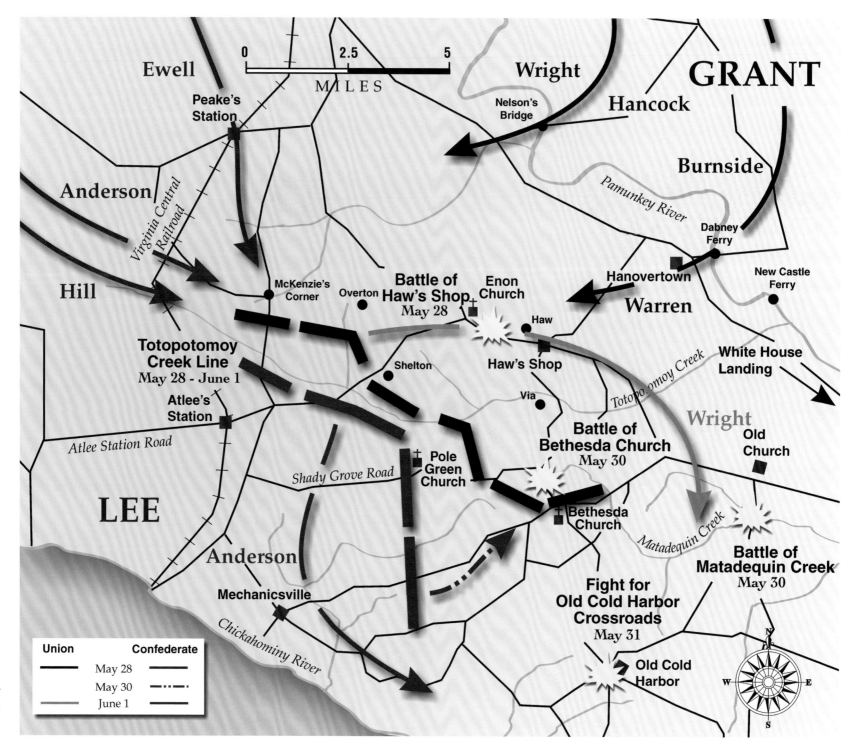

Ewell

Peake's
Station

Wright

Nelson's
Bridge

**GRANT**

Hancock

**Burnside**

*Pamunkey River*

Anderson

*Virginia Central Railroad*

Dabney
Ferry

Hill

McKenzie's
Corner

Overton

**Battle of
Haw's Shop**
May 28

Enon
Church

Hanovertown

New Castle
Ferry

**Warren**

Haw

**Totopotomoy
Creek Line**
May 28 - June 1

Shelton

Haw's Shop

*Totopotomoy Creek*

**White House
Landing**

Atlee's
Station

Via

**Battle of
Bethesda Church**
May 30

*Wright*

Old
Church

*Atlee Station Road*

*Shady Grove Road*

† Pole
Green
Church

**LEE**

Bethesda
Church

*Matadequin Creek*

**Battle of
Matadequin Creek**
May 30

Anderson

**Fight for
Old Cold Harbor
Crossroads**
May 31

Mechanicsville

N

*Chickahominy River*

Old Cold
Harbor

W        E

| Union | Confederate |
|-------|-------------|
| —— May 28 —— | |
| May 30 | |
| June 1 | |

S

0    2.5    5
MILES

Movements to-
ward Cold Har-
bor, May 28–31,
1864

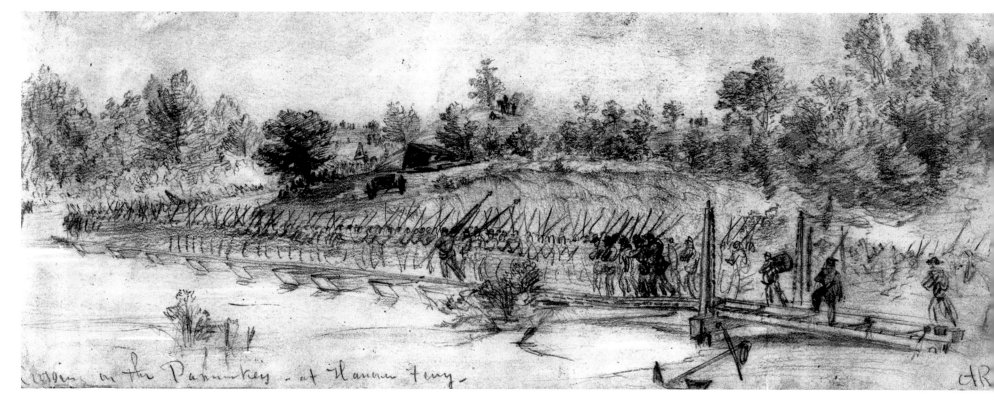

Crossing on the Pamunkey - at Hanover Ferry -

Union troops crossing the Pamunkey at Hanovertown on May 28, 1864. Drawing by Alfred R. Waud, from the Library of Congress.

mained concerned about Lee's whereabouts. Frustrated over the dearth of concrete intelligence, he directed Sheridan to search for the rebels. A cavalry division headed by Brigadier General David McM. Gregg, a heavily bearded Pennsylvanian, began the reconnaissance by shifting south to Haw's Shop, on Atlee Station Road.

Lee, like Grant, needed reliable intelligence, and he also looked to cavalry to get it. While the Army of Northern Virginia shuttled into place along Totopotomoy Creek, its mounted arm reconnoitered west along Atlee Station Road, heading toward Haw's Shop. Fate had placed the opposing cavalry forces on a collision course.

The venture was the Confederate cavalry's first offensive since Stuart's death. Commanding was Major General Wade Hampton, the corps's senior division head and a wealthy South Carolina planter with a natural aptitude for command. Accompanying him was over half of the Confederate cavalry corps and newly arrived reinforcements from South Carolina and Georgia. Carrying muzzle-loading Enfield rifles that were nearly as long as infantry muskets, the newcomers suffered the jibes of Hampton's veterans. "I say," a Virginian announced, "let me have your long shooter and I'll bite off the end."

Riding east, Hampton's foremost elements encountered Federal horsemen near the Haw family farm and drove them back. Gregg pumped more Union troopers into the fray, and battle lines formed. Hampton meant to fight entrenched, inviting the enemy to attack, and his men scooped out shallow pits and stacked tree limbs and fence rails into serviceable breastworks; Gregg's Federal horsemen erected a corresponding line a few hundred yards away.

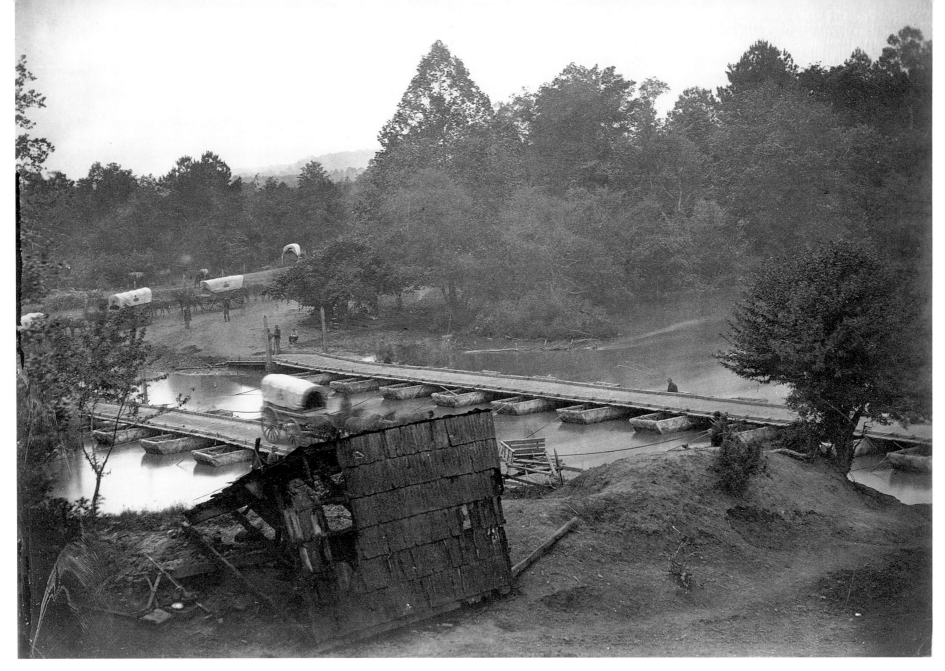

Wartime photograph of the Hanovertown crossing, showing pontoon bridges. From the Library of Congress.

The evolving battle reflected tactical developments that had revolutionized cavalry warfare in the eastern theater. Mounted combat replete with flashing sabers and pistols still had its place, but cavalry had begun acting like infantry, erecting breastworks and fighting dismounted, every fourth man acting as a horse-holder by taking his own horse and three others to the rear. The battle in the Haw family fields resembled an in-

fantry fight more than a traditional cavalry clash.

All morning, Gregg hurled waves of troopers against Hampton's line, feeding a brawl where tactics played no discernible part. Although Union infantry was camped nearby, Sheridan was reluctant to dilute his accomplishments by inviting foot soldiers into the fray. Instead he sent in another cavalry division—Brigadier General Alford T. A. Torbert's outfit—that

Wyoming, wartime home of the widow Henrietta Nelson, gazes over the Pamunkey River's floodplain. Union soldiers using the Nelson's Bridge crossing remarked on the "large, wooden, tumble-down house with a considerable garden and some fine beech trees nearby." Wyoming's current owner, Dorothy Francis Atkinson, is a published authority on local history.

included George Custer's famed Michigan brigade. Near four o'clock—the melee had been raging for six hours—Custer rode into Haw's Shop at the head of his Wolverines. His men cheered loudly, the brigade band struck up "Yankee Doodle," and the golden-haired general gave the order to attack.

Charging forward, Custer's troopers received tremendous fire from the novice rebel units south of the road firing their "Long Tom" Enfields. "The sound of their bullets sweeping the undergrowth was like that of hot flames crackling through dry timber," a northerner recalled. But just as the Wolverines seemed to face extinction at the hands of the low-country marksmen, the Confederate defenses faltered, and Custer's troopers charged into the fleeing Confederates, firing into their backs.

The battle was over by 6:00 p.m., and Hampton's frazzled cavalrymen escaped to the safety of Totopotomoy Creek. Sheridan claimed victory, having driven the rebels from the field. But in important respects, Hampton had come out ahead. He had thwarted Sheridan's objective of locating Lee's army and had captured prisoners from the Union 5th and 6th Corps, confirming Lee's hunch that Grant was across the Pamunkey in force. Perhaps most importantly, he had stood up to Sheridan, giving as good as he took and retreating only when no other choice remained. Since Stuart's death, the Army of Northern Virginia's cavalry corps had needed a general who could give it victories, and Haw's Shop suggested that Hampton might be that man.

Grant's foot soldiers nevertheless saw cause for celebration. Writing home to Wisconsin, an officer proclaimed the march

Spring grain shimmers in the broad field of the Haw family home. During most of May 28, 1864, Confederate cavalry commanded by Major General Wade Hampton clashed here with Major General Philip H. Sheridan's Union horsemen. Late in the afternoon, Brigadier General George Armstrong Custer's Wolverines launched an impetuous charge across these fields that pierced the Confederate line and forced Hampton's troopers back on Confederate infantry supports at Totopotomoy Creek.

*Opposite:* Sluggish, high-banked Totopotomoy Creek meanders through farmland a few miles south of the Pamunkey. During May 28, 1864, Lee positioned his army behind the stream to block Grant's advance on Richmond. The defensive formation was a masterpiece; to attack, the Federals would have had to cross the creek and its swampy lowlands and charge uphill across cleared ground surmounted by entrenched positions.

to the Pamunkey a "glorious achievement" and expressed "admiration and gratitude for the man who has pushed back the rebel army thirty miles without a general battle." An artillerist applauded Grant's objective of destroying Lee's army rather than wasting time trying to take Richmond. "It is the rat we are after," he explained, "not so much the rat hole."

When Grant was leaving the North Anna, he had instructed Benjamin Butler—whose Army of the James was holed up in Bermuda Hundred, southeast of Richmond—to send him Major General William F. "Baldy" Smith's 18th Corps with as many troops as he could spare. Smith's contingent was to travel down the James River on transports, round the peninsula at Fortress Monroe, and then steam up the York and Pamunkey rivers to White House Landing. After the fight at Haw's Shop, Sheridan's cavalry camped near White House to protect the army's new supply depot. Once again, the Union mounted arm was unavailable for offensive operations, leaving Federal infantry to do the job ordinarily assigned to cavalry.

Bereft of Sheridan's horsemen, Meade dispatched a 6th Corps division northwest along River Road, skirting the Pamunkey's southern bank, a 2nd Corps division west along Atlee Station Road, and a 5th Corps division south across Totopotomoy Creek toward Shady Grove Road. The dispersal was a bad idea. Not only did the Federals forfeit their advantage of mass to gather intelligence, but as the three divisions advanced, the roads diverged, leaving each prong vulnerable to attack.

Lee's Totopotomoy Creek defenses, stretching from the stream's headwaters near Atlee Station to Pole Green Church, were a masterpiece. To reach the rebel entrenchments, the Federals had to cross the creek and its swampy lowlands and charge uphill across cleared land and entanglements. Each sector of Confederate line was positioned to support the others, and ample troops stood in reserve.

Rural Plains, home to successive generations of the Shelton family since colonial times, looks today much the same as it did on May 29, 1864, when Hancock's corps commandeered it during the Union advance on Totopotomoy Creek. Reputedly one of Hanover County's oldest dwellings, Rural Plains was built from glazed brick brought from England as ballast in sailing ships. Parts of Hancock's earthworks can still be seen on the property, which overlooks Atlee Station Road's crossing of Totopotomoy Creek. The Shelton house was recently acquired by the National Park Service and will be preserved as a unit of the Richmond National Battlefield Park.

Meade's reconnoitering elements soon discovered the unpleasant truth about Lee's deployments. Francis Barlow, commanding the 2nd Corps's contingent, advanced to where Atlee Station Road crossed Totopotomoy Creek near Colonel Edwin Shelton's home. Confederates—Breckinridge's division—brought them up short. Ordering his men to dig in, Barlow petitioned Hancock for reinforcements. A few miles downstream, Brigadier General Charles Griffin's 5th Corps division crossed Totopotomoy Creek but was stalled near the home of the Via family by Confederate patrols from the Confederate 2nd Corps, now commanded by Major General Jubal A. Early. Visiting the Via yard before dark, Warren studied the distant rebel line through his glasses. A soldier remarked that he had "come to rather dread seeing [Warren] come out to the front, as it seemed to be, usually, a prelude to some desperate work for us." To the north, on River Road, David Russell's 6th Corps division marched to Hanover Court House, where darkness and growing Confederate resistance persuaded the general to camp for the night.

The infantry probes, halting as they were, gave the Union high command a fair picture of Lee's location. The next step was to press the rebel line and find its weak spot. Early in the morning, Hancock was to advance the rest of his corps to the Shelton home and pin Breckinridge in place, locking down the center of the rebel position on Atlee Station Road. At the same time, Wright was to shift the 6th Corps through Hanover Court House and swing south, moving against the rebel army's left flank and linking with Hancock's right. Warren was to push the rest of his corps across the creek with Griffin and test the Confederate right flank on Shady Grove Road. And Burnside was to slip into the gap between Warren and Hancock, slamming into the sector of rebel line south of Atlee Station Road to prevent Lee from reinforcing his beleaguered flanks.

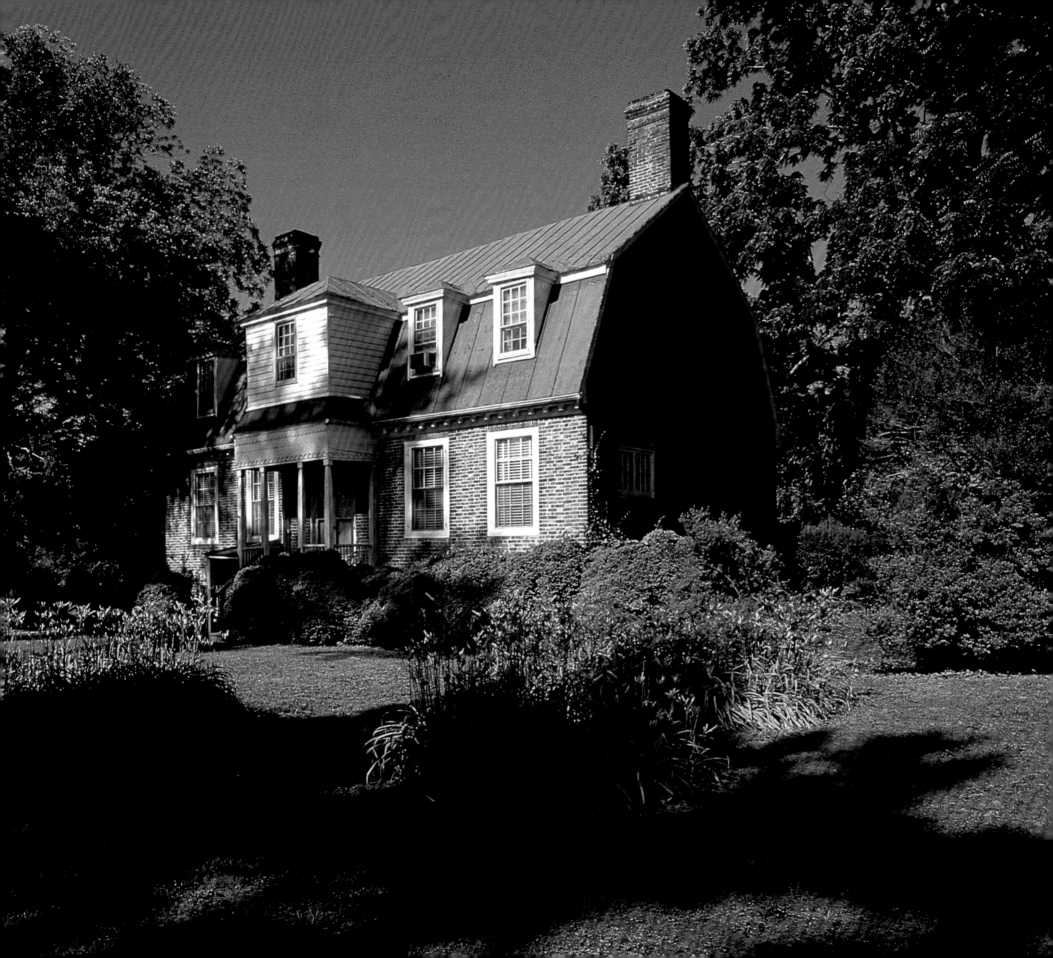

May 30 dawned warm and pleasant. Hancock's corps stood drawn up around the Shelton place, facing Breckinridge's Confederates across the creek. Colonel Shelton's fourteen-year-old son, Walter, could scarcely believe his eyes. "I might have been in Europe for any familiar object I saw," he wrote. "The soldiers had cut down two orchards and built a fortification across the back yard of the house from the Negro graveyard to the road and filled it with guns. All the beautiful palings and arched gates that enclosed the front yard were gone."

Annoyed by Union signal officers on Colonel Shelton's roof, Breckinridge directed his gunners to level the home. "Shells were striking the house, bricks were falling from the chimney," young Walter remembered. "One shell went through a cedar chest of bedding before it exploded." During the bombardment, the Shelton family huddled in the basement, "alternately shrieking and praying," a Union aide recollected. No one was hurt, although one lady suffered so severely from fright that the Federals sent a doctor to tend to her.

Wright, in the battlefield's northern sector, was having an exasperating time. Slowed by Confederate cavalry, his 6th Corps edged south to Totopotomoy Creek and formed a line from McKenzie's Corner to the Overton house, on Hancock's western

An oil slick glistens on Totopotomoy Creek near the Shelton house, where the stream's water once mingled with the blood of heroes. The contamination presents a colorful but jarring reminder of the precarious future of central Virginia's Civil War sites. Crisscrossed by interstate highways and dotted with subdivisions, much of the Old Dominion's hallowed ground has succumbed to "progress."

*Opposite:* The Chickahominy River, shown here near Grapevine Bridge, formed the southern anchor of Lee's defensive position at Cold Harbor. Bracketed by the Chickahominy to the south and Totopotomoy Creek to the north, Lee's line could not be turned, leaving Grant no choice but to attack frontally, or not at all. Concern over fevers associated with these swampy lowlands increased the pressure on Grant to bring matters to a quick conclusion.

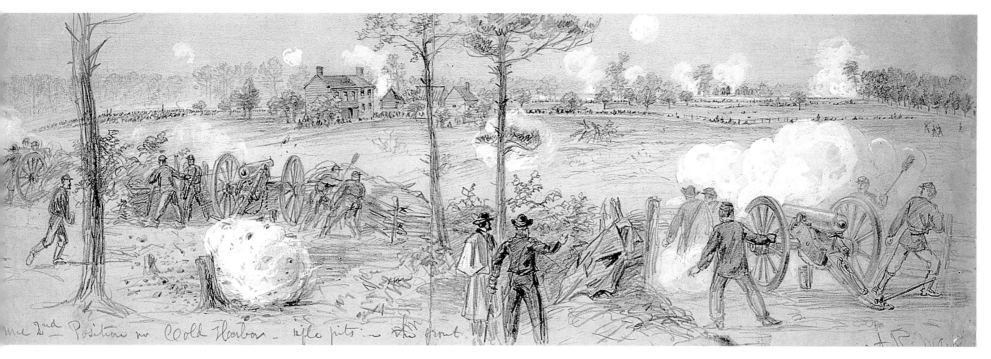

Union line near the Garthright House at Cold Harbor on June 2. From the Library of Congress.

flank. Ordered to attack, Wright's skirmishers pushed through an oak forest, down a bluff, and into swampy low ground bordering Totopotomoy Creek and its tributary Swift Run. Confederate pickets from Hill's Corps contested the movement, and the Federals who made it to the creek saw a chillingly familiar sight on the far side. Visible through the trees was a "high, steep ridge, timber slashed on the slope, and abates immediately in front of the entrenchments." Wright wisely pronounced the rebel position unassailable and cancelled the attack.

The day's main action occurred on Warren's front. Early in the morning, the 5th Corps commander started Griffin's division west along Shady Grove Road, a main thoroughfare paralleling Totopotomoy Creek's southern bank. A companion route, Old Church Road, ran south of Shady Grove Road and was supposedly patrolled by Sheridan's horsemen. Bringing the rest of his corps across Totopotomoy Creek, Warren advanced the troops behind Griffin. Hours of "steady, constant, and heavy"

fighting ensued as Griffin's infantrymen inched toward Early's main fortifications near Pole Green Church.

Lee longed to take the initiative and identified Warren's corps, separated from the rest of the Union army by Totopotomoy Creek, as an inviting target. With Warren now in his front, Early was perfectly situated to mount the attack Lee had in mind. Richard Anderson, on Early's left, was to shift into Early's entrenchments across Shady Grove Road. While Anderson fended off Griffin, Early would slide south onto Old Church Road and march west, maneuvering behind Warren and into a perfect position to maul the isolated Union corps. The Federal high command, firm in its belief that Lee was on the defensive, was in for a terrible surprise.

It just so happened that Warren was also casting an eye toward Old Church Road. Concerned that Sheridan's cavalry was lax in covering his flank, the 5th Corps commander forwarded a brigade of Pennsylvania Reserves to patrol the roadway. Halting

Constructed in the early 1700s, the Garthright house awaits another summer day. Situated west of Old Cold Harbor, the home served as a staging area for Union attacks on June 1 and June 3, 1864. Major General John Gibbon's division advanced across the neighboring fields into the teeth of Confederate firepower that decimated several of his novice regiments. "The air seemed completely filled with screaming, exploding shell and shot of all descriptions, and our soldiers were falling fast," a participant remembered.

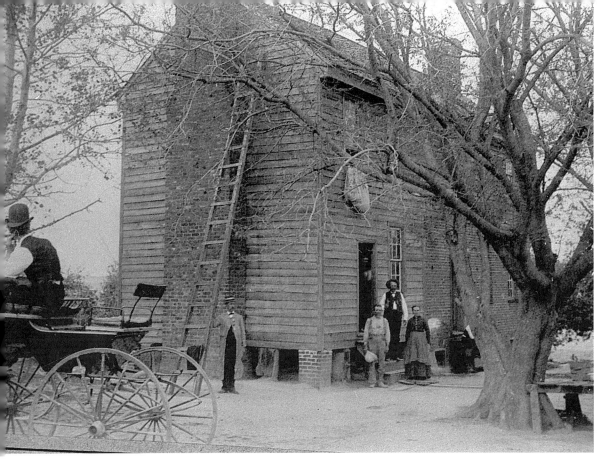

Postwar photograph of the Garthright house. From the Richmond National Battlefield Park.

ascertain his strength." Ramseur chose a veteran brigade of Virginians newly commanded by Colonel Edward Willis, a twenty-three-year-old who had been wounded in the Wilderness but insisted on staying with the army. Willis's troops marched into a slaughter pen of canister that ripped open Willis's abdomen and decimated the brigade. "The ground was strewn with the dead, presenting one of the war's most horrible sights," a Yankee reported. "There were mangled forms, bloody and ghastly; men without heads, heads without bodies, hands wanting arms," recalled another. "There were fragments of human flesh hanging to the lattice fence [of a nearby home], thrown there by cannon shot."

It had been a sad day for the Confederate 2nd Corps. Indirectly, however, Willis's defeat worked to Lee's advantage; the debacle at Bethesda Church further confirmed Grant's impression that Lee's army was dispirited and on the brink of collapse. A few days hence, near a road junction called Old Cold Harbor, the Union chief would discover how wrong his perception had been.

The first of Baldy Smith's reinforcements steamed up to White House Landing around noon on May 30, a few hours before the affair at Bethesda Church. The trip from Bermuda Hundred had taken two days. "We have been crowded together, on this nasty steamer, with nothing fit to drink and little to eat, and a broiling sun over our heads," a New Hampshire soldier complained. Soon White House Landing resembled a bustling port city.

Concerned that Grant might slip Smith past his southern flank and make a dash toward Richmond, Lee dispatched Brigadier General Matthew C. Butler's South Carolina cavalrymen to scout the country below the armies. Some two thousand rebel horsemen passed through the intersection at Old Cold Harbor, only to be brought up short by Federal troopers at Matadequin

west of Bethesda Church, on Old Church Road, the Reserves settled in for what they hoped would be an uneventful assignment. This was their last day of service, and they were uneasy about their exposed position on the 5th Corps's extreme left flank. Their thoughts already turned toward home, the reserves perfunctorily stacked fence rails, dug shallow trenches, and lounged in the shade of a tall hedge.

In midafternoon, Early's troops marched onto Old Church Road and headed directly toward the Pennsylvania Reserves. "The situation was of course an awful one," a Pennsylvanian recalled of the rebels' unexpected appearance. Routed, the Reserves retreated north toward Warren's main force. Alerted to the danger, Warren hurriedly faced his corps toward the Confederates boiling up from Bethesda Church.

Early, anxious to press his advantage, instructed Stephen Ramseur, now commanding a division, to "feel the enemy, and

A prolonged exposure generates the image of a star trail pattern in the night sky above the Cold Harbor battlefield. Photographed near the jumping-off point for the 2nd Connecticut Heavy Artillery, the picture speaks to the plight of wounded soldiers stranded on the battlefield after the failed assaults. Many invalids lay between the lines until the evening of June 7, enduring heat, hunger, and hostile sniper fire. Few came out alive.

Creek, near Old Church. An impetuous charge by Custer and his Wolverines broke Butler's reconnaissance and drove the rebels back to Old Cold Harbor. "The fight was a very unfortunate one," a Confederate officer wrote home, "and nothing was gained by continuing it for so long."

Lee worried that the concentration of Union cavalry toward Old Cold Harbor presaged a shift of Union infantry in that direction. Lacking sufficient troops to both counter Smith and hold the Potomac army at bay, he renewed his pleas to Richmond for reinforcements. With Smith gone, urged Lee,

*Opposite:* Blades of grass at Cold Harbor seem to march in neat ranks, reminiscent of the orderly lines of Federal soldiers that charged across this ground. Here on June 3, 1864, Brigadier General Thomas H. Neill's division of the Union 6th Corps assailed strong earthworks manned by troops from Georgia, Texas, and Arkansas. "The [enemy] came forward in four lines, about fifty yards apart, and thus presented the fairest of targets," a Confederate remembered of the attack.

*Above:* Low earthen mounds are all that remain of Union earthworks at Cold Harbor. Here soldiers of the Union 6th Corps dug an elaborate warren of entrenchments that reminded one observer of prairie dog colonies. "High breastworks were thrown up at all angles with the main line, and deep trenches were dug, in which the men might pass to and from the front without being observed," a Union surgeon recounted. "Not a day passed, even when there was no battle, in which scores of men were not killed or brought to the hospitals with severe wounds."

Sunlight shimmers from water in a swale on the Cold Harbor battlefield. On the morning of June 3, 1864, troops of Major General William F. "Baldy" Smith's 18th Corps charged along this swale in an attempt to overrun earthworks manned by Alabama troops under Brigadier General Evander McIver Law. "It was not war, it was murder," Law later remarked of the slaughter.

Richmond could spare at least a division. Late that evening, the authorities acceded to Lee's demands and dispatched Major General Robert F. Hoke's division, sixty-eight hundred strong, for the Old Cold Harbor front.

Unable to wait, Lee sent a cavalry division under his nephew Fitzhugh Lee to help Butler's frazzled horsemen hold on. During the afternoon on May 31, Sheridan assailed the rebel position. As the fighting warmed, Hoke's vanguard—a North Carolina brigade commanded by Brigadier General Thomas L. Clingman—reached Old Cold Harbor and joined Fitzhugh Lee's troopers. Outflanked by Sheridan's horsemen, the Confederates retreated west to a low ridge.

As night came on, Sheridan called off the pursuit. Weary Union troopers occupied the works at Old Cold Harbor recently evacuated by the rebels, and the Confederates feverishly dug entrenchments a mile away. The rest of Hoke's division arrived during the night and extended the rebel lines.

Confident that his Totopotomoy Creek works were secure, Lee ordered Anderson to slip behind Early and join Hoke in the new line facing Old Cold Harbor. Three weeks earlier, Anderson had inaugurated his tenure as corps commander with a spectacular march that saved Spotsylvania Court House for the Confederates; now Lee was entrusting him with another assignment every bit as important.

Union headquarters was also on high alert. After dark, word arrived from Sheridan that he faced rebel infantry freshly arrived from Richmond. Reports also warned that Anderson was marching to join the burgeoning rebel force. Responding to the threat, Meade instructed Sheridan to hold Old Cold Harbor at all hazards and ordered Wright to join him there. "The cavalry are directed to hold on until your arrival, and it is of the utmost importance you should reach the point as soon after daylight as possible," he urged. Orders also went out to Smith to begin marching, but his destination was erroneously given as New Castle Ferry on the Pamunkey rather than Old Cold Harbor, as Meade had intended.

Early on June 1, Anderson's foremost elements reached the northern end of Hoke's entrenched line and turned east. Leading was a South Carolina brigade commanded by Colonel Laurence M. Keitt, an ardent secessionist recently arrived from the Palmetto State with no experience in warfare Virginia

108

IN THE FOOTSTEPS OF GRANT AND LEE

style. Nearing Beulah Church, Keitt's column came under fire from Sheridan's troopers entrenched around Old Cold Harbor. Charging at the head of the novice 20th South Carolina, Keitt fell, mortally wounded. The attack was broken, and Keitt's frightened soldiers, according to a witness, "actually groveled upon the ground and attempted to burrow under each other in holes and depressions." Repulsed, Anderson's men entrenched next to Hoke, extending the rebel line northward.

Shortly after the fighting quieted, the men of Wright's corps marched into Old Cold Harbor. "Never were reinforcements more cordially welcomed," one of Sheridan's horsemen reminisced. "The tension was relaxed and for the first time since midnight the cavalrymen drew a long breath." Headquarters meantime corrected its order to Smith and instructed him to rush to Old Cold Harbor and join Wright.

By late afternoon, battle lines near Old Cold Harbor had taken shape. The Confederate earthworks ran north to south a mile west of the road junction. Hoke's division covered the sector along Cold Harbor Road, its right anchored on a tributary to Boatswain's Creek and its left resting on the lip of a heavily wooded ravine later dubbed Bloody Run. Anderson's corps extended north from Hoke, with Brigadier General Joseph B. Kershaw's division touching the ravine's northern edge. The Federals deployed in a line parallel to the rebels along high ground half a mile east. Wright's division comprised the southern Union wing, facing Hoke, and Smith's corps made up the northern Union wing, facing Kershaw.

Pockmarked by Union bullets and artillery projectiles, the Allison house chimney reaches skyward on private land west of Old Cold Harbor. It was from this location that Colonel Laurence Keitt, an ardent secessionist from South Carolina, launched an ill-fated attack against Sheridan's entrenched cavalry. Shot through the liver and in severe pain, Keitt was initially taken back to the Allison house, then moved to the Barrick house near Walnut Grove Church, where he died the next morning.

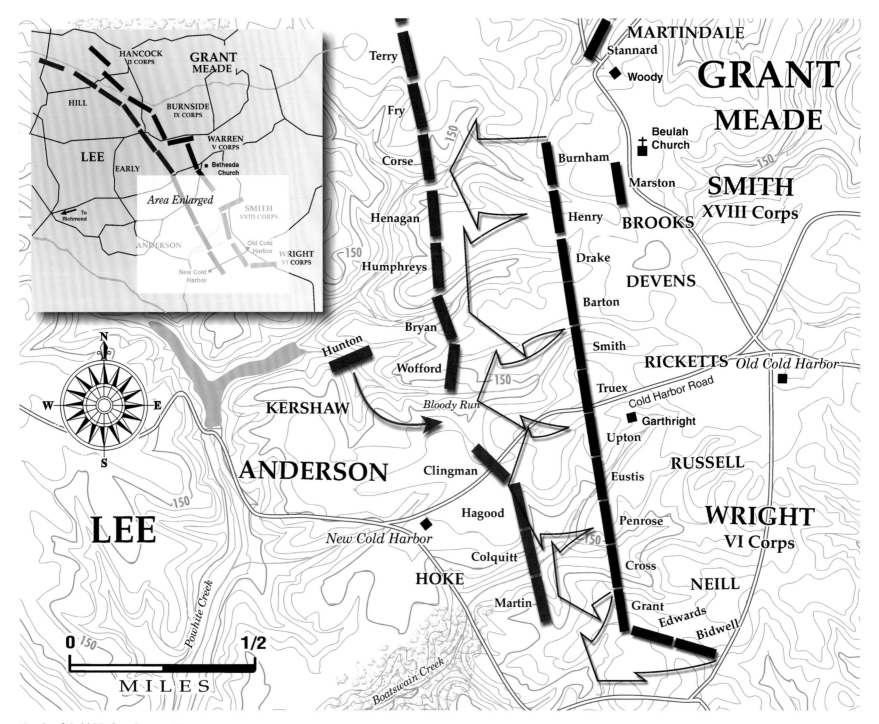

Battle of Cold Harbor, June 1, 1864

Hoke initially plugged the ravine between his and Kershaw's divisions with Brigadier General Johnson Hagood's South Carolina brigade. But as more Union troops arrived, Hoke shifted Hagood south to extend his defensive line. Now unprotected, the ravine provided the Federals with a sheltered pathway leading directly into the heart of the Confederate position.

At 6:00 p.m., Wright and Smith attacked. Immediately north of Cold Harbor Road, Upton's brigade, the newly arrived 2nd Connecticut Heavy Artillery leading, marched into the teeth of Hoke's entrenchments. "A sheet of flame, sudden as lightning, red as blood, and so near that it seemed to singe the men's faces, burst along the rebel breastwork," a Connecticut man recalled. "The rebel fire was very effective and it seemed to us from where we stood that our poor fellows would all get shot," an observer seconded. "Some would fall forward as if they had caught their feet and tripped and fell. Others would throw up their arms and fall backward. Others would stagger about a few paces before they dropped."

Upton's attack faltered, but to the north, troops from Brigadier General James B. Ricketts's 6th Corps division descended into the undefended ravine, pierced the center of the rebel line, and turned north and south to plow into Hoke's and Kershaw's vulnerable flanks. Confederates from North Carolina and Georgia managed to contain the rupture in Hoke's sector, but Kershaw's portion of line gave way, and Smith pushed troops forward to exploit the rupture. Hard-pressed, the rebels were

The fields between the Allison house and Daniel Woody's former home bear no signs of the bloodshed that occurred here during the Cold Harbor combat. Positioned near the northern end of the 18th Corps's line, Brigadier General William T. H. Brooks's division charged across these fields on June 1 only to be beaten back by Brigadier General Joseph B. Kershaw's Confederates entrenched near the Allison house. Two days later, Kershaw's men administered an even bloodier repulse to the troops of Brigadier General John H. Martindale's division.

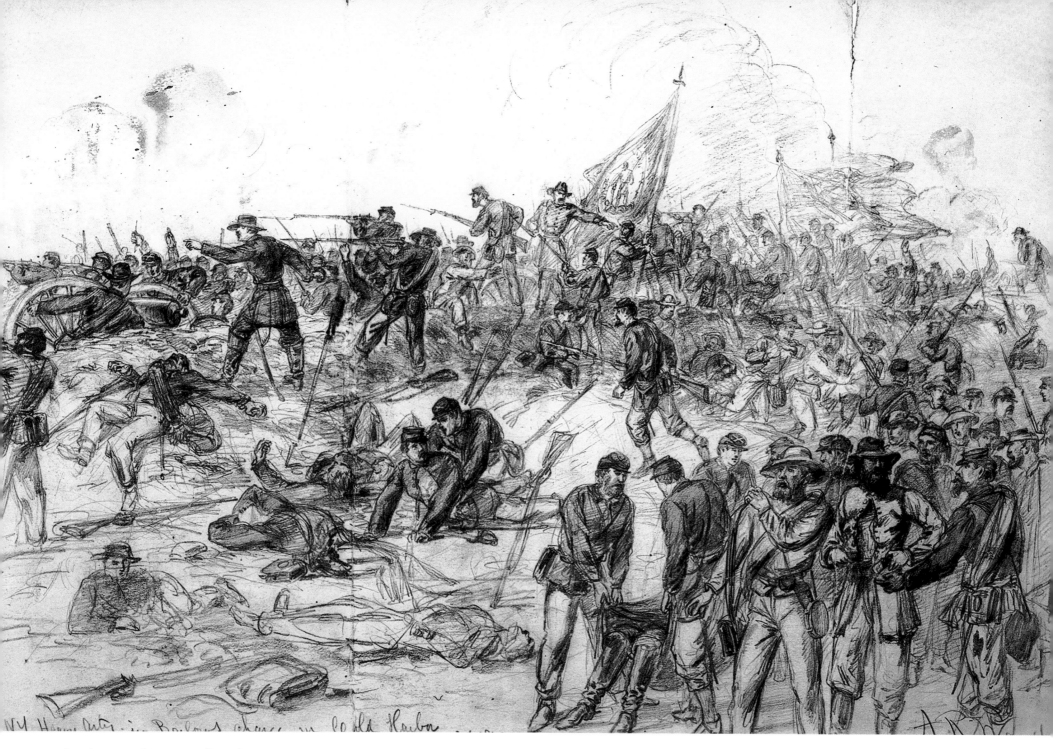

The 7th New York Heavy Artillery of Barlow's division piercing a portion of the Confederate line at the McGhee farm on June 3, 1864. From the Library of Congress.

saved by nightfall and the aggressive use of ordnance, which reminded one dispirited Yankee of "an enormous corn popper over Inferno itself."

Musketry at close quarters continued all night. In places, the battle lines stood only a few yards apart, and wounded men could be heard, "some cursing, some praying, some calling for water, while others cried for help, all mingled in one continuous howl," a soldier recalled.

Wright's and Smith's attack had fallen short, but the Union leaders were encouraged. They had breached the rebel fortifications, and if reinforcements had been available to exploit the breakthrough, Lee's southern wing would have been smashed. Determined to renew the offensive the next morning, Grant and Meade ordered Hancock to withdraw from Totopotomoy Creek, swing behind the Union force, and deploy to the south of Wright, extending the Federal line to the Chickahominy River for a massive attack against Hoke's and Anderson's wing of the rebel army.

The Army of the Potomac's night marches always seemed to go awry. Hancock was on the move by 8:00 p.m., but a guide led the troops on an ill-advised shortcut, and the exhausted soldiers were finally forced to turn around and double back, becoming hopelessly mixed up. The head of the corps straggled into Old Cold Harbor around 6:00 a.m. on June 2, trailed by miles of stragglers. Grant postponed the assault until five in the afternoon, then put it off again until the next morning.

June 2 was a day of missed opportunity for the Federals. Alerted to Hancock's withdrawal, Lee countered by pulling Breckinridge and Hill from the northern end of his line and sending them south, mirroring Hancock's maneuver. For most of the day, Lee's southern flank was vulnerable to attack, but the idea of a turning movement seems simply never to have occurred to the Union brass. By midafternoon, Breckinridge's soldiers,

supported by some of Hill's troops, arrived on Hoke's right, facing Hancock's new deployment and shoring up the vulnerable rebel flank. The Army of the Potomac got a chance to rest, and Lee's men got twelve more hours to perfect their earthworks. The delay proved fatal to Union fortunes on the Cold Harbor front.

Grant remained firm in his determination to attack. As he saw it, relentless pounding in the Wilderness and at Spotsylvania Court House had severely weakened the rebel force. Subsequent events had only strengthened his perception that the rebel army was on its last legs. After all, he had escaped Lee's trap at the North Anna, crossed the Pamunkey unopposed, repulsed Confederate cavalry at Haw's Shop and Matadequin Creek, and seized the critical intersection at Old Cold Harbor, repelling rebel attacks there and at Bethesda Church. Wright's and Smith's near victory the evening of June 1 seemed to confirm that Lee's army was ripe for plucking.

Grant also viewed the tactical situation at Cold Harbor as favoring an attack. Recently reinforced by the 18th Corps and by fresh recruits from Washington, the Union army was stronger than ever. Lee now stood a mere seven miles from Richmond, backed against the Chickahominy River. Delay, Grant decided, would serve no purpose, and further maneuvering would be difficult and uncertain of outcome. A successful assault at this juncture stood to wreck the Confederate army, capture Richmond, and bring the war to a speedy conclusion.

Politics also figured in Grant's calculus. The Republican convention was set to nominate its candidate for president. What better gift could Grant offer President Lincoln than the destruction of the chief Confederate army and the fall of the rebel capital? Aggressive by nature and accustomed to taking risks, Grant seized the opportunity. If the offensive worked, the rewards would be tremendous; if it failed, Grant would treat the reverse as he had his earlier disappointments and try another

tack. In short, the consequences of not assaulting—forfeiting the chance for quick victory and prolonging the war—seemed worse than attacking and failing. Different generals might have reached different conclusions in light of the information at hand, but a compelling logic drove Grant's decision to push the offensive.

Although attacking at Cold Harbor had much to recommend it, Grant's decision to initiate an armywide charge against Lee's entrenched line later provoked legitimate criticism. The Confederate earthworks extended more than six miles, making an assault difficult to coordinate and dissipating the Union army's advantage of mass. Grant left the details of the assault to Meade, and the army commander, still smarting over his diminished status, expressed his pique by doing little. The record reveals no steps to reconnoiter the ground, coordinate the army's elements, or tend to the things that diligent generals ordinarily do before sending soldiers against fortified positions. June 3 would underscore the consequences of leaving operational details of a major offensive to a general with no heart for the assignment.

Rain picked up after dark. Trenches filled with water, and cooking fires sputtered. Meade simply announced the time for the attack—4:30 a.m. on June 3—and left his corps commanders to cooperate. Concerted action, however, was not in the cards. A gap of over a mile separated the southern wing of the Union army—Hancock's, Wright's, and Smith's corps—from the remaining two corps under Warren and Burnside, now clustered near Bethesda Church. Smith had arrived only two days before and was regarded as an interloper by Meade and his corps heads; Wright had precious little experience in major operations; and Hancock still suffered from his Gettysburg wound. The Army of the Potomac was a dysfunctional family, and neither Meade nor Grant seemed willing or able to do anything about it.

Mist swirled near daylight on June 3, obscuring objects more than a few yards ahead. The scene was chillingly familiar to Hancock's veterans on the southern end of the Union line. Three weeks before, on a foggy, rain-drenched morning very much like this one, they had lined up to charge Lee's Mule Shoe at Spotsylvania Court House. Now their superiors wanted them to repeat that performance. "I must confess that order was not received with much hilarity," a Union man related.

At the sound of a signal gun, Hancock's soldiers lunged toward the rebel fortifications. "A simple brute rush in open day on strong works," a participant described the attack. Barlow's troops managed to overrun a small salient in Breckinridge's line, but Hill's reserves drove them out, forcing them to seek shelter in a hollow where artillery fire whined over their heads "much as a charge of fine shot goes among a flock of blackbirds," a Union survivor wrote. Immediately north of Barlow, Major General John Gibbon's division crossed a broad field under rebel artillery fire that "mowed down our lines as wheat falls before the reaper," a northerner recounted. It was "terrible," a Yankee related, "to see our brave boys falling so rapidly and without a chance of success." Another Federal recalled how the "air seemed completely filled with screaming, exploding shell and shot of all descriptions, and our soldiers were falling fast." Unable to advance or retreat, Gibbon's troops scooped out makeshift entrenchments with their canteens. "It could not be called a battle," confessed a New Yorker. "It was simply a butchery, lasting only ten minutes."

North of Cold Harbor Road, Wright's soldiers had held the same ground for two days and knew exactly what they faced. Most advanced a short distance toward the rebels and set to constructing a new line of fortifications. Rebel officers in this sector never realized that an offensive had been attempted. "It may sound incredible," Brigadier General Hagood later reminisced, "but it is nevertheless strictly true, that the writer of

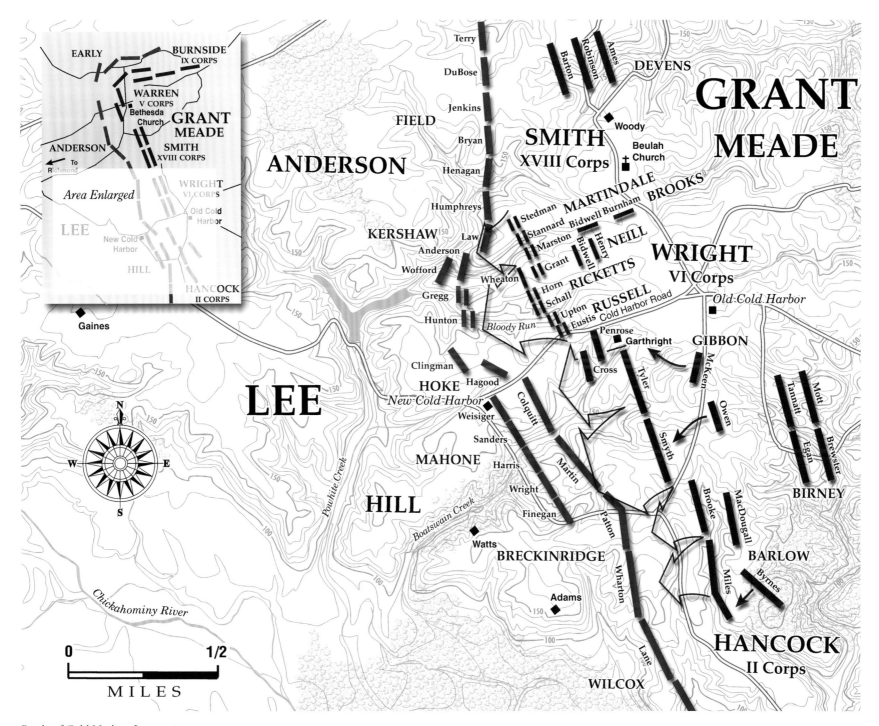

Battle of Cold Harbor, June 3, 1864

Inset map labels:
EARLY
BURNSIDE IX CORPS
WARREN V CORPS
Bethesda Church
GRANT MEADE
ANDERSON
To Richmond
SMITH XVIII CORPS
WRIGHT VI CORPS
Old Cold Harbor
LEE
New Cold Harbor
HILL
HANCOCK II CORPS
Area Enlarged
Gaines

Main map labels:
Terry
DuBose
Jenkins
Bryan
Henagan
Humphreys
ANDERSON
FIELD
KERSHAW
Anderson
Wofford
Gregg
Hunton
Law
Wheaton
Bloody Run
Clingman
Hagood
HOKE
New Cold Harbor
Weisiger
Sanders
Harris
Wright
Finegan
MAHONE
HILL
LEE
Po100chite Creek
Boatswain Creek
Watts
BRECKINRIDGE
Adams
Colquitt
Martin
Patton
Wharton
Lane
WILCOX
Chickahominy River

Barton
Robinson
Ames
DEVENS
Woody
SMITH XVIII Corps
Beulah Church
GRANT MEADE
MARTINDALE
BROOKS
Stedman
Stannard
Marston
Bidwell Burnham
Grant
Henry Bidwell
NEILL
Horn
Schall
RICKETTS
Upton
Eustis
RUSSELL
Cold Harbor Road
WRIGHT VI Corps
Penrose
Garthright
Old Cold Harbor
Cross
Tyler
GIBBON
McKeen
Smyth
Owen
Brooke
MacDougall
Miles
Byrnes
BARLOW
Tannatt
Mott
Egan
Brewster
BIRNEY
HANCOCK II Corps

N
W E
S

0    1/2
MILES

COLD HARBOR                                                                                    115

these Memoirs, situated near the center of the line along which this murderous repulse was given, and awake and vigilant of the progress of events, was not aware at the time of any serious assault having been given."

Not so on Baldy Smith's front. Determined to break through the rebel works, Smith arrayed a portion of his corps in two compact columns and hurled them forward like spears. Aiming at a ravine that penetrated the rebel position, Smith hoped to repeat his success of June 1. Little did he know that the rebels had turned the ravine into a killing ground lined with riflemen and artillery.

Smith's troops marched into a storm of lead. "Men bent down as they went forward, as if trying, as they were, to breast a tempest," a New Englander remembered. "The files of men went down like rows of blocks or bricks pushed over by striking against each other." A colonel from Alabama watched the carnage. "The charging column," he later wrote, "received the most destructive fire I ever saw. They were subjected to a front and flank fire from infantry, at short range, while my piece of artillery poured double charges of canister into them. I could see the dust fog out of a man's clothing in two or three places at once where as many balls would strike him at the same moment." It seemed to one frightened Union soldier hunkering low against the ground that "all the powers of earth and hell [were] concentrated in the endeavor to sweep away every vestige of the Federal army."

Meade urged his generals to renew the offensive, but none was willing to advance without support from the others. Finally the frustrated army commander directed Wright and Smith to attack independently, to no avail. Efforts were also made to get Burnside and Warren into the fray, but coordination seemed impossible, and everyone had excuses. "After the failure [of the initial attacks]," an artillery officer wrote home, "there was still a more absurd order issued, for each commander to attack with-

*Opposite:* A sunset bathes the McGhee farm in a blood-red hue. Here on June 3, 1864, Brigadier General Francis C. Barlow's Union division broke through a salient in the Confederate line held by Major General John C. Breckinridge's Virginians. Reserves from Maryland and Florida quickly expelled the Federals, who sought cover against the face of a ridge. "Fought like hell and got licked like damnation," was a New Yorker's verdict on the attack.

out reference to its neighbors, as they saw fit, an order which looked as if the commander, whoever he is, had either lost his head entirely, or wanted to shift responsibility off his own shoulders."

Shortly before noon, Grant visited the battlefield. "Hancock gave the opinion that in his front the enemy was too strong to make any further assault promise success," he wrote. "Wright thought he could gain the lines of the enemy, but it would require the cooperation of Hancock's and Smith's corps. Smith thought a lodgment possible, but was not sanguine; Burnside thought something could be done on his front, but Warren differed." Exasperated, Grant ended the offensive and instructed the troops to hold their advanced positions, reconnoiter their fronts, and push out by "regular approaches" where feasible.

The big offensive had been a disaster. Hancock, reputedly the best Union field commander, had put in a dismal performance; Wright had never ventured anything resembling an attack; and Baldy Smith's charging columns had presented the rebels with tightly massed targets that Confederate gunners had slaughtered with ease. Stories that proliferated after the battle, of fields littered with blue-clad corpses, convey distorted pictures of what really happened. A few sectors saw tremendous slaughter, but along much of the battle line, Union losses were minor. Later writers suggested Union casualties ranging from 7,500 to well above 12,000, all supposedly incurred during a few terrible minutes after dawn. In fact, the grand charge of the Union 2nd, 6th, and 18th Corps generated perhaps 3,500 Union casualties, with another 3,000-odd casualties occurring during the rest of the day on all fronts. Confederate losses were disproportionately smaller, with about 700 rebels killed and wounded during the early morning attack and double that number throughout the entire day.

Over the years, Union participants condemned the spasmodic cluster of disconnected charges early on June 3 that passed for a grand offensive. The operation, an aide noted, "would have shamed a cadet at his first year at West Point." Baldy Smith later claimed that the idea of an attack across an entire enemy front "is denounced by the standard writers on the art of war, and belongs to the first period in history after man had ceased to fight in unorganized masses." Grant agreed that the offensive had been botched, announcing in his deathbed memoir his regrets that the assault had ever been made. "No advantage whatever was gained to compensate for the heavy loss we sustained," he confessed.

Although Grant and his subordinates were perturbed by their inability to pierce Lee's line at Cold Harbor, they did not consider the reverse any more serious than Lee's previous rebuffs in the Wilderness, Spotsylvania Court House, and North Anna operations. Reviewing the week's events, Grant and Meade thought they had done rather well, having turned Lee out of his North Anna line, maneuvered him nearly twenty miles closer to the Confederate capital, and cornered him against Richmond. The attempt to punch through Lee's works had failed, but the campaign still held fair prospects for ultimate success.

Southerners rightfully viewed their repulse of the Union offensive at Cold Harbor as another signal victory. A Confederate crowed that Grant's initials "U.S." stood for "Unfortunate Strategist" and that the campaign had proven him "the worst used up Yankee commander that we ever combated." Lee's aide Charles Venable proclaimed Cold Harbor "perhaps the easiest [victory] ever granted to Confederate arms by the folly of the Federal commanders."

But impressive as Lee's victory had been, the pattern of the campaign remained troubling. Each time Lee fought Grant to stalemate, the Union general shifted to new ground closer to Richmond, maintaining an intense regimen of maneuver and attack that curtailed Lee's opportunity to counter-maneuver. Southerners not blinded by Lee's successes also saw that attri-

tion in Confederate ranks augured poorly for the army's future. Even though Totopotomoy Creek and Cold Harbor were victories, they had cost Lee about six thousand soldiers, or 10 percent of the men that had started the campaign. Of Lee's four initial corps commanders, only the ailing Hill remained, and attrition in division, brigade, and regimental commanders had been horrific. The Confederates might be winning battles, but the net effect of those victories was to accelerate the Army of Northern Virginia's demise. Lee could ill afford many more successes like Cold Harbor.

# Conclusion

The aftermath of the June 3 offensive was almost as bloody as the battle itself. The butchery shocked even the Confederates. "I had seen the dreadful carnage in front of Marye's Hill at Fredericksburg, and on the 'old railroad cut' which Jackson's men held at Second Manassas; but I had seen nothing to exceed this," reflected Brigadier General Evander McIver Law, whose Alabamians slew Smith's Federals in droves. "It was not war; it was murder."

Perhaps a thousand wounded men, the vast majority wearing blue, dotted the no-man's-land between the armies. Moved by the suffering of their comrades, Union soldiers crept out under cover of night to try to rescue the survivors. But large numbers of wounded soldiers continued to languish beside the decomposing corpses of their friends. Baking under a relentless midsummer sun, tormented by flies and insects, they had neither food nor water, and any movement drew fire from sharpshooters. By June 5 the stench had become intolerable, and cries from wounded men became fewer and fainter.

After noon on June 5, Grant suggested to Meade that a flag of truce "might be sent proposing to suspend firing where the wounded are, until each party get their own." Meade, however, was unwilling to accept responsibility. "Any communication by flag of truce will have to come from you," he insisted, "as the enemy do not recognize me as in command whilst you are present." Grant gamely penned a proposal to Lee "that hereafter when no battle is raging either party be authorized to send to any point between the pickets or skirmish lines, unarmed men bearing litters to pick up their dead or wounded without being fired upon by either party. Any other method equally fair to both parties you may propose for meeting the end desired, will be accepted by me."

Early the next day, Lee wrote back agreeing with the spirit of Grant's suggestion but objecting to his procedure. Allowing litter bearers to wander into sectors where fighting had temporarily quieted struck Lee as a bad idea. "I fear that such an arrangement will lead to misunderstanding and difficulty," he cautioned and proposed instead "that when either party desires to remove their dead or wounded, a flag of truce be sent, as is customary."

Reading Lee's letter as insisting only that a flag of truce accompany the litter bearers, Grant drafted a reply. He intended,

*Opposite:* Over two thousand Union soldiers killed in the 1862 and 1864 campaigns against Richmond are buried in the Cold Harbor National Cemetery. A five-foot-high marble sarcophagus commemorates 889 Union soldiers whose identities are unknown and who lie in nearby trench graves.

he wrote, to "send immediately, as you propose, to collect the dead and wounded between the lines of the two armies, and will also instruct that you be allowed to do the same. I propose that the time for doing this be between the hours of 12m and 3 p.m. today. I will direct all parties going out to bear a white flag, and not to attempt to go beyond where we have dead or wounded, and not beyond or on ground occupied by your troops."

Grant, however, had misunderstood Lee's framework. The rebel commander wanted an armywide armistice, not just informal local truces that might spawn confusion. "I have the honor to acknowledge the receipt of your letter of this date and regret to find that I did not make myself understood in my communication of yesterday," Lee explained in a new message that came across the lines a few hours later. "I intended to say that I could not consent to the burial of the dead and the removal of the wounded between the armies in the way you propose, but that when either party desires such permission it shall be asked for by flag of truce in the usual way. Until I receive a proposition from you on the subject to which I can accede with propriety, I have directed any parties you may send under white flags as mentioned in your letter to be turned back."

The Union chief acquiesced to Lee's apparent insistence on a general armistice. "The knowledge that wounded men are now suffering from want of attention, between the two armies, compels me to ask a suspension of hostilities for sufficient time to collect them in, say two hours," he wrote in response. "Permit me to say that the hours you may fix upon for this will be agreeable to me, and the same privilege will be extended to such parties as you may wish to send out on the same duty, without further application."

The difficulty of sending messages across the lines delayed Lee's reply, however, leaving the long-suffering invalids to endure another agonizing night in no-man's-land. Dickering resumed the next morning, and a bargain was finally struck. An armywide truce began that evening. "Enemies met as friends," remembered a man from Vermont. A Confederate had similar recollections. "Over the breastworks went Rebel and Yank, and met between the lines, and commenced laughing and talking, and you would have thought that old friends had met after a long separation," he related. "Some were talking earnestly together, some swapping coffee for tobacco, some were wrestling, some boxing, others trading knives."

The unexpected show of camaraderie did little to diminish the scene's horror. Few wounded men were still alive, and General Gibbon later reported that bodies had dissolved into a "mass of corruption very offensive to everybody, friends and enemy, in the vicinity." Burial parties deposited the gory remains in common trenches.

Although the truce was set to expire that night, the soldiers seemed reluctant to see it end. Some of Hancock's troops were found bathing the next morning in a creek with Hoke's men. "It seemed very odd to see these men mingling with each other, laughing and joking and very friendly, that only a short time before were watching for an opportunity and trying their best to kill each other, and would so soon be trying it again," a Pennsylvanian reflected. Shortly before noon, a rebel officer instructed his soldiers to get back behind their works and gave the Yankees five minutes notice to do the same.

Minutes later, the rattle of musketry broke the quiet. The truce was over, and the killing started up again.

Aggressive as ever, Grant quickly developed a new strategy for breaking the stalemate at Cold Harbor. Sheridan's cavalry was to raid west toward Charlottesville, cutting the Virginia Central Railroad and linking with another Union army advancing south through the Shenandoah Valley. Meantime the Army of the Potomac would shift south, cross the James River, and sweep on to capture Petersburg and sever the remaining rail lines to

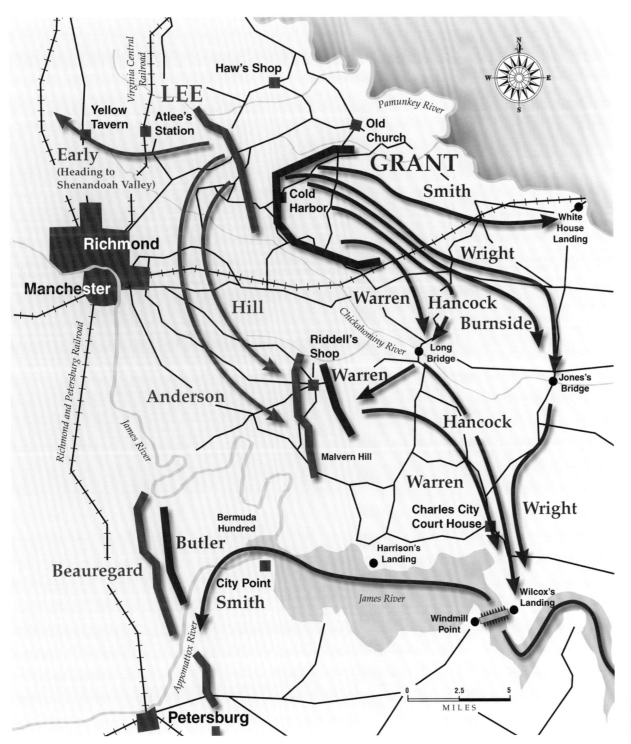

Virginia Central Railroad

Haw's Shop

**LEE**

Yellow
Tavern

Atlee's
Station

Old
Church

Pamunkey River

**GRANT**

Smith

**Early**
(Heading to
Shenandoah Valley)

Cold
Harbor

White
House
Landing

**Richmond**

Wright

**Manchester**

Warren

Hancock

Hill

Burnside

Chickahominy River

Riddell's
Shop

Long
Bridge

**Warren**

Richmond and Petersburg Railroad

**Anderson**

James River

Jones's
Bridge

Hancock

Malvern Hill

**Warren**

Charles City
Court House

Wright

Bermuda
Hundred

**Butler**

Harrison's
Landing

**Beauregard**

City Point

**Smith**

James River

Wilcox's
Landing

Appomattox River

Windmill
Point

0    2.5    5

MILES

**Petersburg**

Disengagement from Cold Harbor and Movement toward
Petersburg, June 12–15, 1864

Richmond. Bereft of supplies, Lee would be denied his base and fatally weakened.

Anticipating Grant's objective, Lee expressed grave concern. "We must destroy this army of Grant's before he gets to James River," the Virginian remarked to Jubal Early. "If he gets there, it will become a siege, and then it will be a mere question of time."

While Grant worked out the details of his plan, the soldiers of both armies settled into a numbing routine of trench warfare. Men hunkered in pits, broiling under the summer sun and digging a warren of trenches for bringing food and ammunition from the rear. The scene reminded an observer of "colonies of prairie dogs with their burrows and their mounds." Sharpshooters kept careful lookouts for signs of movement, and deadly little skirmishes sparked across the lines.

On June 7, Sheridan left with two divisions to tear up the Virginia Central Railroad, and a week later, Lee dispatched Early on a daring raid through the Shenandoah Valley to divert Grant's attention. On the evening of June 12, the Army of the Potomac began withdrawing to the James River. Baldy Smith's corps boarded transports at White House Landing and retraced their river route to Bermuda Hundred while the rest of the Union army marched south, with Warren's corps screening their movement. Lee discovered Grant's departure the next morning but was unable to pierce Warren's protective screen to determine the Union army's whereabouts. "Marse Robert, who knew everything knowable," a rebel cavalryman observed, "did not appear to know just what his old enemy proposed to do."

During the afternoon of June 14, Smith's troops arrived at Bermuda Hundred and prepared to move on Petersburg. That night, boats ferried Hancock, who was to cooperate with Smith, across the James. "I think it is pretty well to get across a great river and, and come up here and attack Lee in his rear before he is ready for us," Grant gloated.

But once again, Union commanders frittered away their advantages. Smith broke through the lightly defended earthworks in front of Petersburg but halted for a fateful night waiting for Hancock's reinforcements. By morning, Hoke's division had arrived from Lee's army and was manning a new defensive line. For three days, disjointed Federal assaults pounded the Petersburg line, made increasingly stronger by the arrival of Lee's veterans. On June 18, Grant bowed to reality and called off the attacks. "I now ordered the troops to be put under cover and allowed some of the rest which they had so long needed," he later wrote. The Overland Campaign was finished, and the armies settled into the siege that Lee had so feared. The end would come eight months later.

Debate continues over which side won the Overland Campaign. The answer turns on how one defines winning. One method is to count casualties. Since Grant lost about 55,000 soldiers, and Lee about 33,000, the rebel commander by this method emerges as the clear winner. Southern partisans also correctly stress that Lee inflicted casualties that nearly equaled the number of men that he commanded when the campaign began. However, if losses are measured against the respective size of each army at the outset of the campaign, Lee's losses exceeded 50 percent, while Grant's were about 45 percent. And while each army received substantial reinforcements, Grant's capacity to augment his force was vastly superior to Lee's. Despite his many tactical setbacks, Grant lost soldiers at a lower overall rate than did Lee, and simple arithmetic suggested that he would prevail.

If the commanders are scored by points like boxers, Lee comes out the clear winner. Although consistently outnumbered, he achieved victories at the Wilderness, Spotsylvania Court House, the North Anna River, and Cold Harbor. But if the campaign is analyzed in its entirety, Grant comes out ahead. Although he suffered serious tactical reverses, he never con-

sidered himself defeated, and he hewed to his general strategic purpose of defeating Lee. The rebel commander's objective was to hold the line of the Rapidan, and he failed; Grant's objective was to destroy Lee's army as an effective fighting force, and he largely succeeded. By the end of the campaign, Grant had pinned Lee against Richmond and Petersburg, ending the rebel army's offensive capacity and seriously diminishing its ability to affect the outcome of the war.

Grant is often criticized for the massive casualties generated by his relentless style of warfare. As the North began to comprehend the campaign's human price, the value of gold almost doubled, and Lincoln's political stock declined precipitously. It was the president's good fortune that Union successes at Mobile Bay, at Atlanta, and in the Shenandoah Valley came along in time to restore northern morale and save his administration.

In retrospect, however, Grant was less reckless with his soldiers' lives than his predecessors had been. No single day of Grant's pounding saw the magnitude of Union casualties that McClellan incurred in one day at Antietam, and no three consecutive days of Grant's warring proved as costly to the Union in blood as did Meade's three days at Gettysburg. It must also be remembered that Grant waged several consecutive major battles in the Overland Campaign, one after the other. Unlike his predecessors, who disengaged after their battles and left Lee to repair his losses, Grant followed up his fights with a vengeance. Most importantly, he had something to show for his efforts in the end. Comparing Union casualties in Virginia before

and after Grant's arrival, Assistant Secretary of War Charles A. Dana noted that Grant "secured the prize with less loss than his predecessors suffered in failing to win it during a struggle of three years."

However one keeps score, Grant and Lee were about as evenly matched in military talent as any two opposing generals have ever been. Grant's strength was unwavering adherence to his strategic objective. He made mistakes, but the overall pattern of his campaign reveals an innovative general employing thoughtful combinations of maneuver and force to bring a difficult adversary to bay on his home turf. Lee's strength was resilience and the fierce devotion that he inspired in his troops. He, too, made mistakes and often placed his smaller army in peril. But each time—Spotsylvania Court House and the North Anna River come to mind—he improvised solutions that turned bad situations his way. In many respects the generals were similar. Each favored offensive operations and took fearless courses of action that left traditional generals aghast; each labored under handicaps, although of different sorts; and each was bedeviled by subordinates who often seemed incapable of getting things right.

The guns of the Overland Campaign have long quieted, but the battle continues to preserve the places where Grant and Lee once clashed. Chris Heisey and I offer this book as a tribute to the soldiers who fought in the Overland Campaign and as inspiration for modern-day warriors dedicated to preserving what remains of the sites where so many fellow Americans sacrificed their lives.

# The Order of Battle at the Opening of the Overland Campaign

## UNION FORCES
*Lieutenant General Ulysses S. Grant*

### ARMY OF THE POTOMAC
*Major General George Gordon Meade*

#### 2nd Army Corps
*Major General Winfield S. Hancock*

**1st Division**
*Brigadier General Francis C. Barlow*
1st Brigade
Colonel Nelson A. Miles
2nd Brigade
Colonel Thomas A. Smyth
3rd Brigade
Colonel Paul Frank
4th Brigade
Colonel John R. Brooke

**2nd Division**
*Brigadier General John Gibbon*
1st Brigade
Brigadier General Alexander S. Webb
2nd Brigade
Brigadier General Joshua T. Owen
3rd Brigade
Colonel Samuel S. Carroll

**3rd Division**
*Major General David B. Birney*
1st Brigade
Brigadier General J. H. Hobart Ward
2nd Brigade
Brigadier General Alexander Hays

**4th Division**
*Brigadier General Gershom Mott*
1st Brigade
Colonel Robert McAllister
2nd Brigade
Colonel William R. Brewster

#### 5th Army Corps
*Major General Gouverneur K. Warren*

**1st Division**
*Brigadier General Charles Griffin*
1st Brigade
Brigadier General Romeyn B. Ayres
2nd Brigade
Colonel Jacob B. Sweitzer
3rd Brigade
Brigadier General Joseph J. Bartlett

**2nd Division**
*Brigadier General John C. Robinson*
1st Brigade
Colonel Samuel H. Leonard
2nd Brigade
Brigadier General Henry Baxter
3rd Brigade
Colonel Andrew W. Denison

**3rd Division**
*Brigadier General Samuel W. Crawford*
1st Brigade
Colonel William McCandless
3rd Brigade
Colonel Joseph W. Fisher

**4th Division**
*Brigadier General James S. Wadsworth*
1st Brigade
Brigadier General Lysander Cutler
2nd Brigade
Brigadier General James C. Rice
3rd Brigade
Colonel Roy Stone

## 6th Army Corps
*Major General John Sedgwick*

### 1st Division
*Brigadier General Horatio G. Wright*
1st Brigade
Colonel Henry W. Brown
2nd Brigade
Brigadier General Emory Upton
3rd Brigade
Brigadier General David A. Russell
4th Brigade
Brigadier General Alexander Shaler

### 2nd Division
*Brigadier General George W. Getty*
1st Brigade
Brigadier General Frank Wheaton
2nd Brigade
Brigadier General Lewis A. Grant
3rd Brigade
Brigadier General Thomas H. Neill
4th Brigade
Brigadier General Henry L. Eustis

### 3rd Division
*Brigadier General James B. Ricketts*
1st Brigade
Brigadier General William H. Morris
2nd Brigade
Brigadier General Truman Seymour

## 9th Army Corps
*Major General Ambrose E. Burnside*

### 1st Division
*Brigadier General Thomas G. Stevenson*
1st Brigade
Colonel Sumner Carruth
2nd Brigade
Colonel Daniel Leasure

### 2nd Division
*Brigadier General Robert B. Potter*
1st Brigade
Colonel Zenas R. Bliss
2nd Brigade
Colonel Simon G. Griffin

### 3rd Division
*Brigadier General Orlando B. Willcox*
1st Brigade
Colonel John F. Hartranft
2nd Brigade
Colonel Benjamin C. Christ

### 4th Division
*Brigadier General Edward Ferrero*
1st Brigade
Colonel Joshua K. Sigfried
2nd Brigade
Colonel Henry G. Thomas

## Cavalry Corps
*Major General Philip H. Sheridan*

### 1st Division
*Brigadier General Alfred T. A. Torbert*
1st Brigade
Brigadier General George A. Custer
2nd Brigade
Colonel Thomas C. Devin
Reserve Brigade
Brigadier General Wesley Merritt

### 2nd Division
*Brigadier General David McM. Gregg*
1st Brigade
Brigadier General Henry E. Davies Jr.
2nd Brigade
Colonel J. Irvin Gregg

### 3rd Division
*Brigadier General James H. Wilson*
1st Brigade
Colonel John B. McIntosh
2nd Brigade
Colonel George H. Chapman

## 18th Army Corps [Joined Army of the Potomac at Cold Harbor]
*Major General William F. Smith*

### 1st Division
*Brigadier General William T. H. Brooks*
1st Brigade
Brigadier General Gilman Marston
2nd Brigade
Brigadier General Hiram Burnham
3rd Brigade
Colonel Guy V. Henry

### 2nd Division
*Brigadier General John H. Martindale*
1st Brigade
Brigadier General George J. Stannard
2nd Brigade
Colonel Griffin A. Stedman Jr.

### 3rd Division
*Brigadier General Charles Devens Jr.*
1st Brigade
Colonel William B. Barton
2nd Brigade
Colonel Jeremiah C. Drake
3rd Brigade
Brigadier General Adelbert Ames

# CONFEDERATE FORCES

## ARMY OF NORTHERN VIRGINIA
*General Robert E. Lee*

### 1st Army Corps
*Lieutenant General James Longstreet*

**Kershaw's Division**
*Brigadier General Joseph B. Kershaw*
Kershaw's Brigade
Colonel John W. Henagan
Humphreys's Brigade
Brigadier General Benjamin G. Humphreys
Wofford's Brigade
Brigadier General William T. Wofford
Bryan's Brigade
Brigadier General Goode Bryan

**Field's Division**
*Major General Charles W. Field*
Jenkins's Brigade
Brigadier General Micah Jenkins
Gregg's Brigade
Brigadier General John Gregg
Law's Brigade
Brigadier General William F. Perry
Anderson's Brigade
Brigadier General George T. Anderson
Benning's Brigade
Brigadier General Henry C. Benning

### 2nd Army Corps
*Lieutenant General Richard S. Ewell*

**Early's Division**
*Major General Jubal A. Early*
Pegram's Brigade
Brigadier General John Pegram
Johnston's Brigade
Brigadier General Robert D. Johnston
Gordon's Brigade
Brigadier General John C. Gordon
Hays's Brigade
Brigadier General Harry T. Hays

**Johnson's Division**
*Major General Edward Johnson*
Stonewall's Brigade
Brigadier General James A. Walker
Jones's Brigade
Brigadier General John M. Jones
Steuart's Brigade
Brigadier General George H. Steuart
Stafford's Brigade
Brigadier General Leroy A. Stafford

**Rodes's Division**
*Major General Robert E. Rodes*
Daniel's Brigade
Brigadier General Junius Daniel
Ramseur's Brigade
Brigadier General Stephen D. Ramseur
Battle's Brigade
Brigadier General Cullen A. Battle
Doles's Brigade
Brigadier General George Doles

## 3rd Army Corps
*Lieutenant General Ambrose P. Hill*

**Anderson's Division**
*Brigadier General Richard H. Anderson*
Perrin's Brigade
Brigadier General Abner Perrin
Mahone's Brigade
Brigadier General William Mahone
Harris's Brigade
Brigadier General Nathaniel H. Harris
Perry's Brigade
Brigadier General Edward A. Perry
Wright's Brigade
Brigadier General Ambrose R. Wright

**Heth's Division**
*Major General Henry Heth*
Davis's Brigade
Colonel John M. Stone
Cooke's Brigade
Brigadier General John R. Cooke
Walker's Brigade
Brigadier General Henry H. Walker
Kirkland's Brigade
Brigadier General William W. Kirkland

**Wilcox's Division**
*Major General Cadmus M. Wilcox*
Lane's Brigade
Brigadier General James H. Lane
McGowan's Brigade
Brigadier General Samuel McGowan
Scales's Brigade
Brigadier General Alfred M. Scales
Thomas's Brigade
Brigadier General Edward L. Thomas

## Cavalry Corps
*Major General James E. B. Stuart*

**Hampton's Division**
*Major General Wade Hampton*
Young's Brigade
Brigadier General Pierce M. B. Young
Rosser's Brigade
Brigadier General Thomas L. Rosser
Butler's Brigade
Brigadier General Matthew C. Butler

**Fitzhugh Lee's Division**
*Major General Fitzhugh Lee*
Lomax's Brigade
Brigadier General Lunsford L. Lomax
Wickham's Brigade
Brigadier General Williams C. Wickham

**William H. F. Lee's Division**
*Major General William H. F. Lee*
Chambliss's Brigade
Brigadier General John R. Chambliss
Gordon's Brigade
Brigadier General James B. Gordon

**Breckinridge's Division (Joined Army of Northern Virginia at North Anna River)**
*Major General John C. Breckinridge*
Echols's Brigade
Brigadier General John Echols
Wharton's Brigade
Brigadier General Gabriel C. Wharton
McLaughlin's Artillery Battalion
Major William McLaughlin
Maryland Line
Colonel Bradley T. Johnson

**Hoke's Division (Joined Army of Northern Virginia at Cold Harbor)**
*Major General Robert F. Hoke*
Martin's Brigade
Brigadier General James G. Martin
Clingman's Brigade
Brigadier General Thomas L. Clingman
Hagood's Brigade
Brigadier General Johnson Hagood
Colquitt's Brigade
Brigadier General Alfred H. Colquitt

# Acknowledgments

## GORDON C. RHEA

As with all my endeavors, this one would not have been possible without the understanding, support, and encouragement of my wife, Catherine, and my two sons, Campbell and Carter, who are an integral part of everything that I do.

The heart of this book is Chris Heisey's photographs, and to Chris goes the credit for whatever merit this work might have. I second his thanks to the various people who assisted in our project and add my special thanks to Robert E. L. Krick of the Richmond National Battlefield Park and to Eric Mink of the Fredericksburg and Spotsylvania National Battlefield Park, each of whom gave selflessly of their time and considerable expertise. I am also grateful to Steven Stanley, whose maps add immeasurably to this book, and to Melanie Samaha of Louisiana State University Press's Design Department, who massaged our bits and pieces into a coherent whole and brought them to life.

## CHRIS E. HEISEY

Whenever General Lee won a great victory, he would attribute his army's triumph to the mercy of Almighty God while thousands lay slain on the battlefield.

I am grateful to the Almighty for mercifully giving me the light needed to take this collection of images. In no way can I thank Gordon Rhea enough for asking me to collaborate with him on this project. He has been generous, gracious, and a real pleasure to work with. His knowledge of the Overland Campaign is stunning, and this book is a testament to him.

My wife, Kim, has endured much as I worked on this project. Being the spouse of a moody and broody photographer is no easy task, especially when that photographer hops out of bed at 3:00 a.m. on another "On to Richmond" campaign designed to commence at sunrise. She was understanding and supportive about every shoot.

Aaron, my son, who loves history, never gave me grief when I needed to go back to 1864 Virginia. He always greeted me when I returned with a kid smile that I will never forget.

My parents, Nancy and Elwood, have always given me reason to love and study the Civil War.

My friend Tim is good-natured and kind to me. The balmy, moonless March night we spent on the spooky Cold Harbor battlefield shooting star trails rolling around the rocks was more fun than any other shoot for this book. "Thank you" covers not enough.

I wish to thank Bishop Kevin C. Rhoades of the Catholic Diocese of Harrisburg, who permitted me to do this project and graciously never questioned where my loyalty lies. So many others at the diocese have been thoughtful to me, and I appreciate their support.

Bobby Krick and Eric Mink of the National Park Service helped me any time I asked. The Park Service has two great ambassadors for history with them wearing the buffalo. Richmond's Chief Ranger Tim Mauch guided me through the bureaucracy in expert fashion, which made the photography part easier and kept me out of trouble.

The images in this book were all done on film. Perhaps film photography is a dying art form, given the tremendous growth of digital technology, but film has a certain vintage look, and Fine Art Photo and Capital Color handled my film with special care.

To Pastor Dave at Massaponax Baptist Church, thanks for the Christian charity one cold winter's night. Expert pilot Les Watson of American Helicopters of Manassas not only was wholly cooperative, but without him I would have lost my way above the Wilderness. Victor Bravo, Les. Jack and Pat North own a sensational inn at Mayhurst in Orange, Virginia. Thank you for your hospitality. Michele and Edward Schiesser run a plantation at La Vista that takes you back to 1864 with little trouble.

Virginia Beard Morton deserves credit for marching us through Culpeper with fashionable zeal. Della Edrington and staff at Graffiti House, Brandy Station, showed me why Civil War history is always such a treasure hunt.

Never have I met a more refined Virginia lady than Ms. Dorothy Atkinson of Wyoming farm along the Pamunkey. She's a walking history book and her love for the past is palpable.

No book ever comes to light without a trusted publisher. Louisiana State University Press does a great service to Civil War enthusiasts by publishing scores of fantastic titles for us to devour. This photographer is grateful for their professionalism and willingness to do this style of book.

My college athletic coach, Dr. Smart, deserves credit for this book also. He's the one who taught me how to persevere and work beyond my abilities. And when I talk to him today, he still treats me like I matter. That makes all the difference to any student.

So much of our hallowed ground is still in private hands, and it is cared for by landowners who are true stewards of our history. For all those who welcomed me on their property with a friendly handshake, I say many thanks. Preserving battlefields is truly a great task to partake.

Never did I forget those long-ago soldiers as I shot this project. Whether it was in a driving ice storm at Spotsylvania or a frigid 4-degree morning at Saunders' Field, those men of Grant and Lee were constantly my focus. When the temperature cracked 100 and storms were brewing, it was quite easy to think of what these soldiers endured in June of 1864.

Without their sacrifice, of course, this book would never have seen the light.

# Note on Sources

To avoid undue distractions from Chris Heisey's photographs, we have elected not to include footnotes. Citations for quoted material can be found in my four books on the Overland Campaign referenced below.

For readers seeking to learn more about General Grant, I recommend the general's *Personal Memoirs of U.S. Grant*, 2 vols. (New York, 1885); the comprehensive collection of Grant's writings in *The Papers of Ulysses S. Grant*, edited by John Y. Simon, 28 vols. (Carbondale, IL, 1967–2005); the aide Horace Porter's *Campaigning with Grant* (New York, 1897); and the best of the modern Grant biographies, Brooks D. Simpson's *Ulysses S. Grant: Triumph over Adversity, 1822–1865* (Boston, 2000).

For Lee material, I recommend Clifford E. Dowdey, ed., *The Wartime Papers of R. E. Lee* (New York, 1961); and sketches by the general's aides, including Charles S. Venable, "The Campaign from the Wilderness to Petersburg," *Southern Historical Society Papers* 14 (1886): 522–42; Walter H. Taylor, *General Lee: His Campaigns in Virginia, 1861–1865, with Personal Reminiscences* (Norfolk, VA, 1906); and R. Lockwood Tower, ed., *Lee's Adjutant: The Wartime Letters of Colonel Walter Herron Taylor, 1862–1865*

(Columbia, SC, 1995). Douglas Southall Freeman's magisterial *R. E. Lee: A Biography*, 4 vols. (New York, 1935), remains an exciting read, and Emory M. Thomas's *Robert E. Lee: A Biography* (New York, 1995) sets the modern standard.

Compared to the extensive scholarship on battles such as Gettysburg, the campaign in central Virginia in the spring of 1864 has received surprisingly little scholarly attention. The earliest, and one of the best, histories of the campaign is *The Virginia Campaign of '64 and '65: The Army of the Potomac and the Army of the James* (New York, 1883), written by George Meade's chief of staff Andrew A. Humphreys. Relying largely on official records and on his own recollections, Humphreys's book is an even-handed rendition. A later thoughtful analysis, grounded largely in official reports, is J. H. Anderson's *Grant's Campaign in Virginia: May 1–June 30, 1864* (London, 1908). Southern partisans will find much to their liking in Clifford Dowdey's *Lee's Last Campaign: The Story of Lee and His Men against Grant, 1864* (New York, 1960). By far the best general modern accounts are Noah Andre Trudeau's *Bloody Roads South: The Wilderness to Cold Harbor, May–June 1864* (Boston, 1989); and Mark Grimsley's *And Keep Moving On: The Virginia Campaign, May–June 1864* (Lincoln, NE, 2002).

The first detailed recounting of Grant and Lee's confrontation in the Wilderness is *The Battle of the Wilderness* (Boston, 1910), written by Morris Schaff, an ordnance officer on Gouverneur Warren's staff. A detailed but sometimes pedantic version of the battle is Edward Steere's *The Wilderness Campaign* (Harrisburg, PA, 1960). My own *Battle of the Wilderness: May 5–6, 1864* (Baton Rouge, LA, 1994) is the most recent book-length study. For aficionados of the battle, I recommend Gary W. Gallagher, ed., *The Wilderness Campaign* (Chapel Hill, NC, 1997), which contains a stimulating collection of essays; and Stephen Cushman's *Bloody Promenade: Reflections on a Civil War Battle* (Charlottesville, VA, 1999), which brings the musings of a poet and professor of American literature to the subject.

The battles around Spotsylvania Court House were first explored in depth by William D. Matter in *If It Takes All Summer: The Battle of Spotsylvania* (Chapel Hill, NC, 1989). Carefully researched, Matter's work has attained the reputation of a Civil War classic. I also humbly recommend my *The Battles for Spotsylvania Court House and the Road to Yellow Tavern: May 7–12, 1864* (Baton Rouge, LA, 1997), which carries the battle through the Bloody Angle; and my *To the North Anna River: Grant and Lee, May 13–25, 1864* (Baton Rouge, LA, 2000), which completes the fighting along the Spotsylvania lines and follows the maneuvers to the stalemate on the North Anna River. Those latter operations are also well described in Michael J. Miller's *The North Anna Campaign: "Even to Hell Itself," May 21–26, 1864* (Lynchburg, VA, 1989). Readers seeking to learn more about the Spotsylvania Court House battles would do well to consult the essays collected by Gary W. Gallagher in *The Spotsylvania Campaign* (Chapel Hill, NC, 1998).

Cold Harbor has been the subject of three book-length treatments: Louis J. Baltz III, *The Battle of Cold Harbor: May 27–June 13, 1864* (Lynchburg, VA, 1994); Ernest B. Furgurson, *Not War but Murder: Cold Harbor, 1864* (New York, 2000); and my own *Cold Harbor: Grant and Lee, May 26–June 3, 1864* (Baton Rouge, LA, 2002).